NATIVE AMERICAN BASKETRY

**Recent Titles in
Art Reference Collection**

NATIVE AMERICAN BASKETRY

An Annotated Bibliography

Compiled by
Frank W. Porter III

Art Reference Collection, Number 10

GREENWOOD PRESS
New York • Westport, Connecticut • London

Library of Congress Cataloging-in-Publication Data

Porter, Frank W., 1947-
 Native American basketry : an annotated bibliography / compiled by
Frank W. Porter III.
 p. cm.—(Art reference collection, ISSN 0193-6867 ; no. 10)
 Includes indexes.
 ISBN 0-313-25363-3 (lib. bdg. : alk. paper)
 1. Indians of North America—Basket making—Bibliography.
I. Title. II. Series.
Z1209.2.N67P67 1988
[E59.B3]
016.74641'2'0899—dc 19 87-37570

British Library Cataloguing in Publication Data is available.

Library of Congress Catalog Card Number: 87-37570
ISBN: 0-313-25363-3
ISSN: 0193-6867

First published in 1988

Greenwood Press, Inc.
88 Post Road West, Westport, Connecticut 06881

Printed in the United States of America

The paper used in this book complies with the
Permanent Paper Standard issued by the National
Information Standards Organization (Z39.48-1984).

10 9 8 7 6 5 4 3 2 1

Contents

Preface

In the Spring of 1985, I wrote an article about the basketry of the Indians of the Middle Atlantic region. Little did I realize then where that small research project would lead. During the past three years, I have come to know and appreciate the work of many basket makers, both past and present. I have also had the opportunity to meet and to correspond with many of the people who are currently studying Native American basketry. They have generously shared the results of their research with me. This bibliography could not have been possible without their cooperation.

I particularly want to thank Deborah Shaffer, Interlibrary Loan librarian at Mount Saint Mary's College, and Karen Williams, head of the Ohio Valley Area Libraries at Ohio University, for their tremendous efforts in obtaining many of the obscure journal articles, dissertations and theses, and out-of-print books. Camera-ready copy of this manuscript was prepared by WordTech, Inc. of Athens, Ohio. Joyce Quillen and Mindy Hill graciously assisted me with the preparation of the index.

NATIVE AMERICAN BASKETRY

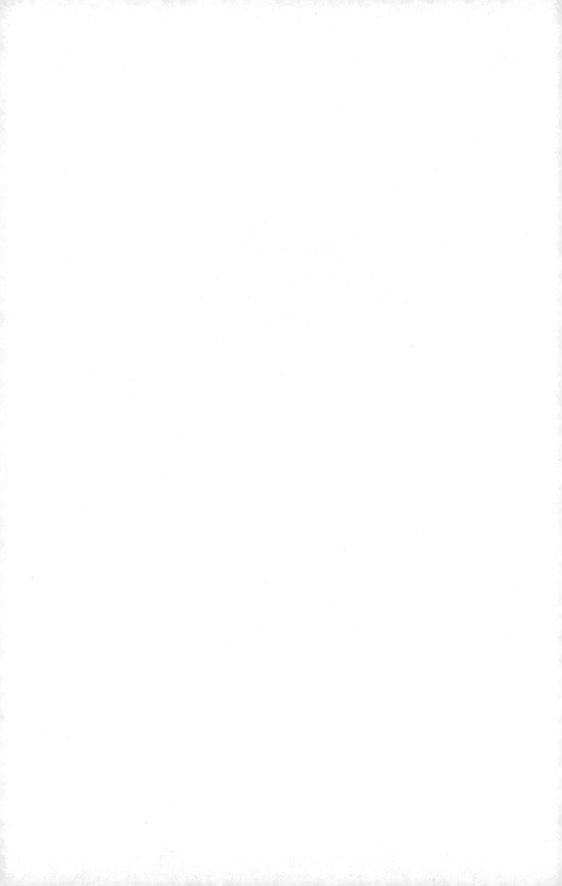

Introduction

The period of greatest productivity in Native American basket making and of the serious and widespread beginning of basket collecting was from the late 1800s and continuing to the early 1900s. The baskets made during this golden era of collecting form the basis of most museum and private collections (Gogol 1985: 12-29). After 1920 basket making began to decline among many tribes, but the collecting of older, traditional specimens continued, usually through salvage ethnography or under the guise of commercial ethnography (Porter 1985).

Traditional Native American basketry is, with only a few exceptions, a product of an earlier time and a vastly different way of life. Those individuals who made baskets did so for the pure joy of creating something of beauty and value. The baskets were to be shared with family and friends in this life and, in some instances, in the hereafter. Each generation of basket makers followed the accepted artistic tradition of its time (Collings 1975).

The development of a commercial market significantly influenced the making of Native American baskets. Tourists and collectors purchased Indian baskets for their beauty and utility. Bright colors, rustic appearance, and the desire to obtain an "authentic" Indian basket helped to nurture this tourist market. The arts and crafts movement of the turn of the century stimulated a new interest in home interior decorating. Many of the popular magazines contained advertisements which emphasized the aesthetic and decorative delights of American Indian baskets, pottery, and textiles. By the late 1800s, Native American baskets had become requisite for many fashionable decors (James 1901: 619).

Curio dealers came into existence to satisfy this growing demand for baskets and other Indian artifacts. By the end of the nineteenth century, California had been

scoured for Indian baskets by several local dealers and by traveling salesmen, who had become affected by the "basket craze" (Dixon 1900: 266). Many Indian basket makers in the Southeast had surrendered to the growing demand for speed of production by cheapening their wares. Commercial dyes were commonly used, because the traditional way of making dyes was too tedious and time-consuming (Dormon 1931: 13). The situation in the Northeast was quite similar. "A century ago . . . the desire was to supply a demand for a merchant-able product," observed Fannie Eckstorm, "and while an article may have been manufactured by an Indian, it was not necessarily made after an aboriginal Indian pattern" (Eckstorm 1932: 20). The appreciation of Indian crafts, especially basketry, among Whites resulted in extensive imitation. The attempts to replicate and mass-produce Indian crafts served only to create a mass of trash. After 1910, interest in Indian basketry began to wane. Antique and curio shops frequently would not stock Indian baskets. Prices, not surprisingly, plummeted.

By the late 1920s, the number of Indians making tradi-tional baskets had become quite small. There are three im-portant reasons for the decline in basket making among Na-tive Americans. Clearly the most significant factor was the breakdown of traditional values and customs. "A buyer [col-lector] knows that in the camp itself the shapely basket is fast being replaced by the unsightly gunny bag and utensils of rusting tin and iron," Ada Woodruff Anderson (1899) la-mented in her commentary about "The Lost Industry of a Van-ishing Race." Furthermore, many basket makers lived in areas where access to essential basketry materials was limi-ted or where the basketry materials were no longer availa-ble. Anderson (Ibid) observed that ". . . as new citizens confiscate their grassy flats and the white settler burns away their choicest groves, these few [older women who adhere to the laborious primitive methods of basket making] must go farther afield, make more toilsome pilgrimages by canoe, on horseback, often afoot and covering solitary nights, to secure the necessary materials." In the early 1900s, the Penobscot Indians' supply of black ash for baskets began to become scarce. Although the introduction of the automobile allowed the basket makers to drive seventy -five miles to the upper Kennebec River to new locations of black ash, the cost of making the baskets increased substan-tially (Eckstorm 1932: 20). "The birch is now disappear-ing," commented a Chippewa Indian. "The Indians have difficulty getting it. People don't want their trees stripped. No, the government will never reforest the reserves, and certainly private capital will not, not for the sake of Indians and an art which is at best of little profit to them" (Wadsworth 1937: 77). Finally, economic factors played an increasingly important role as more and more tribes became dependent on the capital system of white society. "If the Indian woman reaped the profit of her toil, and not the frontier trader (who is a shark in far too many instances)," Neltje Blanchan caustically remarked,

"there might be greater hope of preserving the native indus-
tries. As it is, they are periously near becoming among the
lost arts." Similar complaints echoed from all parts of the
country.

There were many efforts, both public and private, to
preserve and maintain the traditional arts and crafts of
Native Americans. The Sequoya League and the Southwest
Society were early attempts to arrest the extinction of
basketry. They purchased baskets from Indian basket makers
for traditional aesthetic quality only (Lummis 1905). In
the 1920s, the National Park Service held "Indian Field
Days" to encourage the production of Indian basketry and
bead work and to stimulate an interest in Indian art on the
part of the public. Women competed against each other to
win prizes (Bates 1982: 28-35). In 1930, the Museum of
Northern Arizona sponsored "The Hopi Craftsman Exhibition."
Its purpose was to stimulate the work of skilled artisans,
ordinary craftsmen, and the beginners. The American Indian
League endeavored to act as an "exchange for Indian woman's
work." It collected subscriptions, bought blankets,
baskets, rugs, pottery, bead work, and found a market for
them. The Indian artisans and craftsmen were induced to
supply the ever increasing demand for their products among
collectors and institutions worldwide. The Indian Arts Fund
was an organized force which assembled representative col-
lections of Indian art with the purpose of educating the
Indian craftsman to better standards of workmanship.

Similar efforts were made to revive or preserve Indian
arts and crafts in the eastern United States. Sarah
McIlhenny and her sister Mrs. Sidney Bradford of Avery
Island, Louisiana helped Chitimacha women to market their
baskets (Dormon 1931: 66). In the 1930s, the Rochester
Museum of Arts and Sciences provided the Iroquois living on
the Tonawanda Reservation in New York with work benches,
carving tools, silversmith's tools, needles and thread,
patterns, photographs, line drawings, and models with which
to revive their arts and crafts (Hill and Fenton 1935: 13).
The state Legislature of Virginia assisted the Pamunkey
Indians with the development of a tribal pottery industry.
Other arts and crafts were studied (Van Oot 1934: 249-251).
Frank G. Speck, a noted anthropologist from the University
of Pennsylvania, helped numerous tribes along the Atlantic
seaboard to revive traditional arts and crafts (Speck 1915;
1925; and 1928. For an extended treatment of Speck's acti-
vities see Porter 1978).

The present day revival of interest in American Indian
basketry has been stirred by the return to favor of hand-
crafted items in a world of mass-produced machine goods.
Indian basket makers have tried to take advantage of this
current interest by producing traditional baskets. In order
to be self-supporting, however, their baskets must be both
artistic creations and economic assets. These basket
makers, while trying hard to preserve tradition, must also

compete in a commercial world. The types of baskets being made all too often reflect changing markets. A delicate balance exists between what a tourist or a collector will pay and what the craftsman can receive for his efforts. Many of the baskets on the market in the 1960s came from private collections, instead of Indian basket makers.

During the first decade of the twentieth century, there were several scholarly monographs and popular works which sought to analyze, classify, and popularize Native American basketry. In the 1890s, basket classes, schools, and "how to" books created a growing awareness of and interest in Native American basketry. Two individuals epitomize the different ways in which basketry was studied. George Wharton James, who had been a health food faddist, editor, publisher, expert on baskets, pottery, and other Indian crafts, certainly influenced a generation of Americans interested in basketry through the publication of *The Basket; the Journal of the Basket Fraternity, or Lovers of Indian Baskets and Other Good Things*. With regard to Indian basketry, James employed without critical review mythology, hearsay, personal observations, and secondary sources to prepare his widely read book, *Indian Basketry*. In 1904, Otis T. Mason published a monumental study of North America basketry. *Aboriginal American Basketry* depended upon, for the most part, ethnographic material to discuss coiled, twined, and twilled basketry. Mason provided a glossary of basketry terms and attempted to show how different sorts of basketry from all of North America could be distinguished and by what criteria they could be classified.

With the discovery of Cliff Palace in the 1890s, national and international attention focused on the Southwest. Among many museums and private collections in the eastern United States, a market for Southwestern artifacts quickly developed. Many of the wealthier easterners actually visited the sites, and in some cases generously funded major expeditions to explore and excavate prominent sites (Moseley 1966). In 1902, George H. Pepper prepared *The Ancient Basketmakers of Southeastern Utah*. Pepper discussed the various Basketmaker-Anasazi textiles which had been excavated in San Juan County, Utah. The material culture of the Basketmakers, especially their baskets, received the most attention and were described in great detail. Various traveling exhibits of basketry from the Southwest brought the news of these incredulous finds to the general public.

Between 1902 and the early 1930s, archaeologists and ethnographers focused their attention almost exclusively on the basketry of the Great Basin, California, the Southwest, and the Northwest Coast. Cummings (1908-1909), Kidder and Guernsey (1914), Morris (1919), Guernsey (1931), Nusbaum (1922), and Morss (1931) investigated the basketry and textiles from the Basketmaker-Anasazi area, while Morss analyzed textiles from the Fremont River area. In 1919,

4

Loud and Harrington, in their report on Lovelock Cave, included a section on the recovered twined, coiled, and plaited basketry. Their study became the first thorough examination of a significant collection of textiles from the Great Basin. Alfred L. Kroeber (1905; 1909; and 1918), Roland B. Dixon (1900 and 1902), and Samuel A. Barrett (1905; 1908; and 1952) collected considerable information about the basketry and basketry designs of the Indians of California. James A. Teit, H. K. Haeberlin, and Helen H. Roberts (1928) prepared the comprehensive study of the basketry of the Northwest Coast tribes. George T. Emmons (1903) added considerable information about the basketry of the Tlingit.

In 1930, Gene Weltfish attempted a general textile classification of North American Indian basketry. Most of her data came from ethnographic materials; only a small amount of archaeological specimens were used. In 1932 Weltfish, keenly aware of the tremendous diversity of terminology being used to describe coiled, twined, and plaited basketry, sought to illustrate some of the problems inherent in comparative studies of basketry. Despite her efforts, as James M. Adovasio (1970: 2) points out, "these articles fell on unreceptive ears, for as more perishables were recovered, terminology appeared to become even less standardized."

Although the absence of a standardized terminology and the need for comparative studies continued to be inherent problems in the investigation of prehistoric basketry materials, some progress was being made. In 1941, Earl H. Morris and Robert F. Burgh published *Anasazi Basketry, Basketmaker II through Pueblo III. A Study Based on Specimens from the San Juan River Country.* Morris and Burgh limited their investigation to Basketmaker-Anasazi coiled and plaited basketry, but they did establish guidelines for the analysis of coiled basketry. At approximately the same time, Luther S. Cressman, in his *Archaeological Researches in the Northern Great Basin,* presented a detailed and comprehensive discussion of Archaic twined textiles.

During the next two decades, archaeological investigations continued to concentrate on western North America. *Caves of the Upper Gila and Hueco Areas in New Mexico and Texas* (Cosgrove 1947), *The Archeology of Castle Park* (Burgh and Scoggin 1948), *Ventanna Cave* (Haury 1950), *Humboldt Cave* (Heizer and Kreiger 1956), and *Danger Cave* (Jennings 1957) illustrate the wide-ranging archaeological investigations conducted during this period. The investigators discussed basketry remains, and attempted to make regional and cultural comparisons. The problem of diverse terminology and unstandardized classification, however, continued to be an impediment to a broader understanding of the evolution of basketry in the Great Basin and the Southwest.

In the late 1960s, James M. Adovasio began to analyze

Introduction

systematically over 5,000 specimens of twined, coiled, and plaited basketry from prehistoric sites in the Great Basin. In the succeeding years Adovasio was able to identify three major textile manufacturing centers: the Northern, Western, and Eastern Basin Centers. The manufacture of textiles in the Great Basin dates to 9,000 B. C. Twining was the earliest technique, to the exclusion of all others. Coiling was restricted to the Eastern Basin; and it appeared there 2,000 years earlier than any other center (Adovasio 1970a; 1970b; 1976; 1980; and 1986). In time, Adovasio was able to provide a general overview of all areas where firm developmental sequences were available.

Throughout this period, archaeologists and ethnographers paid little attention to the basketry of Indians in the eastern United States. Few examples of baskets from the early contact period in this region have survived to the present. Until recent years, there has been a widespread belief that the Indians had become extinct, and with them their material culture. Many anthropologists, museum curators, and collectors have expressed their opinion that the art of basketry in the eastern United States was not aesthetically pleasing or technologically sophisticated. Charles Miles, in his *American Indian and Eskimo Basketry*, observed that "the area in which basketry was of great importance was roughly from the southern Eskimo country of Alaska in a sweep west of the Rockies around through the Southwest to *peter out* in the eastern woodland to a simple minor craft or art" (1969: 12 emphasis added). "The Algonquians in early historic days were expert basket makers," Charles C. Willoughby stated, but the "excellence and variety of the old basket work of New England Indians . . is represented to-day only by the degenerate splint basketry which is not worthy of a place upon the shelves of a museum" (1902: 31-32).

It has only been in recent years that archaeologists and ethnographers have concentrated on the basketry of the eastern United States. Basketry specimens from areas east of the Rocky Mountains could, in fact, be the oldest dated remains in the world. A specimen of simple plaiting found at Meadowcroft Rockshelter in Washington County in south-western Pennsylvania has been dated at 12,800-11,300 B. P. An older specimen of a cut, birch-like bark strip from near the bottom of this site is dated at 19,600 +/- 2,400 B. P., making it the oldest known basketry in the world (Stile 1982).

The study of the historical and ethnographical aspects of the basketry of the eastern United States has been put together in two recently edited volumes. Marshall Gettys' *Basketry of Southeastern Indians* discusses the basketry and basket makers of the Seminole, Creek, Choctaw, Chitimacha, and Coushatta. Ann McMullen and Russell G. Handsman's A *Key Into the Language of Woodsplint Baskets* focuses specifically on the woodsplint baskets of the Penobscot, Passamaquoddy,

6

Mohegan-Pequot, Maliseet, and Schaghticoke.

Although there are well over 1,100 entries in this bib-
liography, a tremendous amount of work about Native American
basketry remains to be done. With the exception of Otis T.
Mason's out-of-date *Aboriginal American Basketry*, there is
no single volume which provides a thorough and comprehensive
discussion of the basketry of the native peoples of North
America. For the individual just beginning to study Native
American basketry, there are several books which offer re-
gional and topical coverage. James M. Adovasio, *Basketry
Technology: A Guide to Identification and Analysis*
(Chicago: Aldine Publishing Company, 1977) clearly describes
the terminology, techniques, and identification of basketry.
Frank W. Lamb, *Indian Baskets of North America* (La Pine:
Rubidoux Publication, 1985) is a useful, though limited,
guide to the basic aspects of the Indian basketry of North
America. Molly Lee, *Baleen Basketry of the North Alaskan
Eskimo* (Barrow: North Slope Planning Department, 1983)
offers a thorough discussion of this much neglected form of
basketry. Ann McMullen and Russell G. Handsman, editors, *A
Key Into the Language of Woodsplint Basketry* (New Haven:
Eastern Press, Inc., 1987) and Marshall Gettys, editor,
Basketry of Southeastern Indians (Idabel: Museum of the Red
River, 1984) present detailed discussions and descriptions
of the historical and contemporary basketry of the major
tribes of Indians of the eastern United States. James A.
Teit, et al., *Coiled Basketry in British Columbia and Sur-
rounding Regions*. Annual Report of the Bureau of American
Ethnology 41, (Washington, D. C.: Government Printing
Office, 1928) remains the most comprehensive study of the
basketry of this region. Clara Lee Tanner, *Apache Indian
Baskets* (Tucson: University of Arizona Press, 1982) and
Indian Baskets of the Southwest (Tucson: University of
Arizona Press, 1983) represent several years of research and
fieldwork among the various southwestern tribes. Christo-
pher L. Moser, *Native American Basketry of Central
California* (Riverside: Riverside Museum, 1986) is an excel-
lent and exhaustive study. Although no longer being pub-
lished, the *American Indian Basketry* journal (20 issues)
provides extensive coverage for most of North America.

It has been my intent to compile a comprehensive bibli-
ography about Native American basketry. There is no claim
whatsoever that every single publication has been identified
or located. Many of the publications are as obscure as the
early basket makers themselves. Included in the bibliogra-
phy are books, journal articles, dissertations, theses, and
selected newspaper articles. With the exception of some
Master's theses and a small number of books, which I was
unable to obtain through Interlibrary Loan services, all of
the entries have been annotated. The entries have been
organized under the major culture areas of North America.
In some cases, an entry appears in more than one section
because of the broad coverage of the text. The comprehen-
sive index is keyed to each bibliographical entry and the

7

Introduction

subject matter and geographical area reflected in each
entry. Hopefully, this bibliography will be used to
generate research in hitherto neglected areas and subjects.

SELECT REFERENCES

[Only references not included in the bibliography are cited]

Anderson, Ada Woodruff. "Lost Industry of a Vanishing Race." *Harper's Bazaar* 32 (1899).

Blanchan, Neltje. "What the Basket Means to the Indian." *Everybody's Magazine* 5 (1901): 561-570.

Guernsey, Samuel J. "Explorations in Northeastern Arizona in the Archaeological Fieldwork of 1920-23." *Papers of the Peabody Museum of American Archaeology and Ethnology* 12.1 (1931).

James, George Wharton. "Indian Basketry in House Decoration." *The Chautauqua* 33 (1901): 619.

Kidder, A. V. and S. J. Guernsey. "Archaeological Explorations in Northeastern Arizona." *Bulletin of the Bureau of American Ethnology*, no. 65. Washington, D. C.: Government Printing Office, 1919.

Lummis, Charles F. "Reviving an Ancient Craft." *Out West* 23.6 (1905): 539-543.

Miles, Charles and Pierre Bovis. *American Indian and Eskimo Basketry--A Key to Identification*. San Francisco: P. Bovis, 1969.

Morris, Earl H. "Preliminary Account of the Antiquities of the Region Between the Maneos and La Plata Rivers in Southwestern Colorado." *Annual Report of the Bureau of American Ethnology* 33. Washington, D. C.: Government Printing Office, 1919.

Morss, Noel. "The Ancient Culture of the Fremont River in Utah." *Papers of the Peabody Museum of American Archaeology and Ethnology* 12 (1931).

Porter, Frank W. "Anthropologists at Work: A Case Study of the Nanticoke Indian Community." *American Indian Quarterly* 4 (February 1978): 1-18.

Willoughby, Charles C. "Coiled Basketry." *Science* 16 (1902): 31-32.

Northeast

1. Adovasio, James M. and R. L. Andrews (External Correlations prepared with R. C. Carlisle. "Basketry, Cordage and Bark Impressions from the Northern Thorn Mound (46Mg78), Monongalia County, West Virginia." *West Virginia Archaeologist* 30 (1980): 33-72.

 Adovasio and Andrews discuss seventy specimens of unfired and partially fired puddled clay which bore either the negative impressions of decomposed perishables or the actual perishables which were excavated from the Northern Thorn Mound in Monongalia County, West Virginia. Four types of twining and two types of cordage were identified.

2. Anonymous. "Highlights on the Museum." *Notes of the Robert Abbe Museum.* n.d.

 The Robert Abbe Museum houses a fine collection of Penobscot Indian baskets. Although the earliest known containers of this tribe appear to have been made of birch bark, for generations Penobscot basket makers have used black ash splints with bales and hoops of maple to make their baskets. There are illustrations and descriptions of weaving techniques, tools, and finished baskets.

3. _____. "Penobscot Indian Baskets." *Notes of the Robert Abbe Museum.* 4 (no date).

 Describes Penobscot baskets in the Robert Abbe Museum collections.

4. _____. "The Roland M. Howard Collection of American Indian Crafts." *Wilson Museum Bulletin* 3.3 (Spring 1985): [2-3].

 Roland M. Howard donated his extensive collection of American Indian craft work to the Wilson Museum in Castine, Maine. Included in the collection are baskets from various

regions of North America. There is a brief description of some of the baskets.

5. Bardwell, Kathryn. "The Case for an Aboriginal Origin of Northeast Indian Woodsplint Basketry." *Man in the Northeast* 31 (1986): 49-67.

Scholars have debated whether or not plaited woodsplint baskets woven by Indians in the Northeast were an indigenous technology which had developed prior to the arrival of Europeans or that this technique was introduced by Swedish colonists in the early eighteenth century. Bardwell points out the technology of Swedish and Indian woodsplint basketry had distinct methods of manufacture with regard to materials and process. Furthermore, archaeological evidence of ash splint basket fragments from early to mid-historic Seneca burial sites have been documented.

6. _____. "Interlaced Histories of Indian Woodsplint Plaited Basketry and Anthropology." Master's thesis, State University of New York at Albany, 1984.

See above entry.

7. Beauchamp, William M. *Aboriginal Use of Wood in New York*. New York State Education Department, Bulletin, no. 344. New York State Museum Bulletin, no. 89. Archaeology 11. Albany: New York State Museum, 1905.

Basket making among the Iroquois is briefly discussed on pages 163-165. Included is a drawing of an Onondaga woman making a splint basket.

8. Benedict, Salli. "Mohawk Basketmakers of Akwesasne." *American Indian Basketry* 3.1 (1983): 10-16.

The Mohawk community at Akwesasne excels in the making of black ash splint and sweetgrass basketry. Benedict discusses traditional utilitarian forms and the incorporation of intricate ornate surface decoration in some baskets into basic design forms.

9. _____. "Teionkwahontasen Basketmakers of Akwesasne Mohawk Basketry Past and Present." *Artifacts* 13.3 (Summer 1985): 3-6.

Teionkwahontasen means "sweetgrass grows around us" or "surrounds us." Baskets made from sweetgrass were prized for their fragrance, usefulness, and fine quality. The Akwesasne Mohawk and a few Seneca people continue this basketry tradition. As in many other Indian communities, Akwesasne Mohawk basket making has undergone change in form, purpose, and use. Originally made and kept for personal use, baskets gradually were made to meet the growing demand of non-Indians from neighboring communities. Modern Akwesasne Mohawk basket makers, freed from financial dependence

on basketry as a livelihood and from the necessity of meeting the inflexible demands of wholesale basket merchants, have elevated this craft into a refined art, creating for themselves endlessly innovative designs.

10. Bockhoff, Ester. "The Passamaquoddy: Basketmakers of the East." *The Explorer* 17.3 (Fall 1975): 4-12.

Although the Passamaquoddy have established modern basket cooperatives to meet the demands of the tourist trade, they continue to use traditional techniques in the manufacture of their baskets. Bockhoff describes the basket making activities of the Passamaquoddy living in Sibayig on the Pleasant Point Reservation, Medakmigood Village at Peter Dana Point and Odeneg Village, both of which are on Indian Township Reservation.

11. Brasser, Ted. *A Basketful of Indian Culture Change.* Mercury Series, Canadian Ethnology Service, no. 22. Ottawa: National Museum of Canada, 1975.

Brasser argues that splint baskety was introduced to the Delaware Indians by Swedish settlers and was later diffused to other tribes in the northeast by an extensive trade network.

12. Bushnell, David I. "The Sloane Collection in the British Museum." *American Anthropologist* 8.4 (October-December 1906): 671-685.

Bushnell mentions a South Carolina Indian basket and an Iroquois burden strap.

13. Butler, Eva L. "Algonkian Culture and Use of Maize in Southern New England." *Bulletin of the Archaeological Society of Connecticut* 22 (1948): 3-39.

The use of baskets for storage and the use of corn husks in making baskets is discussed on pages 23-24, 32, and 35.

14. _____. "Some Early Indian Basket Makers of Southern New England." In *Eastern Algonkian Block-Stamp Decorations: A New World Original or An Acculturated Art,* pp. 35-54. Research Series, no. 1. By Frank G. Speck. Trenton: Archaeological Society of New Jersey, 1947.

Drawing upon state and town archives, church, court, probate and census records, marriage licenses, birth and death certificates, overseers' reports, and numerous other documentary sources, Butler provides detailed information about early Indian basket makers of southern New England and their products.

15. Butler, Eva L. and Wendell S. Hadlock. *Uses of Birch-Bark in the Northeast.* Bulletin of the Robert Abbe

Museum, no. 7. Bar Harbor: The Robert Abbe Museum, 1957

The various uses of birch bark, including the manufacture of baskets, is discussed.

16. Conway, Donna L. and Mary Moser. "An Analysis of Cordage and Textile Industry of Sheep Rock Shelter." In *A Preliminary Report of Archaeological Investigations at the Sheep Rock Shelter Site, Huntingdon, Pennsylvania*, pp. 257-301. Edited by J. W. Michaels and I. F. Smith. University Park: Department of Sociology and Anthropology, Pennsylvania State University, 1967.

Conway discusses the cordage and textile remains unearthed during the excavation of the Sheep Rock Shelter.

17. Crosby, Everett U. *Books and Baskets, Signs and Silver of Old-Time Nantucket*. Nantucket: Printed by Inquirer and Mirror Press, 1940.

The Nantucket Lightship basket is peculiar to Nantucket. A large number of their baskets were made for personal use by individuals employed on the Nantucket Lightship between 1854 and about 1890. Crosby states that there is "nothing to suggest its origin with the Indian inhabitants of the Island, but it can better be ascribed to the cooper."

18. Curtis, W. Conway. "The Basketry of the Pautatucks and Scatacooks." *The Southern Workman* 33.7 (1904): 385-390.

Curtis briefly describes the basketry of the small remnant groups of Pautatuck and Schaghticoke Indians.

19. Dodge, Ernest S. "An Early Nineteenth Century Passamaquoddy Bark Box with an Anthropomorphic Decoration." *Bulletin of the Massachusetts Archaeological Society* 14.2 (January 1953): 77-78.

Dodge briefly describes and illustrates a Passamaquoddy birch bark box upon which has been carved the figure of a man.

20. _____. "Some Thoughts on the Historic Art of the Indians of the Northeastern North America." *Bulletin of the Massachusetts Archaeological Society* 13.1 (1951): 1-4.

The widely divergent ethnological points of view concerning Indian art of northeastern North America of Frank G. Speck and Marius Barbeau are noted. Dodge poses the question: "What are the historic arts of our Indians?" Citing skin painting, bark engraving, porcupine quill work, moose hair embroidery, splint basketry decoration, wood carving, bead work, and ribbon applique, Dodge argues that all the

designs used in these arts fall into four particular cate-
gories. These are linear designs, lozenges (a four-sided,
equilateral figure whose opposing sides are equal), linked
ovoids, scallops, and other decorations. With reference to
distribution and decoration of splint basketry, Dodge notes
the controversy about whether it is an aboriginal craft or
one introduced by Europeans.

21. Douglas, Frederic H. *Indian Basketry East of the Rocky
 Mountains.* Denver Art Museum, Indian Leaflet Series,
 no. 87. Denver: Denver Art Museum, 1934.

 Contains photographs of sixteen different baskets,
including coiled, plaited, wicker, and twined weaving from
the Northeast, Plains, and Great Lakes areas. There is a
brief description of techniques used in making each type of
basket and their uses.

22. Doyle, Claire. "Baskets of Akwesasne." *Fiberarts* 11.1
 (January-February 1984): 77.

 Doyle describes an exhibition of baskets made by Mohawk
Indians from the Akwesasne Reservation in northern New York
and Canada at the Center for Music, Drama, and Art in Lake
Placid, New York. Seventy-five baskets, both old and new
pieces, were selected from the Akwesasne Museum of Natural
History and from private collections.

23. Eckstorm, Fannie H. *The Handicrafts of the Modern In-
 dians of Maine. Illustrating the Mary Cabot Wheel-
 wright Collection and Other Gifts to the Abbe Museum,
 Lafayette Park.* Lafayette National Park Museum Bulle-
 tin, no. 3. Bar Harbor: The Robert Abbe Museum, 1932;
 reprint ed.,Bar Harbor: The Robert Abbe Museum, 1980.

 The basketry of the Penobscot Indians is discussed in
detail on pages 19-30. Eckstorm describes the methods of
manufacture, types of dyes, basket making tools, and diffe-
rent styles of baskets.

24. Gazillo, Karen W. "Jim Harris: The Last Scaughti-
 coke." *The Indian Trader* 14.8 (August 1983): 12-14.

 There is a short account on page 14 of Harris' basket
making skills. Harris makes a wager he can weave a basket
that can hold cider without leaking. He does so by drop-
pring a basket into freezing water of a river in order to
hold the cider.

25. George Walter Vincent Smith Art Gallery. *American In-
 dian Basketry Work: Gathered from Connecticut Valley
 Collections.* Springfield: The Gallery, 1975.

 This is a catalog with photographs and descriptions of
an exhibit of baskets from the Connecticut Valley collec-
tions of the George Walter Vincent Smith Art Gallery. The

catalog consists primarily of photographs of the baskets. The tribal source of many of the baskets is incorrectly identified.

26. Gettys, Marshall. *Basketry of the Eastern United States.* n.p. and n.d.

This pamphlet presents a brief overview of basketry in the eastern United States. The text is complemented with photographs of representative samples of basketry, line drawings, and a bibliography.

27. Glassie, Henry. "William Houck: Maker of Pounded Ash Adirondack Pack-Baskets." *Keystone Folklore Quarterly* 12.1 (Spring 1967): 23-54.

Glassie argues that the tradition of pounded ash basketry in the eastern United States is complicated by American Indian basketry. Although the pounded ash basketry tradition is not common in England today, during the colonial period it may have been more widely practiced because of the greater availability of wood. The arrival of the English in New England with a pounded ash basketry tradition may help to explain why this type of basketry became so rapidly and widely adopted by the Indians of the Northeast.

28. Goggin, John M. "Plaited Basketry in the New World." *Southwestern Journal of Anthropology* 5.2 (1949): 165-168.

Responding to Taylor and Moore's "A Note on Dominican Basketry and Its Analogues," *Southwestern Journal of Anthropology* 4.3 (1948): 328-343, Goggin argues that an indicated relationship may be more apparent than real. A detailed study demonstrated that plaited twilled basketry has a much greater distribution than generally known.

29. Handsman, Russell G. "Stop Making Sense: Towards an Anti-Catalogue of Woodsplint Basketry." In *A Key Into the Language of Woodsplint Basketry,* pp. 144-163. Edited by Ann McMullen and Russell G. Handsman. New Haven: Eastern Press, Inc., 1987.

Handsman argues that when American Indian artifacts are seen merely as art, they are separated from their cultural, historical, and political context. Through the medium of an "Anti-Catalogue," he challenges the reader to question "what is always too certain and obvious." In the study of any material culture, there will always be a plurality of truths. Through this plurality, a whole new vista can be opened for investigation.

30. Handsman, Russell G. and Ann McMullen. "An Introduction to Woodsplint Basketry and Its Interpretation." In *A Key Into the Language of Woodsplint Basketry,* pp. 16-

35. Edited by Ann McMullen and Russell G. Handsman.
 New Haven: Eastern Press, 1987.

Handsman and McMullen attempt to show that the study of
woodsplint baskets is more than a "matter of simple discove-
ry, classification, or contemplation." Woodsplint baskets,
like all other material culture, were made by peoples at
specific times and in particular settings. The study of
woodsplint basketry, therefore, can offer insight into the
society, history, and people who made these baskets. Bas-
kets, argue the authors, are more than objects.

31. Harrington, Mark R. "A Preliminary Sketch of Lenape
 Culture." *American Anthropologist* 15.2 (1913): 208-235.

Harrington briefly describes the basketry of the Lenape
Indians.

32. _____. "Vestiges of Material Culture Among the Canadi-
 an Delawares." *American Anthropologist* 10.3 (1908):
 408-418.

The basketry of the remnant Delaware who had migrated
to Canada is briefly discussed.

33. Herman, Mary W. "A Reconstruction of Aboriginal Del-
 aware Culture from Contemporary Sources." *Kroeber An-
 thropological Society Papers*, no. 1 (1950): 45-77.

The basketry of the Delaware Indians is briefly men-
tioned on page 54.

34. Hill, Cephus and William Fenton. "Reviving Indian Arts
 Among the Seneca." *Indians at Work* 11 (1935): 13-15.

Hill and Fenton describe the efforts on the Tonawanda
Reservation in New York to provide employment while reviving
the material culture of the Seneca. The Rochester Museum of
Arts and Sciences provided work benches, carving tools, sil-
versmith's tools, needles and thread, patterns, and photo-
graphs with which to work. Basketry was part of this pro-
ject.

35. Holland, Nina. *Baskets of Akwesasne*. New York: Fine
 Arts Gallery Center for Music, Drama and Art, 1983.

Holland describes and illustrates the baskets of the
Iroquois Indians of Akwesasne.

36. Hopf, Carroll J. "Basketware of the Northeast: A Sur-
 vey of the Types of Basketware Used on the Farm from
 the Colonial Period to 1860." Master's thesis, State
 University of New York College at Oneonta, at its
 Cooperstown Graduate Program, 1965.

There is very little reference to Indian basketry, but

this thesis is useful for information about woodsplint bas-
ketry in the nineteenth century.

37. Jedlicka, Judith A. "Decorated American Splint Bas-
 kets." *Arts and Antiques* 5 (1982): 80-85.

 Jedlicka briefly traces the origins of United States
basket weaving and decorations to the techniques brought
from Europe and Africa by the early settlers, and those of
decorating and dyeing on splint baskets by Indians who lived
in the northeastern United States and eastern Canada during
the mid-seventeenth century.

38. Johnson, M. G. "An Introduction to Porcupine Quillwork
 on Birchbark." *Indian-Artifact Magazine* 3 (1984): 10-
 12, 37.

 Johnson briefly discusses porcupine quillwork on birch-
bark specimens.

39. Lamb, Frank W. *Indian Baskets of North America.* La
 Pine: Rubidoux Publication, 1972; 1976; 1981; and
 1985.

 Baskets of the Northeast tribes are discussed on pages
137-145.

40. Lane, Sheryl. "We Don't Make Baskets Any More." *SALT:
 Journal of Northeast Culture* 4 (1979): 4-16.

 This article is based on an interview with Madasa Sapi-
el, a seventy-five year old woman who is half Penobscot and
half Passamaquoddy. She lives on Indian Island in the mid-
section of Maine. Sapiel discusses the loss of many tradi-
tional arts and crafts, espcially basket making in her
tribe.

41. Leone, Mark P. "Public Interpretation: A Plurality of
 Meanings." In *A Key Into the Language of Woodsplint
 Basketry*, pp. 164-167. Edited by Ann McMullen and Rus-
 sell G. Handsman. New Haven: Eastern Press, Inc.,
 1987.

 Leone adeptly summarizes the essays of *A Key Into the
Langauge of Woodsplint Basketry*. Noting the conflict of in-
terpretation of woodsplint basketry among the authors, he
observes that such disparity can help us to reevaluate not
only the past but also the present manufacture and use of
baskets.

42. Lester, Joan. "'We Didn't Make Fancy Baskets Until We
 Were Discovered': Fancy-Basket Making in Maine." In *A
 Key Into the Language of Woodsplint Basketry*, pp. 38-
 59. Edited by Ann McMullen and Russell G. Handsman.
 New Haven: Eastern Press, Inc., 1987.

The production of fancy-baskets among the Indian tribes of Maine was made possible by the introduction of blocks and gauges (two basket making tools), and was sustained by the tourist industry of New England. The collection of Penobscot blocks and gauges of Chief Bruce Poolaw, a Kiowa who had married a Penobscot woman, is described and discussed. Lester analyzes the effect of tourism on Penobscot basket making, and the status of the craft today.

43. Lindquist, G. E. E. "Indians of Maine Still Carrying On." *The Southern Workman* 58.11 (November 1929): 517-519.

Lindquist notes that basket making among the Passamaquoddy provided 60% of the tribe's income. Many of their baskets were exhibited at summer resorts and State fairs.

44. Lismer, Marjorie. *Seneca Splint Basketry*. Indian Handcrafts, no. 4. Washington, D. C.: United States Department of the Interior, Branch of Education, 1941; reprint ed., Ohsweken, Ontario: Iroqrafts, 1982.

Basket making is one of the best preserved crafts among the Iroquois. Although there are variations in methods of making baskets among the different groups which comprise the Six Nations of Iroquois, the Seneca's methods of making plaited splint baskets exhibit techniques of manufacture fundamental to all of them.

45. Little, Molly. "Mary Leaf, Mohawk Basketmaker." *Artifacts* 13.3 (Summer 1985): 14.

Little discusses the basket making techniques of Mary Leaf, a Mohawk Indian.

46. Lyford, Carrie Alberta. *Iroquois, Their Art, Culture and Crafts*. Surrey, British Columbia: Hancock House, 1982.

The basketry of the Iroquois is briefly discussed.

47. Lyford, Carrie Alberta. *Iroquois Crafts*. Indian Handcrafts, no. 6. Washington, D. C.: United States Department of the Interior, Branch of Education, 1945; New Haven: HRAF, 1955; Washington, D. C.: U. S. Department of the Interior, Bureau of Indian Affairs, 1957; Lawrence, Kansas: Haskell Institute, 1960; 1976; and Stevens Point, Wisconsin: R. Schneider, 1982.

Lyford briefly discusses the various types of basketry made by the Iroquois tribes.

48. Mason, Bernard Sterling. *The Book of Indian Crafts and Costumes*. New York: A. S. Barnes and Company, 1946; and New York: Ronald Press, 1946.

Birchbark baskets from northeastern North America are discussed on page 91.

49. Mason, Otis T. *Aboriginal American Basketry: Studies in a Textile Art Without Machinery*, pp. 171-548. Annual Report of the United States National Museum for 1902. Washington, D. C.: Government Printing Office, 1904.

Mason, in *Aboriginal American Basketry*, synthesized the basketwork of more than a thousand Indian tribes and bands. Confronted with the problem of ordering and describing the basketry of all of North America, Mason established a useful typology which resulted in a coherent, ordered, and culturally meaningful taxonomy. Although filled with many errors, especially with regard to interpretation and taxonomy, this book remains the most comprehensive study of Native American basketry. It was reprinted commercially in 1904 by Doubleday, Page in New York in a two-volume edition with the title *Indian Basketry: Studies in a Textile Art Without Machinery*. It has been reprinted in 1970, 1972, and 1984 by the Rio Grande Press in Glorieta, New Mexico. It has also been reprinted in 1976 by Peregrine Smith, Inc. in Santa Barbara, California and Salt Lake City, Utah. This edition contains a foreword by James M. Adovasio.

50. McFeat, Tom F. S. "Space and Work in Maliseet Basket-Making." In *A Key Into the Language of Woodsplint Basketry*, pp. 60-73. Edited by Ann McMullen and Russell G. Handsman. New Haven: Eastern Press, Inc., 1987.

McFeat identifies two basket industries among the Maliseet: the "Fancy Basket" industry and the "Work Basket" industry. The source of basket materials, the shops in which baskets were made, and the marketing of baskets is fully discussed.

51. McMullen, Ann. "Interpreting Woodsplint Basketry: Changing Traditions in Northeastern CT." *Artifacts* 13.3 (Summer 1985): 7-9.

Woodsplint basketry in the northeast has undergone considerable change in form, materials, and technique of decoration since the eighteenth century. Modern woodsplint basketry among tribes in the northeast represents the redefinition of this craft from utilitarian objects into collectible items. Focusing on the Schaghticoke reservation in Kent, Connecticut, McMullen discusses the nineteenth century basketry of Eli Bunker and Henry Harris.

52. _____. "Looking for People in Woodsplint Basketry Decoration." In *A Key Into the Language of Woodsplint Basketry*, pp. 102-123. Edited by Ann McMullen and Russell G. Handsman. New Haven: Eastern Press, Inc., 1987.

McMullen offers three examples of interpretation based on woodsplint baskets: the analyses of the relationship between technology and social relations, the importance of regional styles, and the interpretation of basket designs.

53. _____. "Plants and Paints: Pigments Used to Decorate Woodsplint Baskets." *Artifacts* 12.1 (Fall 1983).

See next entry.

54. _____. "Research Brief: Pigments Used to Decorate Woodsplint Baskets." *The News Basket* 2.2 (April 1985): 7.

This brief note first appeared in *Artifacts* 12.1 (Fall 1983). Coloring was applied to the surface of baskets by dyeing, staining, and painting. Tests were conducted on certain plants to determine if they would replicate the colors seen on nineteenth century baskets. Except for bloodroot and poke, these plants yielded only pale washes. An examination of cakes of paint from a late eighteenth century watercolor kit indicated that they were identical to the vibrant colors found on nineteenth century Algonkian baskets. McMullen concludes that American Indians did use some natural vegetal and mineral pigments to decorate woodsplint baskets, but most of the colors were of commercial origin.

55. _____. "Tribal Style in Woodsplint Basketry: Early Paugusett Influence." *Artifacts* 11.4 (1983): 1-4.

Molly Hatchett was one of the last Paugusett Indians to live on the reservation at Turkey Hill in Derby, Connecticut. By the time of her death in 1829, she had become a well-known basket maker. McMullen evaluates the influence of Hatchett on other basket makers and how her heritage is evident in later Paugusett and Schaghticoke basketry.

56. _____. "Woodsplint Basketry of the Eastern Algonkian." *Artifacts* 10.5 (1982): 1-9.

McMullen attempts to reconstruct the development of woodsplint basketry during the eighteenth and nineteenth centuries. The influence of European basket making techniques, tools, and decorations on the basketry of the eastern Algonkians is discussed.

57. McMullen, Ann and Russell G. Handsman. *A Key Into the Language of Woodsplint Basketry*. New Haven: Eastern Press, Inc., 1987.

This is a catalog of an exhibit sponsored by the American Indian Archaeological Institute. The individual essays which comprise this volume discuss how splint baskets were made and decorated, how splint baskets represent and express changes in work and labor, the relations between American Indians and Euro-Americans, the emergence of individualism,

and the redefinition of basket making as industrial production, and how different people can interpret splint baskets in different ways.

58. Miller, Roland B. "The Adirondack Pack-Basket." *New York State Conservationist* 3.1 (August-September 1948): 8-9.

Miller argues that it was the Abenaki Indians who originated the Adirondack pack-basket. Based on information from Julius Paul Dennis of Old Forge, an Abenaki, it is suggested that this type of basket was designed and made to replace the old Canadian tumpline pack.

59. Morgan, Lewis Henry. "Report on the Fabrics, Inventions, Implements and Utensils of the Iroquois." *Annual Report, New York State Cabinet of Natural History* 5 (1852): 68-117.

Among the Iroquois specimens collected by Morgan for the Regents of the University of the State of New York were a bark barrel, splint basket fishtrap, and several black ash splint baskets. Due to the length of his report, Morgan provided only "a passing notice" of basket making on pages 109-110.

60. Newcomb, William W. *The Culture and Acculturation of the Delaware Indians.* Museum of Anthropology, University of Michigan, Anthropological Papers, no. 10. Ann Arbor: University of Michigan, 1956; New Haven: HRAF, 1961; Ann Arbor: University Microfilms International, 1980; and Ann Arbor: Xerox University Microfilms, 1976.

Delaware basketry is briefly mentioned on pages 28-29.

61. Nicholas, Joseph A. *Baskets of the Dawnland People.* Calais, Maine: Project Indian PRIDE, n.d.

Nicholas describes the brown ash basketry of the Micmac, Maliseet, Passamaquoddy and Penobscot Indians of Maine. In 1969, Tony thomas, a VISTA worker, invented an ash pounding machine at the University of Maine at Orono. The decreasing sale of baskets, however, resulted in the discontinued use of the machine. This booklet is profusely illustrated with photographs of Northeast baskets and basket makers.

62. Pelletier, Gaby. *Abenaki Basketry.* Canadian Ethnology Service, no. 85. Ottawa: National Museum of Canada, 1982.

The basket makers at the Abenaki Indian Reserve at Odanak in Quebec made baskets between 1870 and 1920 which rivalled the work of the Maliseet, Passamaquoddy, and Penobscot. Pelletier traces the development of splint basketry

during the past century at Odanak, analyzes the basketry styles and methods of construction, and considers the possible reasons for its decline.

63. Porter, Frank W. "American Indian Baskets in the Middle Atlantic Region: Material Survival and Changing Function." *Material Culture* 17.1 (Spring 1985): 25-45.

Using ethnohistorical and ethnographic information and analysis of baskets collected by anthropologists during the early 1900s, Porter makes several inferences about the construction and changing function of Indian baskets in the Middle Atlantic region. A major question has been whether woodsplint baskets evolved from the use of cane splints by Southeastern tribes, already existed in the Northeast and Middle Atlantic regions, or were introduced by the Swedes to the Lenape (Delaware Indians) who in turn diffused this specific form of basket to other tribal groups. Evidence is offered that the Indians made decorated woodsplint baskets prior to contact with Europeans.

64. Rainey, Froelich G. "A Compilation of Historical Data Contributing to the Ethnography of Connecticut and Southern New England." *Bulletin of the Archaeological Society of Connecticut* 3 (1936): 5-49.

Weaving is discussed on pages 24-25 and art on pages 29-30.

65. Richmond, Trudie Lamb. "Spirituality and Survival in Schaghticoke Basket-Making." In *A Key Into the Language of Woodsplint Basketry*, pp. 126-143. Edited by Ann McMullen and Russell G. Handsman. New Haven: Eastern Press, Inc., 1987.

Richmond, a Schaghticoke Indian, points out that Native American basket making is more than a craft or art form. There was, at one time, a spirituality in the making of baskets. This spirituality is still felt by many Indians who make baskets, and appreciated by others who behold such baskets. The history of basket making among the Schaghticoke is discussed.

66. Russell, Lyent W. "Ten Scaticook Indian Baskets." *Bulletin of the Archaeological Society of Connecticut* 39 (1975): 18-22.

Russell describes baskets made by Henry Harris in the 1890s which had been collected by an unidentified man from Sherman, Connecticut.

67. Schneider, Richard C. *Crafts of the North American Indians. A Craftsman's Manual*. New York: Van Nostrand Reinhold Company, 1972.

Schneider discusses the crafts of the Woodland Culture

Area. Detailed instructions are provided to make containers from birch bark and splint, willow, wickerwork, and coiled basketry.

68. Speck, Frank G. *Decorative Art of Indian Tribes of Connecticut*. Canadian Geological Survey, Memoir no. 75, Anthropological Series, no. 10. Ottawa: Government Printing Office, 1915.

The basket making techniques, tools, and decorations of the Mohegan, Niantic, and Schaghticoke Indians are described and illustrated. Speck argues that "the stamped and painted designs are original to the southern New England Indians, and that they spread from them to the Iroquois.

69. _____. *The Double-Curve Motive in Northeastern Algonkian Art*. Canada Department of Mines, Geological Survey Memoirs, no. 42. Anthropological Series, no. 1. Ottawa: Government Printing Office, 1914.

Speck presents an overview of the double-curve motive in northeastern Algonkian art. Included are illustrations of this design on Montagnais bark baskets.

70. _____. *Eastern Algonkian Block-Stamp Decoration; A New World Original or an Acculturated Art*, Research Series, no. 1. Trenton: The Archaeological Society of New Jersey, 1947.

Speck examines the historical circumstances surrounding the existence of a decorative technique employing stamp-blocks cut-out of raw vegetable sections among the various tribes in New England and eastern Canada. Speck admits that "evidence is lacking to affirm the pre-European existence of block-stamp printing in the East, even in New England where the oldest specimens are found." Speck concludes, however, that the use of stamp-blocks for designs originated in the eastern Woodlands as an independent feature of Indian decorative art, and that it was probably related to earlier free-hand painting.

71. _____. *The Iroquois*. Bulletin of the Cranbrook Institute of Science, no. 23. Bloomfield Hills: Cranbrook Institute of Science, 1945; second edition, Bloomfield Hills: Cranbrook Institute of Science, 1955; reprint second edition, 1965; 1971; and 1982.

Speck discusses baskets and basketry on pages 43-45.

72. _____. *Naskapi: The Savage Hunters of the Labrador Peninsula*. Philadelphia: University of Pennsylvania Press, 1935; reprint ed., 1963, new edition, with a Foreword by J. E. Michael Kew.

Naskapi deals with religious beliefs and practices. Analysis of decorative work on baskets seeks to understand

the underlying ideological connections between them and the
supernatural. On page 58, there is an illustration of a
birch bark food tray used by a hunter when eating game, in
particular beaver, which had been killed after the hunter
had received a dream admonition.

73. _____. "A Note on the Hassanamisco Band of Nipmuc."
 Bulletin of the Massachusetts Archaeological Society
 4.4 (1943): 49-56.

Speck discusses basket painting and block-stamping
among the Nipmuc descendants in central Massachusetts.

74. _____. *Penobscot Man: The Life History of a Forest
 Tribe in Maine.* Philadelphia: University of Pennsyl-
 vania, 1940; reprint ed., New York: Octagen Books,
 1970.

The making of plain baskets for domestic use is a well-
established feature in the later native life of the North-
east. An extension of the northern frontier of the splint
basketry industry had gradually effaced the southern bounda-
ries of the more primitive birch bark technique. While the
shape and functions vary somewhat, only two or three types
of baskets were then in use. The ordinary weave was the
checkerwork or over-one-under-one, while a hexagonal twill
comprised the other two forms. The materials used in bas-
ketry were mainly black and brown ash for the splints, and
maple for the hoops and bales. The basketry of the Penob-
scot, like that of all the eastern tribes, had been tremen-
dously stimulated by trade in the last generation or so.
Many innovations both in form, function, and in the imple-
ments for basket manufacture, had crept in, though the art
was fundamentally native. Sweet grass was much more in use
than formerly; some informants of Speck even stated that it
was not used at all in basket making before the latter quar-
ter of the nineteenth century.

75. _____. "Some Uses of Birch Bark by Our Eastern Indi-
 ans." *Museum Journal, University of Pennsylvania* 1
 (1910): 33-36.

The most significant use of birch bark, next only to
the making of a canoe, was the birch bark basket. Speck de-
scribes and illustrates a Penobscot pack basket. Also dis-
cussed is the double-curve motive.

76. Stile, T. E. "Perishable Artifacts from Meadowcroft
 Rockshelter, Washington County, Southwestern Pennsyl-
 vania." In *Meadowcroft: Collected Papers on the Ar-
 chaeology of Meadowcroft Rockshelter and the Cross
 Creek Drainage*, pp. 130-141. Edited by R. C. Carlisle
 and J. M. Adovasio. Pittsburgh: Department of Anthro-
 pology, University of Pennsylvania, 1982.

Four classes of perishable artifacts, which include

basketry and cordage as well as implements of modified wood
and bone, were recovered from Meadowcroft Rockshelter. Three
carbonized basketry fragments were found in Stratum IIb.
One basketry specimen each was found in the lower and middle
of Stratum IIa. The basketry fragment from lower Stratum
IIa yielded a radiocarbon date of 17,650 +/- 2400 B. C.
(19,600 B. P.). All of the basketry specimens were of sim-
ple plaiting with a 1/1 interval and were probably portions
of rectangular or circular containers.

77. Tantaquidgeon, Gladys. "Newly Discovered Straw Baske-
 try of the Wampanoag Indians of Massachusetts." *Indian
 Notes, Museum of the American Indian, Heye Foundation.*
 7.4. New York: Museum of the American Indian, 1930,
 pp. 475-484.

Tantaquidgeon describes straw baskets made by Emma
Stafford, a Wampanoag Indian. These baskets were apparently
made from the common rye straw. The straw was soaked in wa-
ter and split. The simple checker weave was also used to
make the baskets. Tantaquidgeon also describes similar bas-
kets made by the Delaware Indians of Oklahoma.

78. _____. "Notes on Mohegan-Pequot Basketry Designs."
 Indians at Work 2.17 (1935): 43-45.

Mohegan-Pequot basket makers produced at least four
types of baskets. Tantaquidgeon discusses the rectangular
baskets, round-bottomed baskets with handles or bails, the
"melon," "rib," or "gizzard" baskets, and the openwork or
"lace-work" baskets.

79. _____. "Notes on the Gay Head Indians of Massachu-
 setts." *Indian Notes, Museum of the American Indian,
 Heye Foundation* 7.1. New York: Museum of the American
 Indian, 1930, pp. 1-26.

Basketry is discussed on pages 12-16. Beach grass was
used to make cordage and baskets. The making of straw bas-
kets is briefly mentioned. The introduction of splint bas-
ketry caused the abandonment of traditional materials.
Splint basketry, however, was not introduced on Martha's
Vineyard.

80. Tantaquidgeon, Gladys and Jayne G. Fawcett. "Symbolic
 Motifs and Painted Baskets of the Mohegan-Pequot." In *A
 Key Into the Language of Woodsplint Basketry*, pp. 94-
 101. Edited by Ann McMullen and Russell G. Handsman.
 New Haven: Eastern Press, Inc., 1987.

Tantaquidgeon and Fawcett, both Mohegan Indians, argue
that designs on historic Mohegan-Pequot and other coastal
Algonkian baskets were developments which pre-dated contact
with Europeans, and that they have symbolic content.

81. Turnbaugh, Sarah Peabody. "The Technology of Basketry:

North American Roots and Relations to Cloth." *Shuttle, Spindle & Dyepot* 8.1 (1976): 32-36.

Basketry and cloth weaving share many similarities. Early basket making may have laid the foundation for the development of the woven soft textiles in North America. Turnbaugh examines the varieties in basket weaving and demonstrates the extent to which it served as the basis for cloth weaving.

82. Turnbaugh, Sarah Peabody and William A. Turnbaugh. "Weaving the Woods: Tradition and Response in Southern New England Splint Basketry." In *A Key Into the Language of Woodsplint Basketry*, pp. 76-93. Edited by Ann McMullen and Russell G. Handsman. New Haven: Eastern Press, Inc., 1987.

The Turnbaughs describe the distinctive cultural styles in the woodsplint basketry tradition of New England. The development of these styles are considered to be the response to changing cultural and historical contexts. Basket forms, handle types, decoration and design, splint width preferences, and the number and placement of narrow-filling splints are examined and classified to show regional and cultural differences.

83. Vidler, Virginia. *American Indian Antiques: Art and Artifacts of the Northeast.* South Brunswick and New York: A. S. Barnes and Company, 1976.

Pages 78-86 contain a section about baskets. There is a brief text and several illustrations of baskets from the Northeast.

84. Volkman, Arthur G. "Lenape Basketry in Delaware." *Bulletin of the Archaeological Society of Delaware* 4.5 (1949): 15-18.

Volkman acknowledges that the Lenape (Delaware Indians) made plaited baskets prior to contact with Europeans. He leaves unanswered, as do many other investigators, the question whether or not the Lenape knew how to make splint baskets before contact with Europeans. Two baskets made by Indian Hannah, a Lenape woman living in southeastern Pennsylvania in the early 1800s, are described and illustrated. The baskets are in the Chester County Historical Society. The first of the two baskets is plaited with the common over-one-under-one weave. Below the plain top rim are three narrow wefts, then a wide weft followed again below by three narrow ones, continuing down to the base. All of the wefts are colored brown. The other basket is referred to as a "melon basket."

85. Waugh, Frederick W. *Iroquois Foods and Food Preparation.* Canada Department of Mines, Geological Survey Memoir, no. 86, Anthropological Series 12. Ottawa:

Government Printing Office, 1916; New Haven: HRAF, 1955; facsimile edition, Ottawa: Government Printing Office, 1973.

Waugh provides descriptions of a pack basket, washing basket, and sifting basket.

86. Webber, Alika. "Wigwamatew: Old Birch Bark Containers." *American Indian Art Magazine* 4.1 (November 1978): 56-61.

Webber discusses and illustrates various birch bark containers from the northeastern regions of North America. The Tetes-de-Boule Indians continue to make this type of container. It is called "wigwamatew."

87. Webber, Laurence. "An Ancient Craft Prospers." *New Hampshire Profiles* 18 (1969): 44-47, 64-65.

The Peterboro Basket Company in Petersborough, New Hampshire makes over 300 different sizes and shapes of baskets. Brief mention is made of the Indians of the Pennacook Confederacy and a lone Indian working in the Monadnock Region who evolved a type of square-bottom round basket locally known as the Peterborough Basket.

88. Weslager, C. A. "The Non-Food Use of Corn in the Domestic Economy of the Eastern United States." *Proceedings of the Delaware County Institute of Science* 10.3 (1947): 3-22.

The use of cornhusks to make mats is noted.

89. White, John Kennardh. "Twined Bags and Pouches of the Eastern Woodlands." *Handweaver & Craftsman* 20.3 (Summer 1969): 8-10, 36-37.

Twined bags and pouches in the eastern United States ranged in size from three-by-five inches to almost three feet square. Three main types of these bags are identified. Type A is woven with a plain warp and plain weft. Type B is woven with a colored warp and a plain weft. Type C is woven with a plain warp and a colored weft.

90. Willoughby, Charles C. *Antiquities of the New England Indians.* Cambridge: Harvard University, Peabody Museum of American Archaeology and Ethnology, 1935; reprint ed., Cambridge: Harvard University, Peabody Museum of American Archaeology and Ethnology, 1973.

Willoughby discusses and illustrates the various types of bags, baskets, and matting made by the Indian tribes of New England. Much of the information is based on the accounts of early explorers and colonists and a small number of remains from archaeological sites.

91. _____. "Textile Fabrics of the New England Indians."
 American Anthropologist 7 (1905): 85-93.

 Willoughby argues that little is known of the indige-
nous art products of the New England Indians. The snow-
shoes and bark canoes of the Abenaki Indians of Maine are
practically the only modern native artifacts of the New
England Indians which remain unmodified. The manufacture
and sale of splint basketry had been for several generations
the primary means of subsistence of many families. The
distribution of splint basketry, according to Willoughby,
seemed to indicate a survival of this type from prehistoric
times. No mention of splint baskets had been found in the
records of the early explorers and settlers of New England,
although eight other types were noted. Referring to an
article by the Reverend W. C. Curtis (1904), Willoughby
identifies three types of splint basketry: (1.) handleless
baskets with square or oblong base and rim more or less
rounded; (2.) baskets similar to the preceding type, but
with a handle; and (3.) baskets with a square base and a
circular upper portion, the diameter being almost equal to
the height.

92. Wissler, Clark. *The American Indian; an Introduction
 to the Anthropology of the New World.* New York: Ox-
 ford University Press, 1917.

 On page 78 Wissler discusses the resemblances between
basketry of the eastern United States and South America.

Southeast

93. Anonymous, "Chetimachan Basketry." *Papoose* 1.3 (February 1903): 19-20.

Discusses the efforts of Mrs. Sidney Bradford to revive basketry among the Chitimacha.

94. _____. "Medford Exhibit Set." *The Indian Trader* 14.5 (May 1983): 23-24.

Describes Claude Medford's basket making skills and an exhibition of his work to be held at The Southern Plains Indian Museum and Crafts Center in Anadarko, Oklahoma.

95. _____. *Pine Needle Basketry.* Livingston, Texas: Alabama-Coushatta Indian Reservation, n.d.

This is a flyer published by the Alabama-Coushatta Indians. This tribe is noted for its pine needle basketry. These baskets are made from the needles of the Long Leaf Pine trees. The manufacture of this type of basket is briefly described.

96. _____. "Tracing a Craft Heritage in Mississippi." *Southern Living* 21.10 (October 1986): 36-37.

Describes the efforts of Dianne Dixon to learn basketry from two Choctaw sisters living in Mississippi.

97. Ataloa. "The Revival of Indian Art in Oklahoma." *Indians at Work* 4.21 (June 15, 1937): 37-43.

Ataloa notes that there has been a recent revival of basket making among the Choctaw and Cherokee in Oklahoma, and laments the Indians' use of analine dyes instead of traditional vegetable dyes.

98. Barnes, Lynn. "Creek Basketry." In *Basketry of South-*

eastern Indians, pp. 11-16. Edited by Marshall Gettys. Idabel: Museum of the Red River, 1984.

The basket making tradition of the Creek Indians has been overlooked or given minimal consideration because of the difficulty of searching primary historical sources which did not always distinguish Creek culture from that of the entire Muskogean language stock and the more dramatic and colorful nature of the baskets of other Southeastern tribes. Barnes examined baskets primarily from individual collectors, the Creek Indian Nation Museum in Okmulgee, the Stovall Museum in Norman, and the Oklahoma Historical Society. Four major shapes were discerned in these baskets. They are the corn holder, sifter or riddle, tray, and utility basket. Creek baskets share the following distinguishing features. They are typically a single element twill-plaited weave. A double false-braid rim is the preferred finish. They have no lids. Handles are rare and appear to have been applied after the basket is finished. There are relatively few forms, all with squared bottoms and rounded openings. Dyed splints are rare, although there is some use of walnut or lighter brown in simple diagonal stripe patterns. Baskets are split cane or hickory. Splints are trimmed with neatly beveled edges on all hickory specimens.

99. Beyer, George Eugene. "Ancient Basket Work from Avery's Island." *Publications of the Louisiana Historical Society* 2.2 (1899): 23-26.

Nearly thirty years earlier, a specimen of woven matting or basket work was found at Avery's Island, Louisiana and was sent to the Smithsonian Institution. In November of 1898, another piece of basketry was discovered. Beyer visited the site, but found only very small pieces of basketry in the location of the earlier find. He concluded, however, that the basketry had been found *in situ* and beneath the skeletal remains of extinct Pleistocene fauna.

100. Black, Patti Carr. *Made by Hand: Mississippi Folk Art.* Jackson: Mississippi Department of Archives and History, 1980.

Contains Kenneth H. York, "Choctaw Arts and Crafts" on pages 38-44.

101. _____. *Persistence of Pattern in Mississippi Choctaw Culture.* Jackson: Mississippi Department of Archives and History, 1987.

Discusses in detail the survival and persistence of identity of the Mississippi Choctaw. There are brief references in the text about women making cane baskets. Jeffrie D. Solomon, a basket maker from the Conchatto community, is pictured. There are also photographs of two nineteenth century and one twentieth century swamp cane baskets.

102. Bockhoff, Esther. "Cherokee Basketmakers, the Old Tra-
 dition." *The Explorer* 19 (1977): 10-15.

 Bockhoff discusses the contemporary Cherokee basket
makers who continue to adhere to traditional weaving tech-
niques.

103. Brain, Jeffrey P. *Tunica Treasure*. Papers of the Pea-
 body Museum of Archaeology and Ethnology, no. 71. Sa-
 lem, Massachusetts: Harvard University and the Peabody
 Museum of Archaeology and Ethnology, 1979.

 Contains a brief discussion of cane basketry and photo-
graphs of basketry remains on page 253.

104. Brown, James A. "The Artifacts." In *Spiro Studies*, no.
 4. Norman: University of Oklahoma, Stovall Museum of
 Science and History, 1976.

 Brown describes fragmentary basketry remains from
Spiro. He suggests that "one should look to the Chitimacha
basketry of the Mississippi Lowland to recognize aspects of
what was present at Spiro."

105. Bushnell, David I., Jr. *The Choctaw of Bayou Lacomb,
 St. Tammany Parish, Louisiana*. Bulletin of the Bureau
 of American Ethnology, no. 48. Washington, D.C.: Go-
 vernment Printing Office, 1909.

 Choctaw baskets and dyes are briefly discussed on pages
13-15. Bushnell identifies five types of Choctaw baskets:
kishe' (pack basket), *taposhoke shakapa* (elbow shape),
tapshoke chufa (pointed), covered baskets, and sieves or
winnowing baskets.

106. _____. "Fragmentary Textiles from Ozark Caves." *Jour-
 nal of the Washington Academy of Sciences* 5.9 (May
 1915): 318-323.

 Bushnell describes basketry specimens excavated from a
cave in McDonald County, Missouri. Particular attention is
given to a fragment of a coiled basket.

107. _____. "The Sloane Collection in the British Museum."
 American Anthropologist 8.4 (October-December 1906):
 671-685.

 Bushnell mentions a South Carolina Indian basket and an
Iroquois burden strap.

108. Chapman, B. J. and J. M. Adovasio. "Textile and Bas-
 ketry Impressions from Icehouse-Bottom, Tennessee."
 American Antiquity 42 (1977): 620-625.

 The analysis of several negative impressions in fired
clay found during excavations at Icehouse-Bottom, Tennessee

revealed the presence of both single element textiles and basketry. Knotted looping, one type of single element textile, was represented by a single specimen. One of the three major sub-classes of basketry was present. There were nineteen samples of a single structural type of weaving.

109. Davis, Christopher. *North American Indian*. Feltham: Hamlyn, 1969.

Indian baskets from Florida, Virginia, and South Carolina are illustrated.

110. Deagan, Kathleen A. "Afro-American and Native American Traditions in Florida Basketry." In *Florida Basketry: Continuity and Change*, pp. 18-19. By Kathleen Deagan and Deborah Harding. White Springs: Florida Folklife Program, 1981.

Deagan emphasizes that Florida has been a region of many cultural traditions. Archaeological evidence indicates the early use of basket making by such groups as the Timucua of north-central and northeast Florida. Twilling was the most common weave. It is characteristic of early twilled Creek and Seminole baskets. Most of these early twilled baskets were made from cane. Contemporary Creek and Seminole baskets have changed drastically from the early twilled baskets. The use of new materials and ideas from other cultural groups are responsible for the style of contemporary American Indian basketry in Florida. Many of the Creek and Seminole basket makers use the coiling technique. Deagan suggests that the commercial rejuvenation of coiled basketry in the 1930s and the use of wire grass and pine needles are responsible for the emphasis on coiled baskets.

111. _____. "An Early Seminole Cane Basket." *The Florida Anthropologist* 30.1 (1977): 28-33.

Examples of Seminole cane baskets are rare in collections of southeastern basketry, and examples dating from the time (1817-1842) of the Seminole Wars are virtually unknown. The basket described in this article is believed to be dated from the 1830s, and has been in the possession of a family from Williston, Florida since that time. The basket is plaited of split cane in a twilled weave, producing a herringbone effect.

112. Dellenbaugh, F. S. "Fabric-Marked Pottery." *Popular Science Monthly* 52.5 (1898): 674-677.

Dellenbaugh suggests that early potters used baskets that came up to the curved-in part of the jar (or was continued above the basket by deft handling) to form their wares. In the initial stages of pottery, the potter may have molded his jar on the inside of a basket frame of similar form and then allowed the basket to be consumed in the baking process.

113. Dickerman, C. Henry. "Secrets of Indian Basketry." *The Red Man* 7.5 (1915): 176-181.

Dickerman briefly describes the efforts of Clara Dardin, a ninety year old Chitimacha Indian, to teach traditional basketry to ten young girls in the tribe. The remainder of the article relates to an exhibit of basketry and weaving crafts sponsored by the American Indian League.

114. Doering, Mavis. *Baskets by Mavis Doering*. Anadarko: Southern Plains Indian Museum and Crafts Center, 1980.

Mavis Doering, a Cherokee basket maker, specializes in traditional styles as well as contemporary basketry of her own design. This is the first comprehensive exhibit of her work.

115. Dormon, Caroline. "The Last of the Cane Basket Makers." *Holland's Magazine* (1931): 13, 66.

A small group of Chitimacha Indians remained in their traditional habitat near Bayou Teche in Louisiana. About six women continued to make traditional cane baskets for domestic use. Dormon describes the manufacture of their baskets and the use of traditional dyeing techniques. Several photographs of these Chitimacha women and their baskets are included.

116. Douglas, Frederic H. *A Choctaw Pack Basket.* Denver Art Museum, Material Culture Notes, no. 4. Denver: Denver Art Museum, 1937, pp. 15-18; reprint ed., *Material Culture Notes* (Denver: Denver Art Museum, 1969), pp. 22-26.

Although there is no definite data, this Choctaw pack basket is reputed to have been collected in the 1880s. It resembles similar baskets made by the Bayou Lacomb Choctaw of Louisiana. Illustrations show rim technique and pattern of weave.

117. _____. *Three Creek Baskets*. Denver Art Museum, Material Culture Notes, no. 15. Denver: Denver Art Museum, 1941, pp. 66-69; reprint ed., *Material Culture Notes* (Denver: Denver Art Museum, 1969), pp. 86-93.

Two of these baskets were collected in 1938 from their maker, Mrs. Arhalochee, by Alice Marriott. The third basket was purchased by Mrs. Marriott at Lamb's Trading Post in Pawhuska, Oklahoma in 1938. The baskets are made from Dogwood splints. Douglas notes that these baskets are typical of the Southeast because of their plaited weave, shallow form, combination of square bottom and round mouth, convex bottom with sharply projecting corners, and use of a double rim.

118. Estes, James R. and Rahmona A. Thompson. "Cane: Its Characteristics and Identification in Baskets." In *Basketry of Southeastern Indians*, pp. 57-64. Edited by Marshall Gettys. Idabel: Museum of the Red River, 1984.

American Indians in the Southeast recognized two types of cane: switch cane and the giant cane-*macrosperma* complex. Estes and Thompson discuss the classification of cane. Basketry materials were examined by a scanning electric microscope (SEM) in order to identify type of materials. They conclude that "much more work needs to be accomplished before this tool can be conveniently and confidently used to identify unknown archaeological materials or ethnological specimens of questionable provenience."

119. Field, Clark. *American Indian Pottery and Baskets*. Tulsa: Philbrook Art Center, 1952.

Field, who began in 1918 to collect Indian baskets and pottery, later donated his collection to the Philbrook Art Center. He noted that his collection contained only authentic specimens of baskets made for actual use by all basket making tribes. No tourist specimens were included. Field introduces the reader to the pottery and basketry collections of the Philbrook Art Center. This small volume contains an "Introduction" by Frank G. Speck. Also included are "Root Runner Basketry," "Root Runner Baskets in Virginia," "Root Runner Baskets in Oklahoma," and "Root Runner Baskets in North Carolina," which were written by Field but who relied heavily on the research and publications of Speck.

120. Foreman, Carolyn Thomas. *Cherokee Weaving and Basketry*. Muskogee: Star Printery, 1948.

Foreman discusses Cherokee baskets and basket makers living in Oklahoma.

121. Foster, John Wells. "On the Antiquity of Man in North America." *Transactions of the Chicago Academy of Sciences* 1 (1867): 227-257.

Foster argued that the Avery Island, Louisiana discoveries were indicative of the contemporaneity of man and Pleistocene fauna. He included an illustration of a basketry specimen.

122. Freeman-Witthoft, Bonnie. "Cherokee Indian Craftswoman and the Economy of Basketry." *Expedition: the Magazine of Archaeology/Anthropology* 19 (1977): 17-27.

Freeman-Witthoft identifies three distinct Cherokee basketry traditions. Cane splint basketry was used in the distant past, but was not used by modern Cherokee basket makers living in the Qualla Boundary because of the exces-

sive distance from cane resources. Baskets of rods and narrow splints are considered to be of European origin. This type of basket, commonly referred to as a rib or melon basket, is found in non-Indian communities throughout the eastern United States. Baskets made of broad oak splints are considered to be of aboriginal origin. The impact of highway construction and the resulting increase in the tourist industry on the manufacture and marketing of baskets and other crafts is discussed.

123. Fundaburk, Emma L. and Mary D. Foreman. *Sun Circles and Human Hands: the Southeast Indians' Art and Industries*. Luverne: Robert Clark, 1957.

Fundaburk and Foreman use extensive excerpts from John R. Swanton, *The Indians of the Southeastern United States*, Bulletin of the Bureau of American Ethnology, no. 137. Washington, D. C.: Government Printing Office, 1946 as the text for their chapter on "Wood." Illustrations for the text are taken from the works of Otis T. Mason and the engravings of Theodore De Bry.

124. Gagliano, Sherwood M. *Occupation Sequence at Avery Island*. Baton Rouge: Louisiana State University Press, 1967.

The controversial split-cane matting discovered at the Avery Island salt dome in Louisiana and presented to the Smithsonian Institution by J. F. Cleu, along with two fossil mammoth bones, was subjected to radiocarbon 14 dating. There was a significant disparity in the dates.

125. Gettys, Marshall. *Basketry of the Eastern United States*. n.p. and n.d.

This is a brief overview of American Indian basketry in the eastern United States. The text is complemented with photographs of representative samples of basketry, line drawings, and a bibliography.

126. _____, ed. *Basketry of Southeastern Indians*. Idabel: Museum of the Red River, 1984.

The papers in this volume rely primarily on material in Oklahoma. The authors examined collections within the state and interviewed one or more craftspersons. Significantly, there is a bias toward those southeast tribes who had been removed to Indian Territory. Included in the book are Lynn Barnes, "Creek Basketry;" Donald Reeves, "Comments on Seminole Basketry;" Richard Sattler, "Baskets of the Cherokees;" Marshall Gettys, "The Choctaw Basket Tradition;" Hiram F. Gregory and Clarence H. Webb, "Chitimacha Basketry;" Claude Medford, "Coushatta Baskets and Basketmakers;" James R. Estes and Rahmona A. Thompson, "Cane: Its Characteristics and Identification in Baskets;" and Candace S. Green, "Care of Baskets."

127. _____. "The Choctaw Basket Tradition." In *Basketry of Southeastern United States*, pp. 35-42. Edited by Marshall Gettys. Idabel: Museum of the Red River, 1984.

Although there are many Choctaw basket forms, the best known is the three piece food preparation set, consisting of a winnowing basket, a tray or catch basket, and a sieve. Other forms are the pack basket, the triangular basket, and the elbow basket. Miniature baskets are a recent innovation. It is difficult to determine attributes that are specifically Choctaw. Gettys identifies three attributes which usually indicate Choctaw weaving: (1.) a basket with a sharply constricted opening and a reenforced band around the shoulder; (2.) an obliquely woven single-walled basket; and (3.) handles that are generally poorly integrated into the basket.

128. _____. "The Functional Riddle--A Sifter?" *The News Basket* 3.1 (February 1986): 12-13.

Gettys discusses the sifter baskets of the Choctaw, Seminole, Creek, and Cherokee tribes of the Southeast. Even though the sifter basket is one of the more traditional and purely functional of all baskets made by the tribes of the Southeast, variations in style do exist.

129. _____. "The Spiro Basket Form: A Woven Link to the Past." *Center of the American Indian, Newsletter* 2.3 (Fall 1985): 3.

Oklahoma has several archaeological sites that have yielded fragments of basketry. Gettys describes a single form of basketry found at Spiro Mound. It was the only relatively complete basket recovered at Spiro. The basket is flat and rectangular, with a deep slip-over lid. The material, technique of manufacture, general form, and size of the basket indicates a link to the manufacture of cane basketry by Indians in the southeastern United States.

130. Gettys, Marshall and Donald Reeves. "A Select Bibliography." In *Basketry of Southeastern Indians*, pp. 71-73. Edited by Marshall Gettys. Idabel: Museum of the Red River, 1984.

This is a listing of twenty-nine items.

131. Gifford, Edward W. "Indian Basketry." In *Introduction to American Indian Art, Part II*. New York: The Exposition of Indian Tribal Arts, Inc., 1931; reprint ed., Glorieta, New Mexico: Rio Grande Press, 1970; and 1979.

This is one of a series of pamphlets which was later bound into a two-volume set, entitled *Introduction to American Indian Art*. Gifford presents an overview of the

Indian basketry of California, the Northwest Coast, the Southwest, and the Atlantic and Gulf Coast states.

132. Gilmore, Melvin R. "Vegetal Remains of the Ozark Bluff Culture." *Papers of the Michigan Academy of Science, Arts and Letters* 14 (1931): 83-102.

In the early 1920s Mark R. Harrington, under the auspices of the Museum of the American Indian, Heye Foundation, discovered remains of a prehistoric people which he identified as the Ozark Bluff-Dweller Culture. Melvin R. Gilmore was assigned the task of investigating the plant remains. Mats and bags were made from bulrushes (*Scirpus validus* Vahl.). Cane (*Arundinaria tecta* [Walt.] Muhl.) was used to make baskets of different types and sizes. A brief description is given about the manufacture of split-cane baskets.

133. Goggin, John M. "Louisiana Choctaw Basketry." *El Palacio* 46 (1939): 121-123.

Near Lake Ponchartrain there lived about a dozen survivors of the Choctaw tribe. Although they had lost much of their aboriginal culture, they continued to make baskets. The baskets were made to sell to the neighboring White communities. Only on occasion were traditional types of baskets produced. The twilled or diagonal method of weaving was the oldest method employed in making baskets. The modern basket makers, however, almost exclusively used wicker weaving. Goggin found examples of the *taposhoke chufa* (pointed basket) and the *tapshoke shakapa* (elbow basket), which were considered to be old forms of Choctaw baskets.

134. _____. "Style Areas in Historic Southeastern Art." *Proceedings of the International Congress of Americanists* 29 (1951): 172-176.

Goggin notes that the art and material culture of the Indians of the southeastern United States has been a neglected field of study. This was due to the belief in a general scarcity of material culture and an acceptance that existing material culture comes from thoroughly acculturated groups. The most useful cultural approach of southeastern archaeologists had been the comparative analysis of pottery. Goggin posits that "if art styles on pottery were useful for comparative purposes, art styles among other mediums should also be valuable." Four classes of decorated objects were identified to be of comparative value: silverwork, basketry, bead embroidery and woven beadwork, and textiles. Basketry was set aside because "its designs are too closely tied to the limitations and nature of the medium."

135. Gower, Charlotte. *The Northern and Southern Affiliation of Antillean Culture.* Memoir of the American Anthropological Association, no. 35. Washington, D. C.: American Anthropological

Association, 1927.

Gower briefly mentions southeastern basketry on page 77.

136. Greene, Candace S. "Southeastern Basketry: Tradition and Ecology." *Papers in Anthropology, Department of Anthropology*, no. 24. Norman: University of Oklahoma, 1983, pp. 131-144.

Greene argues that change and variability in Southeastern basket materials cannot adequately be explained on the basis of form, function, acculturation, degeneration, or diffusion. An examination of changing ecological factors resulting from dislocation and environmental modification, and their interaction with technological processes better explain the dynamic history of basketry in the Southeast.

137. Gregory, Hiram F. and Clarence H. Webb. "Chitimacha Basketry." *Louisiana Archaeology* 2 (1975): 23-28.

Reprinted in Marshall Gettys, ed., *Basketry of Southeastern Indians*, Idabel: Museum of the Red River, 1984. See next entry.

138. _____. "Chitimacha Basketry." In *Basketry of Southeastern Indians*, pp. 43-50. Edited by Marshall Gettys. Idabel: Museum of the Red River, 1984.

This paper first appeared in *Louisiana Archaeology* 2 (1975): 23-28. Gregory and Webb, relying on archaeological and ethnographic data and interviews with contemporary weavers, discuss the survival of Chitimacha basket making in Louisiana. The Chitimacha, like many other Southeastern tribes, relied primarily on cane to make their baskets. Baskets were woven in either fine or coarse single weaves, or in the more complex--often watertight--double-weave. The major forms of Chitimacha baskets are the small, lidded and round basket, the clam basket, the small round basket, the heart-shaped basket, the trunk-shaped basket, and the fanner. The scarcity of cane has limited the size and manufacture of baskets today among the Chitimacha.

139. Griffin, John W. *Investigations in Russell Cave*. Publications in Archeology, no. 13. Washington, D. C.: U. S. Department of the Interior, 1974.

Griffin fails to mention the charred basket remains discovered in 1956 by Carl Miller in Russell Cave. He does, however, briefly describe and illustrate a matting impression on page 62. The matting appears to have been made of split cane, held together by cordage in a simple over-under lacing.

140. Hall, Charles L. "Bugtussle Rockshelter: A Preliminary Statement." *Tennessee Anthropological Association*

Newsletter 10.2 (March-April 1985): 1-6.

Bugtussle Rockshelter is located in Macon County, Tennessee. Because of its location, the sheltered area has been protected from the weather. Consequently, unprocessed plant remains, processed plant materials (textiles and tools), human feces, and animal tissues were preserved. Recovered from the grave of a 25-30 year old female American Indian were fragments of cordage and a nearly complete woven bag.

141. Hamel, Paul B. and Mary U. Chiltoskey. *Cherokee Plants and Their Uses--A 400 Year History*. Sylva, N.C.: Herald Publishing Company, 1975.

Gourd containers for carrying and storing were perhaps among the oldest household utensils, because they could be grown and used with minor modifications. Baskets are probably the next oldest. Some of the finest craftsmanship of the Cherokee people is devoted to the making of baskets. The traditional materials for basket work are cane; white oak when metal tools became available; and more recently Japanese honeysuckle vines and maple. The cane and oak were used for heavy-duty and all-purpose wares, while the honeysuckle and maple were used primarily for light and ornamental pieces intended for the tourist trade. The authors briefly discuss on pages 18-20 the various uses of river cane, the manufacture of dyes for the cane, and designs on the baskets.

142. Harrington, Mark R. "Among the Alibamu Indians." *The Southern Workman* 43.10 (October 1914): 544-551.

The basketry of the Alabama Indians is discussed on pages 550-551. The Alabama's basketry resembles the weaves and patterns of the Mississippi Choctaw, but did not (according to Harrington) equal the detail and coloring of the Chitimacha of Louisiana.

143. _____. *Certain Caddo Sites in Arkansas*. Indian Notes and Monographs, Miscellaneous Series, Museum of the American Indian, Heye Foundation, no. 10. New York: Museum of the American Indian, Heye Foundation, 1920.

The basketry of the Caddo is discussed on pages 221-223. Harrington describes and illustrates a fragment of a twilled basketry pouch from the Mineral Springs Site, and discusses briefly early historical references to basketry among the Caddo.

144. _____. *The Ozark Bluff Dwellers*. Indian Notes and Monographs, Museum of the American Indian, Heye Foundation, no. 12. New York: Museum of the American Indian, Heye Foundation, 1960.

Harrington discusses and illustrates cane splint basketry. Some of the basketry specimens had intricate woven

patterns similar to those of the Chitimacha of Louisiana.
Four major types of cane baskets were observed: (1.) a
flat, dish-like form; (2.) a similar type but with an open
weave at the bottom for use as a sieve; (3.) a deep basket;
and (4.) an oblong shape, with a diagonal twilled weave.

145. Hartung, A. Bruce. "Baskets of the Eastern Cherokee."
 Antiques Journal 35 (1980): 17.

 This short article gives a brief description of the
basketry materials and procedures involved in their prep-
aration for use in traditional Cherokee basket weaving.

146. Harvey, Amy E. "Archaeological Fabrics from the Lower
 Missouri Valley." *Irene Emery Roundtable on Museum Tex-
 tiles 1974 Proceedings*, pp. 133-140. Edited by Patricia
 Fiske. Washington, D. C.: The Textile Museum, 1975.

 Based on a brief summary of some representative speci-
mens from central and southern Missouri. Included are frag-
ments of mats, nets, and a bag.

147. Henning, Amy E. "Fabrics and Related Materials from
 Arnold-Research Cave." *The Missouri Archaeologist* 28
 (1966): 41-53.

 Raw materials of bast and other vegetal fibers, cord-
age, fabrics, sandals, and several miscellaneous cord ob-
jects were found during the excavation of Arnold-Research
Cave. No complete items were recovered, except for a few
sandals. There is no mention of basketry.

148. Holmes, William H. "Prehistoric Textile Art of Eastern
 United States." *Annual Report of the Bureau of American
 Ethnology* 13. Washington, D. C.: Government Printing
 Office, 1892, pp. 9-46.

 Drawing upon early historical sources, Holmes discusses
and illustrates various types of basketry used by Indians in
the eastern United States. See especially pages 15-21.

149. Hughes, Juanita. *Wind Spirit, an Exhibition of Chero-
 kee Arts and Crafts*. Cherokee: Qualla Arts and Crafts
 Mutual, n.d.

 This forty-four page booklet shows thirty-four present-
day artists among the Eastern Band of Cherokee, along with
their baskets, pottery, carvings, beadwork, weaving, and
doll-making. Included are pictures of honeysuckle baskets,
oak-ribbed baskets, oak splint baskets, and river cane bas-
kets.

150. Hunter, Donald G. "Coushatta Basketry in the Rand Col-
 lection." *The Florida Anthropologist* 28.1 (1975): 27-
 37.

A large number of Coushatta baskets were collected by Mrs. Paul King Rand, Sr. (1890-1973). This article describes these baskets and the revival of basket making among the Coushatta of Louisiana.

151. Indian Arts and Crafts Board. *Masterpieces of Chitimacha Basketry: Contemporary and Traditional*. Baton Rouge: Anglo-American Art Museum, Louisiana State University, 1981.

This brief catalog describes a display of the contemporary Chitimacha baskets made by Ada V. Thomas. The traditional baskets are from the collection of the McIlhenny family of Avery Island, Louisiana.

152. _____. *Seminole Sweet Grass Baskets*. Washington, D.C.: United States Department of the Interior, 1979.

The Seminole Indians of southern Florida used the stems of the palmetto plant and sweet grass to make baskets. In the past, the Seminoles used the century plant as a material for binding the sweet grass baskets together. Today, they use commercial thread. This four page pamphlet describes a sales exhibit, organized by the Indian Arts and Crafts Board, of three of the most talented Seminole basket makers. Included are photographs of Lena Frank Rosada, Ethel Santiago, and Alice Osceola making baskets.

153. Irwin, John Rice. *Baskets and Basket Makers in Southern Appalachia*. Exton, PA: Schiffer Press Company, 1982.

Very little attention has been given to the extent to which Indians and White settlers influenced each other in the manufacture of baskets. Irwin observes that the influence of the American Indian in southern Appalachia varied significantly with the physical environment and with the ethnic background of the settlers. In the isolated regions of the Smoky Mountains, Irwin discerned a major blending of Indian and non-Indian characteristics in the baskets. In several instances, it is almost impossible to ascribe a basket to an Indian or non-Indian craftsperson. Several baskets, considered by Irwin and local collectors to be made by Indians, are illustrated and described.

154. Joor, Joseph F. "Notes on a Collection of Archeological and Geological Specimens Collected in a Trip to Avery's Island (Petit Anse), Feb. 1st, 1890." *The American Naturalist* 29.340 (April 1895): 394-398.

Joor mentions the discovery of a fragment of cane basketry. He concludes that there is "no reason for assigning any very enormous antiquity to these fabrics," because the basketry fragments were probably washed into the salt pits.

155. Lamb, Frank W. *Indian Baskets of North America*. La
 Pine: Rubidoux Publications, 1972; 1976; 1981; and
 1985.

 Baskets of the Southeast tribes are discussed on pages
123-126.

156. Langley, Edna. *Coushatta Indian Crafts*. New Orleans:
 The Cabildo, 1974.

 Edna Langley, a Coushatta Indian, is trying to preserve
a comprehensive aspect of the rich cultural heritage of her
tribe. This exhibition, sponsored by the Indian Arts and
Crafts Board, includes a turkey effigy basket and a coiled
sweet grass waste basket.

157. Lasiter, Mary E. "The Textile World of the Ozark Bluff
 Dwellers." *Arkansas Historical Quarterly* 5.3 (Autumn
 1946): 274-277.

 Lasiter briefly mentions the discovery of fragments of
coiled and twined basketry in Benton, Carroll, Madison, and
Newton Counties, Arkansas.

158. Leftwich, Rodney L. *Arts and Crafts of the Cherokee*.
 Cullowhee, North Carolina: Land-of-the-Sky Press, 1970;
 reprint ed., Cherokee, North Carolina: Cherokee
 Publications, 1986.

 Leftwich discusses in detail the various types of Cher-
okee basketry.

159. _____. "Arts and Crafts of the Cherokee." Ph.D. dis-
 sertation, Bradley University, 1952; Ann Arbor: Uni-
 versity Microfilms, 1973.

 Leftwich examines the arts and crafts of the Cherokee
Indians from prehistoric times to the present day. Only the
Eastern Band of Cherokee living on the Qualla Reservation in
western North Carolina were studied. The art and craft ac-
tivities included pottery making, woodcarving, weaving,
metal work, bead work, and basketry. The chapter on Chero-
kee basketry discusses how they harvest, prepare, and dye
materials, and how they fashion these materials into fin-
ished products of various sizes and shapes.

160. _____. "Cane Basketry of the Cherokees." *School Arts*
 56.6 (February 1957): 27-30.

 This is an illustrated description of the techniques
used in preparing cane for weaving and of twilling, the pre-
vailing weave in Cherokee cane basketry. Included are pho-
tographs of various Cherokee cane baskets.

161. _____. "Cherokee White Oak Basketry." *School Arts* 54.1
 (September 1954): 23-26.

The Eastern Band of Cherokee, located in the Smoky Mountains of western North Carolina, excel in basketry. Leftwich discusses the various steps in making oak-splint baskets.

162. _____. "Making Honeysuckle Baskets." *School Arts* 55.6 (February 1956): 27-29.

Since its introduction from Japan, honeysuckle has been used very successfully by the Cherokee as a basketry material. Leftwich describes how honeysuckle is gathered, prepared, and woven in Cherokee wicker work baskets.

163. Leidy, Joseph. "Remarks." *Proceedings of the Academy of National Sciences of Philadelphia* (1866): 109.

This is the first disclosure that Pleistocene fauna skeletal remains were present at Avery Island, Louisiana. Beneath the bones were pieces of split-cane matting.

164. MacCauley, C. *The Seminole Indians of Florida.* Annual Report of the Bureau of American Ethnology 5. Washington, D. C.: Government Printing Office, pp. 469-531.

On page 517, MacCauley briefly comments that the Seminole are no longer weavers. They were, however, basket makers. Using swamp cane and the palmetto, the Seminole made flat baskets and sieves for domestic use.

165. Mason, Otis T. *Aboriginal American Basketry: Studies in a Textile Art Without Machinery,* pp. 171-548. Annual Report of the U. S. National Museum for 1902. Washington, D. C.: Government Printing Office, 1904.

For a discussion of Southeast Indian basketry see pages 372-90. For the full annotation see entry **49**.

166. McGimsey, Charles R., III. *Indians of Arkansas.* Publications on Archeology, Popular Series, no. 1. Fayetteville: Arkansas Archeological Society, 1969.

In northwest Arkansas during the Archaic Period, Indians occupied bluff shelters. The extreme dryness of the deposits on the floors of these shelters served to preserve basketry, woven materials, and wood objects. A woven cane basket and grass bag are illustrated on pages 8-9.

167. Medford, Claude. "Chitimacha Split Cane Basketry: Weave and Design." *American Indian Art Magazine* 3.1 (1977): 56-61, 101.

Medford, an accomplished basket maker, provides a vivid description of the making of Chitimacha cane splint baskets.

168. _____. "Coushatta Baskets and Basketmakers." In *Baske-*

try of Southeastern Indians, pp. 51-56. Edited by
Marshall Gettys. Idabel: Museum of the Red River,
1984.

Early Coushatta cane baskets in Alabama resembled those
of their Muskogean neighbors. They were usually plain win-
nows, sifters, burden, utility, and storage baskets. Basket
making changed after Coushatta weavers arrived in Louisiana,
where they came under the influence of a more complicated
form of cane work. New shapes, such as the elbow and heart
baskets of the Choctaw and the intricately woven patterns of
the Chitimacha, Caddo, and Atakapan affected earlier Cou-
shatta styles. Significantly, the Coushatta continued to
make these new shapes after they had been abandoned by other
Louisiana tribes. During the 1920s, changing agricultural
practices in Louisiana resulted in the increasing scarcity
of cane and sedgegrass. The needle of the Long Leaf Pine
provided Coushatta basket makers with a natural substitute.
Raffia, an African palm fiber, replaced the inner bark of
elm which had been used to stitch the coil of the pine
needle baskets.

169. _____. "Southeastern Basketry: Past and Present."
Artifacts 13.3 (Summer 1985): 10-11.

Medford discusses the reasons for the changes in types
of basketry materials used by various tribes from the South-
east.

170. Mercer, Henry Chapman. "The Antiquity of Man on Petit
Anse (Avery's Island) Louisiana." The American Natura-
list 29.340 (April 1895): 393-394.

Mercer raised the possibility that Indian salt-pit dig-
ging may account for the presence of basketry remains in
situ with the skeletal remains of Pleistocene fauna. The
tusks and bones of a fossil elephant were found in the same
soil two feet above the matting fragments.

171. Merwin, Bruce W. "Basketry of the Chitimacha Indians."
Museum Journal, University of Pennsylvania 10.1 and 2
(1919): 29-34.

Mrs. William Pepper presented the University Museum
with a collection of baskets. Included in the collection
were twelve Chitimacha baskets. The baskets are made of
split cane, and are red and black in color. Four of the
baskets are illustrated in this article. Merwin interpreted
each of their designs as worm tracks, alligator, eyes of
cattle, and blackbird's eyes. Relying on information from
A. S. Gatschet and John R. Swanton, Merwin identified these
baskets as being used in mortuary practices.

172. Miller, Carl and Brooks Honeycutt. "Life 8,000 Years
Ago Uncovered in an Alabama Cave." National Geographic
Magazine 110.4 (October 1956): 542-558.

Russell Cave is located in northeastern Alabama. Miller describes the discovery of a basket, "saucer shaped, about 10 inches in diameter, and made of coiled strands of grass fiber sewed together." Before the basket could be excavated, pot-hunters vandalized the site and removed the basket. For a critical review of Miller's findings, see Bruce D. Smith, "The Role of 'Chenopodium' as a Domesticate in the Pre-Maize Garden Systems of the Eastern United States," *Southeastern Archaeology* 4.1 (Summer 1985): 51-72, who argues that the basketry remains were in fact from a storage pit.

173. Miner, Horace. "The Importance of Textiles in Archaeology of the Eastern United States." *American Antiquity* 1 (1936): 181-192.

Miner argues that sufficient textile materials had been collected to facilitate the development of a terminology. He concludes that "the numerous weaving methods employed by the different early groups reflect other differences in culture and are of considerable value to the archaeologist.

174. Neuman, Robert W. *An Introduction to Louisiana Archaeology.* Baton Rouge and London: Louisiana State University Press, 1984.

Neuman provides a detailed narrative about the discovery of split-cane basketry in the ground "beneath" the bones of Pleistocene fauna at the Avery Island salt-dome in Iberia Parish, Louisiana.

175. Orchard, William C. *Sandals and Other Fabrics from Kentucky Caves.* Indian Notes and Monographs, Miscellaneous Series, Museum of the American Indian, Heye Foundation, no. 4. New York: Museum of the American Indian, Heye Foundation, 1920.

Orchard describes two complete twine bags and several basketry fragments.

176. Owen, Richard. "On the Deposit of Rock Salt at New Iberia, La." *Transactions of the St. Louis Academy of Science* 2 (1868): 250-252.

Owen, a geologist and later Professor at Indiana State University, made the initial report about finding matting made of split-cane on the surface of the rock salt-dome, fifteen feet below the surface of the soil on Avery Island in Iberia Parish, Louisiana.

177. Pierite, Joseph A. "Present Day Crafts of the Tunica and Biloxi Tribes of Louisiana." *American Indian Crafts and Culture* 8 (1974): 4-5, 12.

States that only Mrs. Pierite and Mrs. Juneau continue

regularly to make baskets. One elderly cane basket maker was still living, but was unable to make them.

178. Porter, Frank W. "American Indian Baskets in the Middle Atlantic Region: Material Survival and Changing Function." *Material Culture* 17.1 (1985): 25-45.

For a complete annotation see entry **63**. Porter discusses the manufacture of oak splint baskets and eel pots among the Rappahannock, Mattaponi, and Chickahominy Indians of Virginia.

179. _____. "Material Acculturation Among Indian Survivals in the Middle Atlantic Region." *Pioneer America Society, Transactions* 5 (1982): 37-48.

There has been a general consensus that American Indians in the Middle Atlantic region had become extinct. This was not the case. Many groups of Indians survived the onslaught of White settlement. Changes in material culture may help to explain the paucity of observations about Indians in this region in the nineteenth century. An examination of the vestiges of material culture among Indian survivals offers significant insight into the process of acculturation and the integration of Indians into White society.

180. Reeves, Donald. "Comments on Seminole Basketry." In *Basketry of Southeastern Indians,* pp. 17-24. Edited by Marshall Gettys. Idabel: Museum of the Red River, 1984.

The appearance of Seminole basketry today does not reflect its traditional foundation. The migrations and the isolation of the Seminoles resulted in specific adaptations to differing geographical environments, but during these moves basketry changed very little in traditional form. In Florida, however, materials shifted from cane and hickory splints to palmetto. Basket makers in Indian Territory continued to use traditional materials. In the 1920s, the Seminole in Florida began to make sweetgrass baskets. Sweetgrass baskets were an effort to create attractive and marketable baskets for tourists.

181. Reyman, Jonathan E., with Sandra Faikus, Sari Kessler, Laurie Ruedi, Anne Weirich, and Susan Wexler. *A Catalogue of Native American Basketry at the LaSalle County Historical Society Museum Utica, Illinois.* Utica: Illinois State University, Anthropology Program, 1979.

Reyman discovered a collection of American Indian baskets in the LaSalle County Historical Society Museum in Utica, Illinois. The baskets were in need of cleaning and preservation. After restoration, an effort was made to identify the baskets. At least fifteen groups are represented by the various basketry specimens in the collection. Southeastern baskets are represented by the Choctaw. The speci-

mens in this catalogue are listed in the order of the
accession numbers assigned by the LaSalle Historical Society
Museum.

182. Sattler, Richard. "Baskets of the Cherokees." In *Bas-
 ketry of Southeastern Indians*, pp. 25-34. Edited by
 Marshall Gettys. Idabel: Museum of the Red River,
 1984.

Traditional Cherokee basketry utilized cane. Contem-
porary Cherokee basket makers, however, use a wide variety
of raw materials for their baskets. Much of the time de-
voted to basket production is spent in the preparation of
these raw materials. White oak, hickory, cane, honeysuckle,
and buckbrush are used. All Cherokee basketry is made by
plaiting. The most common techniques are simple checker-
work, twill, and wicker. Traditional Cherokee basket forms
were the burden, storage, carrying, and food preparation
baskets.

183. Scholtz, Sandra C. "Cordage, Netting, Basketry and Fa-
 brics from Ozark Bluff Shelters." Master's thesis, Uni-
 versity of Arkansas, 1970.

See next entry.

184. Scholtz, Sandra C. *Prehistoric Plies: A Structural
 and Comparative Analysis of Cordage, Netting, Basketry,
 and Fabric from Ozark Bluff Shelters*. Arkansas
 Archeological Survey, Research Series, no. 9.
 Fayetteville: Arkansas Archeological Survey, 1975.

Cultural groups have used natural bluff shelters in the
Ozark Mountains for at least 10,000 years. In several of
these shelters, the arid environment has preserved basketry,
fabric, cordage, matting, and netting that otherwise would
have deteriorated. Several anthropologists have postulated
relationships between the Ozark area and the southwestern
United States. These postulations have been based primarily
on the presence of such perishable objects as sandals and
baskets. Scholtz concludes that on the whole "there seems
to be very little technical and formal similarity between
the perishable artifacts from the Southwest and those from
the Ozark Bluff shelters other than the western Texas mater-
ial." This material is the coiled basketry in which the
grass and splint bundle of the Ozark area is very similar in
technique and form to some of the western Texas coiled bas-
kets.

185. Skinner, Alanson B. "Cherokee Collection." *Anthropolo-
 gical Papers, American Museum of Natural History* 4
 (1910): 284-89.

Skinner lists artifacts obtained by the Department of
Anthropology of the American Museum of Natural History from
the Qualla, Nantahala, and Cheowa Reservations in North

Carolina. Several baskets used in the preparation of corn foods were obtained. Included were large winnowing baskets, a fine sieve basket also used as a skimmer, a hominy sieve basket, and a storage basket. The sieve, except for material, is identical in appearance with forms used by the Iroquois in New York.

186. Smith, Bruce D. "The Role of 'Chenopodium' as a Domesticate in the Pre-Maize Garden Systems of the Eastern United States." *Southeastern Archaeology* 4.1 (Summer 1985): 51-72.

Smith notes that the research findings in John W. Griffin's (see entry **139**) investigations of Russell Cave in Alabama failed to mention or discuss Carl Miller's recovery of a small charred basket containing carbonized chenopod seeds. In August of 1982, Smith located the charred basket section and remains of fruits excavated by Miller. After analysis of this material, Smith strongly argued that the "basket" was in fact the remains of the grass lining of a storage pit.

187. Speck, Frank G. "Aboriginal Culture in the Southeastern States." *American Anthropologist* 9 (1907): 287-295.

Baskets made from cane splints are discussed on page 293.

188. _____. *Chapters in the Ethnology of the Powhatan Tribes of Virginia*. Indian Notes and Monographs, Museum of the American Indian, Heye Foundation, no. 1.5. New York: Museum of the American Indian, Heye Foundation, 1928.

Basketry is treated very briefly on pages 384-385. Speck notes that in the 1920s basketry for agricultural use was seldom made, although some men constructed them to carry fish. Among the Mattaponi, young girls made baskets from honeysuckle stems. Speck believed this type of basketry was European in origin.

189. _____. *The Creek Indians of Taskigi Town*. Memoirs of the American Anthropological Association, no 2.2. Washington, D. C.: American Anthropological Association, 1907; reprint ed., Millwood, New York: Kraus Reprint, 1974.

Baskets of various shapes were made for household use of cane and hickory splint. The favorite technique in basketry was twilled. The weaving showed some diversity in details produced by allowing the woof strands to pass over one, two, three, and frequently four warp strands at a time. Decoration on baskets, according to Speck's informants, was rare, but when desired was obtained by manipulating varicolored splints in the woof. The splints were shaved from

the rind of cane. This gave a smooth glossy surface on one side which was turned outward in weaving. The commonest basket shape had the bottom quite flat and wide with the wall tapering slightly inward toward the top. Sieves of open twilled work were made for sifting pounded corn. Twilled mats of cane were formerly made, but are no longer produced. Facing page 111 is a photograph of Creek basketry extracted from *Report of the Indian Inspector for Indian Territory* for 1901.

190. _____. "Decorative Art and Basketry of the Cherokee." *Bulletin of the Public Museum of the City of Milwaukee* 2.2 (1920): 53-86.

Speck discusses the various types of cane and oak baskets made by the Cherokee Indians of North Carolina.

191. _____. *The Nanticoke Community of Delaware.* Contributions from the Museum of the American Indian, Heye Foundation, no. 2. New York: Museum of the American Indian, Heye Foundation, 1915.

The Nanticoke made only plain splint baskets for household and farm use. There were a variety of sizes but only one style, which was the common, circular-bottomed twill weave. White and yellow pine were used to make these baskets. Speck describes the auxiliary rim-hoop of the Nanticoke baskets.

192. _____. *The Rappahannock Indians of Virginia.* Indian Notes and Monographs, Museum of the American Indian, Heye Foundation, no. 5.3. New York: Museum of the American Indian, Heye Foundation, 1925.

Basketry is discussed on pages 56-69. Speck found several basket makers among the Rappahannock. Baskets with rectangular bottoms and handles, or with circular bottoms were the common forms. The baskets were made from splints of white oak. No gauges or other types of finishing tools were used. The auxiliary rim-hoop of the Rappahannock and Nanticoke is illustrated and described. No cane basketry was found among the Virginia tribes.

193. Stephenson, Sue H. *The Basketry of the Appalachian Mountains.* New York: Van Nostrand Reinhold Company, 1977; New York: Prentice-Hall, 1986.

Stephenson discusses the divergent basketry traditions of the Appalachian Mountains, emphasizing methods, patterns and colors of Indian and European settlers prior to the twentieth century. Typical wickerwork basket bases used by Indians are illustrated.

194. Stites, Raymond S. *The Arts and Man.* New York: McGraw-Hill, 1940.

Basket weaving methods are illustrated. A Cherokee basket is described on pages 53-54.

195. Sylestine, Rosabel. *Coushatta Pine Needle Coiled Basketry.* New Orleans: Cabildo Museum, 1973.

This is a brief catalog about an exhibition, sponsored by the Indian Arts and Crafts Board, of the pine needle basketry of Rosabel Sylestine.

196. _____. *Coushatta Pine Needle Coiled Basketry.* Baton Rouge: The Louisiana Arts and Science Center, 1973.

Same as above entry.

197. Taylor, Douglas and Harvey C. Moore. "A Note on Dominican Basketry and Its Analogues." *Southwestern Journal of Anthropology* 4.3 (1948): 328-43.

The similarities between the basketry of the Dominican Carib and that described for the Guiana Indians suggests possible relations with other areas possessing similar basketry. Too hasty an inference that similar design types are related should be avoided. The evidence presented supports the view that the Antilles, northeastern South America, and southeastern United States form an area having pronounced similarities in basketry.

198. Van Oot, B. H. "Reviving Indian Arts and Crafts: Pamunkey Indians." *Industrial Arts and Vocational Education* 23.8 (August 1934): 249-251.

Although this article deals with the development of a tribal pottery industry by the state of Virginia among the Pamunkey Indians of Virginia, other arts and crafts--including basketry--were studied.

199. Weltfish, Gene. "Problems in the Study of Ancient and Modern Basket-Making." *American Anthropologist* 34.1 (1932): 108-117.

Weltfish develops a typological consideration of North American prehistoric basketry and the historical problems suggested by it. Five general types of prehistoric basketry material are identified: Southwestern, Ozark Bluff Dwellers, Lovelock, Snake River, and California Cave. Significantly, parallels for the prehistoric technical types in all five cases were found in modern areas closely contiguous to the prehistoric sites.

200. West, Patsy. "Glade Cross Mission: An Influence on Florida Seminole Arts and Crafts." *American Indian Art Magazine* 9.4 (Autumn 1984): 58-67.

West provides a history of the craft program at Glade Cross Mission. This program was created and operated for

twenty-seven years among the Mikasuki-speaking Seminoles by Harriett M. Bedell, the mission's Episcopalian Deaconness.

201. Wilson, Thomas. "Ancient Indian Matting--from Petit Anse Island, Louisiana." *Annual Report of the United States National Museum for 1888*. Washington, D. C.: Government Printing Office, 1890, pp. 673-675.

Wilson, reviewing all of the available geological data about the salt deposits on Petit Anse Island, argues that the locale in which the Indian basketry remains were found was "detrital mass." As a consequence, he concluded that there was no evidence for the antiquity of man.

202. York, Kenneth H. "Choctaw Arts and Crafts." In *Made by Hand: Mississippi Folk Art*, pp. 38-44. Edited by Patti Carr Black. Jackson: Mississippi Department of Archives and History, 1980.

York briefly discusses the intricate designs and varied styles of Choctaw baskets (*tapossik*).

203. Young, Stephen Flinn. *Mississippi Choctaw Crafts*. Jackson: Craftsmen Guild of Mississipi, Inc., 1983.

Because of the isolation of the Mississippi Choctaw, their crafts are not well known. Interest in the crafts of the Choctaw, however, has helped to lessen this separateness. Young discusses the white oak basketry of Melvin Henry. Various swamp cane and white oak baskets are illustrated.

204. _____. "Mississippi Choctaw Basketry." *Art Papers* (March-April 1983): 12-13.

Young provides a general historical background of the Choctaw prior to the removal of the tribe to Indian Territory. A small group of Choctaw remained in Mississippi, and continued their self-sufficient way of life. The salvage ethnography of Mark R. Harrington is discussed. Young describes the white oak baskets made by Melvin Henry.

Great Lakes

205. Alexis, Philip and Barbara Paxson. *Potawatomi Indian Black Ash Basketry.* Dowagiac: Published by the Potawatomi Indian Tribe, 1984.

 For the Potawatomi, basketry has become a symbol of their cultural identity. Some tribal elders, who recall the techniques, processes, and styles of black ash basketry, have been teaching this craft to both young and old students. This booklet provides photographs and short biographies of present-day basket makers, and illustrates and describes techniques of making black ash splint baskets.

206. Anderson, Marcia G. and Kathy L. Hussey-Arnston. "Ojibway Beadwork Traditions in the Ayer Collections." *Minnesota History* 48.4 (Winter 1982): 153-157.

 The authors review briefly the history of the Jeannette O. and Harry D. Ayers collections of the Minnesota Historical Society and the Mille Lacs Indian Museum and Trading Post. The collections of the Minnesota Historical Society contain a few examples of games, fishing gear, women's clothing, and pre-1880s artifacts. Woven grass bags, birch-bark containers, dolls, and smoking equipment are better represented. The Ayers Collection offers excellent examples of a wide range of techniques and de-corated surfaces, and allows new insights into the design and production of beaded items, including bandolier bags, and makuks, made during the first half of the twentieth century.

207. Anonymous. "Indian Maker of Baskets." *The American Indian* 2.5 (1928): 14.

 William Augusta, a Potawatomi Indian from Dowagiac, Michigan was a well-known maker of baskets. Augusta and his wife made splint baskets, with sweet grass woven in. This is a summary of an article about Augusta written by

NATIVE AMERICAN BASKETRY

Frederick E. Howe in the *Kalamazoo Gazette*.

208. Blessing, F. K. "The Physical Characteristics of Southern Ojibwa Woodcraft." *Minnesota Archaeologist* 18.4 (1952): 9-21.

There is a discussion about birch bark baskets. Plate XVIII illustrates a rib basket made of ash.

209. _____. "Some Observations on the Use of Bark by the Southern Ojibwa Indians." *Minnesota Archaeologist* 19.4 (1954): 3-14.

Blessing states that the lack of birch bark, the availability of the White man's products, the gradual loss of the wild rice beds, the loss of traditional values, and the move to metropolitan areas by the younger generation were responsible for the loss of material culture among the Ojibwa. Various birch bark baskets and makuks are described and illustrated.

210. Buckstaff, Karen. "Socio-Cultural Aspects of Basketry with Respect to Winnebago Culture." Unpublished manuscript.

This manuscript is cited in William H. Hodge, ed., *A Bibliography of Contemporary North American Indians; Selected and Partially Annotated with Study Guide* (New York: Interland Publishers, 1976.

211. Carter, B. F. "The Weaving Technic of Winnebago Bags." *The Wisconsin Archaeologist* 12.2 (1933): 33-47.

Carter discusses the various methods of preparing the material and weaving the different types of bags. Also considered are the designs on the bags.

212. Coleman, Sister Bernard. *Decorative Designs of the Ojibwa of Northern Minnesota*. Catholic University of America, Anthropological Series, no. 12. Washington, D. C.: The Catholic University of America, 1947.

Focusing on the Ojibwa of northern Minnesota, Coleman discusses typical Ojibwa designs, investigates their use in material, religious, and social culture, and determines the relation of the design pattern assemblage to the social milieu and to the individual before and after contact with Whites. The weaving of bags and mats are discussed and illustrated.

213. Commanda, Gisela. "Handicrafts of the Ojibway." *School Arts* 50.9 (May 1951): 310-312.

Commanda married Antoine Commanda, an Ojibwa. From her relatives she learned Ojibwa crafts. Miniature birch bark baskets are briefly discussed on page 312.

214. Densmore, Frances. *Chippewa Customs*. Bulletin of the Bureau of American Ethnology, no. 86. Washington, D. C.: Government Printing Office, 1929.

The making of baskets was not a highly developed art among the Chippewa, as the birch bark makuk answered the purpose of a general carrier and was made more easily than a basket. Baskets were made of willow branches at an early date. The "melon-shaped basket" was an old form. Covered baskets were made at an early date and the willow was sometimes colored with native dye. Baskets were made of stiff strips of the inner bark of basswood, woven in a lattice having the upright and transverse strips the same width. This custom was not observed among the Minnesota Chippewa by Densmore, but was seen at Lac Court Oreilles, Wisconsin and among the Canadian Chippewa. Black ash was used in making baskets by the Chippewa at Mille Lac. Coiled baskets were made of sweet grass but were more akin to bowls, as they had no handles. It is said that the oldest forms of these had covers made of birch bark bound with sweet grass. Birch bark is combined with coiled sweet grass in the making of a great variety of mats and shallow dishes or trays.

215. _____. "Material Culture Among the Chippewa." *Smithsonian Miscellaneous Collections* 70.1 (1919): 114-118.

Densmore, who had been studying Chippewa material culture for several years, visited the White Earth and Red Lake Reservations in Minnesota. She discusses the process of securing and storing birch bark and the various ways it is used.

216. _____. "Native Art of the Chippewa." *American Anthropologist* 43.4 (October-December 1941): 678-681.

Each tribe of American Indians expressed its art instinct in the material that was available in the region where they lived. The native art of the Chippewa was connected with the birch tree, which , they say, was the gift of Winbojo to the tribe. Densmore describes birchbark transparency and designs fashioned in birch bark with a fishbone and a knife.

217. _____. "Study of Chippewa Material Culture." *Smithsonian Miscellaneous Collections* 68.12 (1918): 95-100.

Densmore briefly discusses birch bark baskets.

218. _____. *Uses of Plants by the Chippewa Indians*. Annual Report of the Bureau of American Ethnology 44. Washington, D. C.: Government Printing Office, 1928, pp. 275-397.

The information for this study was obtained from informants on the White Earth, Red Lake, Cass Lake, Leech Lake, and Mille Lac Reservations in Minnesota, the Lac Court Oreilles Reservation in Michigan, and the Manitou Rapids Reserve in Ontario, Canada. Densmore studied in particular the ethnobotany of the Chippewa and was able to obtain a collection of about 200 plants used as medicines, food, dyes, charms, and general utility. Birch bark trays and wooden mats are briefly discussed.

219. Douglas, Frederic H. *Indian Basketry East of the Rocky Mountains.* Denver Art Museum, Indian Leaflet Series, no 87. Denver: Denver Art Museum, 1934.

Contains photographs of sixteen different baskets, including coiled, plaited, wicker, and twined from the Northeast, Plains, and Great Lakes areas. There is a brief description of techniques used in making each type of basket and its uses.

220. _____. *Ottawa Cedar Bark Mat.* Denver Art Museum, Material Culture Notes, no. 16. Denver: Denver Art Museum, 1941; reprint ed., *Material Culture Notes* (Denver: Denver Art Museum, 1969), pp. 94-97.

This cedar bark mat was collected by Albert G. Heath from the Ottawa of Emmet County, Michigan. It is estimated the mat was made about 1890. The Ottawa, according to Heath, used cedar bark mats for floor coverings, wigwam covers, as ground cover on which to dry corn, and as wind breakers while ice-fishing.

221. Eastman, Charles A. "Life and Handicrafts of the Northern Ojibwas." *The Southern Workman* 40 (1911): 273-278.

Eastman describes stripping birch and cedar bark for canoes and basket making. Pine roots were also gathered to make baskets. There is a photograph of Ojibwa basket makers.

222. Faben, W. W. "Pottawatomi Basketry." *Hobbies; the Magazine for Collectors* 48 (October 1943): 103.

Faben describes the making of a Potawatomi black ash splint basket. Mary Mandoka, a Potawatomi basket maker, discusses the traditional and modern uses of dyes. Tourists and collectors have heavily influenced modern Potawatomi basketry.

223. Forelli, Sally. "Twined Bags of the Indians of the Western Great Lakes." Master's thesis, University of Wisconsin, 1973.

224. Garte, Edna. *Circle of Life: Cultural Continuity in*

Ojibwe Crafts. Duluth: St. Louis County Historical
Society, 1984.

Garte dispels any notion that the traditional crafts of
the Ojibwa are disappearing. This catalog of an exhibition
offers an impressive cross-section of Ojibwa art, and
demonstrates that Ojibwa craft traditions are changing, but
that the artists continue to relate to the work of their
ancestors. The exhibit included Ojibwa willow baskets,
woven mats, and bags of rush, cattail, and cedar bark.

225. Gettys, Marshall. *Basketry of the Eastern United
 States.* n.p., n.d.

This is a brief overview of basketry in the eastern
United States. The text is complemented with photographs of
representative samples of basketry, line drawings, and a
bibliography.

226. Gilman, Carolyn. "Chippewa Customs: The Collection of
 Frances Densmore." *The Minnesota Archaeologist* 39.1
 (February 1980): 3-16.

In 1930 Frances Densmore, a noted anthropologist, made
a trip to Grand Portage, Minnesota to collect Chippewa
artifacts for the Minnesota Historical Society. The Frances
Densmore Collection is unusual in that it consists of
utilitarian objects of the everyday life of the Chippewa.
There are sets of tools to illustrate the processes of hide
tanning, twine making, wild rice processing, birch bark
crafts, maple sugar making, and the use of kinnikinic for
smoking.

227. Gilmore, Melvin R. "Some Chippewa Uses of Plants."
 *Papers of the Michigan Academy of Science, Arts and
 Letters* 17 (1933): 119-143.

The information in this article was obtained from
interviews with Chippewa men and women unknown to one
another and resident in different places, primarily at
Pinconning and Lapus, Michigan and in the Chippewa community
near Sarnia, Ontario. The article is a listing of plant
species and their uses by the Chippewa. Of interest to
basketry are the following: Great Bulrush (*Scirpus validus*
Vahl), bulrushes were used for weaving mats for the floors
and walls; twisted threads of basswood fiber formed the
warp. Soft Rush (*Juncus effusus*), were used for weaving
little bags, pouches, and small mats. Sandbar willow (*Salix
longifolia* Muhl), also called "kokbenognik keya," was used
for making baskets. Basswood (*Tilia americana* L.), fibers
were spun into fine yarn for weaving bags. Black ash
(*Fraxinus nigra* Marsh), was used for basket making.

228. Gogol, John M. "Potawatomi Indian Basketry." *American
 Indian Basketry* 5.1 (1985): 4-5.

Gogol describes a postcard postmarked 1912 which shows Potawatomi Indian basket makers with their large black ash splint baskets near Battle Creek, Michigan. Also illustrated are two black ash splint baskets made by Hattie Little.

229. Haltiner, Robert E. *Pioneer and Indian Basketry*. Alpena, Michigan: Jesse Besser Museum, 1980.

This is a catalog which accompanied the exhibit of "Pioneer and Indian Basketry" from the collections of the Jesse Besser Museum. It is profusely illustrated, and contains an informative description of the basketry.

230. Hatt, Marcelle R. *Basketry of North American Indians, with Notes on Michigan Canoes and Pottery*. Bloomfield Hills: Cranbrook Institute of Science, 1941.

This is a catalog of an exhibit of American Indian basketry from the collections of the Cranbrook Institute of Science. The exhibit demonstrates the range of basketry developed by American Indians north of Mexico.

231. Healy, Ginny. "The Potawatomi Basket Project." *The News Basket* 2.3 (June 1985): 18.

Healy briefly describes the Potawatomi Basket Project conducted by the Leopold Pokagon Band of Potawatomi in Dowagiac, Michigan.

232. Hilger, Sister M. Inez. "Indian Women Preparing Bulrush Mats." *Indians at Work* 2.2 (July 1, 1935): 41.

Hilger describes the manufacture of bulrush mats by the Indian women on the Red Lake Reservation in Minnesota.

233. _____. "Indian Women Making Birch Bark Receptacles." *Indians at Work* 3.3 (September 15, 1935): 19-31.

Hilger describes the manufacture of various birch bark receptacles by the Indian women of the Red Lake Reservation in Minnesota.

234. _____. "Some Phases of Chippewa Material Culture." *Anthropos* 32 (September-December 1937): 780-782.

Hilger describes the making of birch bark receptacles among the Chippewa.

235. Hoffman, W. J. *The Menomini Indians*. Annual Report of the Bureau of American Ethnology 14. Washington, D. C.: Government Printing Office, 1896, pp. 3-328.

On pages 258-263, Hoffman describes Menominee mats, baskets, twine and rope, and medicine bags. Baskets were made using the same principle of plaiting employed in the

manufacture of bark mats. Strips or osiers were made from black elm.

236. Jones, Volney H. "Notes on the Manufacture of Cedar-bark Mats by the Chippewa Indians." *Papers of the Michigan Academy of Science, Arts and Letters* 32 (1946): 341-363.

Jones describes the complete process of manufacture of a cedar-bark mat at the Garden River Reserve in Ontario, Canada.

237. _____. "Notes on the Preparation and the Uses of Basswood Fiber by the Indians of the Great Lakes Region." *Papers of the Michigan Academy of Science, Arts and Letters* 22 (1936): 1-14.

In the Great Lakes region, cordage, thongs, and weaving materials were made from the fibers, barks, and stems of several wild plants. The bast, or inner bark of the basswood tree, was one important source of material. Jones describes the gathering and preparation of the fiber of the basswood tree and the manufacture of this processed fiber into cord by the Chippewa Indians of the Walpole Island Reserve in Ontario, Canada.

238. _____. "Some Chippewa and Ottawa Uses of Sweet Grass." *Papers of the Michigan Academy of Science, Arts and Letters* 20 (1934): 23-30.

Jones describe the making of coiled baskets from sweet grass.

239. King, R. "Reviving the Lost Art of Woodland Indian Bag Weaving." *Fiberarts* 13 (March-April 1986): 27-28.

King briefly discusses the revival of weaving twined bags among some of the Great Lakes tribes.

240. Kinietz, W. Vernon. *The Indians of the Western Great Lakes, 1670-1760.* Occasional Contributions from the Museum of Anthropology, University of Michigan, no. 10. Ann Arbor: University of Michigan, 1940; reprint ed., Ann Arbor: University of Michigan, 1965.

Although Kinietz offers a broad overview of the tribes of the Great Lakes region, the use of baskets by the various tribes is only briefly mentioned.

241. Kinietz, W. Vernon and Volney H. Jones. "Notes on the Manufacture of Rush Mats Among the Chippewa." *Papers of the Michigan Academy of Science, Arts and Letters* 27 (1942): 525-538.

Mats made of bark rushes were once common throughout most of eastern North America. They have been replaced by

commercially manufactured products. Kinietz and Jones describe the making of rush mats among the Chippewa of the Great Lakes region. Jones observed the gathering and preparation of materials at the Walpole Island Reserve in Ontario, Canada in 1933. Kinietz recorded the making of mats by two Indian women at Lac Vieux Desert, Michigan in 1939.

242. Lanford, Benson L. "Winnebago Bandolier Bags." *American Indian Art Magazine* 9.3 (1984): 30-37.

Lanford describes and illustrates decorated bandolier bags made by Winnebago Indians of the western Great Lakes region.

243. Lurie, Nancy O. "Beaded Twined Bags of the Great Lakes Indians." *Bulletin of the Detroit Institute of Arts* 62.1 (1986): 39-44.

One variation of the fiber bags made by the Great Lakes Indians and neighboring tribes of the Prairie area, the beaded bag, has not been studied in detail. Lurie examined the beaded bags in the Chandler/Pohrt collection at the Detroit Institute of Arts.

244. Lyford, Carrie Alberta. *The Crafts of the Ojibwa (Chippewa).* Washington, D. C.: United States Office of Indian Affairs, Education Division, 1942; Indian Handcrafts, no. 3. Lawrence: Haskell Institute, 1943 (title changed to *Ojibwa Crafts (Chippewa)*; second edition Washington, D. C.: Department of the Interior, Bureau of Indian Affairs, Branch of Education, 1953; reprint of 1943 edition, Lawrence: Haskell Institute, 1963; 1965; and Stevens Point, Wisconsin: R. Schneider, 1982.

Basket making is discussed on pages 60-64. The art of basketry, though practiced, was not highly developed among the Ojibwa, probably because of the ease with which birch bark could be converted into containers, and of the skill of the Ojibwa in making woven bags that served for carrying and storage purposes.

245. Mason, Bernard Sterling. *Woodcraft.* New York: A. S. Barnes, 1939.

Mason describes and illustrates on pages 218-255 the various baskets, boxes, and other receptacles made from birch bark by the Chippewa.

246. Mason, Otis T. "Coiled Basketry." *Science* 15.387 (May 30, 1902): 872.

In this brief note, Mason emphatically declared that "no coiled basketry of any kind was made by Indians of North America east of the Rocky Mountains." Charles C. Willough-

by, citing coiled basketry made by the Chippewa, refuted this claim. See entry **272**.

247. Minneapolis Public Schools. *Winnebago Basketry*. St. Paul: Minnesota State Department of Education, Indian Section, 1979.

This booklet, developed for elementary students, discusses how the Winnebago weave baskets from the bark of the black ash tree. It is illustrated with line drawings. There are black and white photographs and short narratives to explain the procedure of making Winnebago baskets.

248. Nichols, Phebe Jewell. "Weavers of Grass: Indian Women of the Woodlands." *Wisconsin Magazine of History* 36 (1952-1953): 130-133.

Nichols describes the woven grass rugs made by Grandma Dutchman, a Menominee Indian. There is also a brief discussion about wall and roof matting made from cattail reeds, sweet grass baskets, and a basswood fiber bag.

249. Paxson, Barbara. "Potawatomi Indian Black Ash Basketry." *American Indian Basketry* 5.1 (1985): 6-11.

Paxson describes the recent revival of black ash splint basketry among the Potawatomi Indians of Michigan. This basketry project, organized and directed by Mark Alexis, meets each Saturday in the Potawatomi Hall. Interested students and observers learn black ash splint basketry techniques from tribal elders.

250. Peterson, Karen Daniels. "Chippewa Mat-Weaving Techniques." *Bulletin of the Bureau of American Ethnology*, no. 186. Washington, D. C.: Government Printing Office, 1963, pp. 217-285.

Peterson presents a detailed discussion about the techniques for making cedar-bark and rush floor mats, cattail lodge-cover mats, and minor mats of braided cattails and rushes. Observations are based on several fieldtrips to Chippewa reservations in Minnesota. She concludes that Chippewa mat weaving is rapidly disappearing.

251. Petrullo, Vincent M. *Decorative Art on Birch Bark Containers from the Algonquin River du Lievre Band*. Indian Notes and Monographs, Museum of the American Indian, Heye Foundation, no. 6. New York: Museum of the American Indian, Heye Foundation, 1929, pp. 225-242.

Petrullo describes and illustrates four decorated birch bark vessels collected from the River du Lievre Band of Algonquin Indians.

252. Phillips, Ruth B. "Dreams and Designs: Iconographic

Problems in Great lakes Twined Bags." *Bulletin of the Detroit Institute of Arts* 62.1 (1986): 26-37.

Phillips discusses the various problems inherent in trying to interpret the designs and motifs in Great Lakes twined bags.

253. Ritzenthaler, Robert E. "The Potawatomi Indians of Wisconsin." *Bulletin of the Public Museum of the City of Milwaukee* 19.3 (1953): 99-174.

Black ash splint baskets were being made to a limited extent chiefly by the older women. Most of the craftwork was of the limited tourist trade variety.

254. Ritzenthaler, Robert E. and Pat Ritzenthaler. *The Woodland Indians of the Western Great Lakes*. Garden City: The Natural History Press, 1970.

Baskets are briefly discussed on pages 79-80. The authors state that "among the Forest peoples birchbark containers were more extensively used than baskets, although all Woodland groups had some form of basketry."

255. Roaix, Jim. "Barking Up the Right Tree." *The News Basket* 4.2 (June 1942): 4-5.

Roaix refers briefly to the Indians' use of birch bark to make canoes and baskets. Information is provided for the novice about obtaining, preparing, and using birch bark to make baskets.

256. Schlick, Mary D. "Ojibway Chippewa Basketry: A Search for Basketmakers." *American Indian Basketry* 3.3 (1983): 15-18.

Mary D. Schlick, a basket maker, began a search for contemporary baskets made by the Chippewa and Ojibwa. She describes the basket making techniques of Margaret Aas and Verna KaykayGeesick.

257. Schneider, Richard C. *Crafts of the North American Indians. A Craftsman's Manual. New* York: Van Nostrand Reinhold Company, 1972.

Schneider discusses the crafts of the Woodland Culture Area. Detailed instructions are provided to make containers from birch bark and splint, willow, wicker work, and coiled basketry.

258. Schoewe, C. G. "Uses of Wood and Bark Among the Wisconsin Indians." *Wisconsin Archaeologist* 11 (1932): 148-152.

Schoewe briefly mentions the making of baskets from wood and bark.

259. Shippen, Herbert H. "A Woven Bulrush Mat from an
 Indian Tribe of the Great Lakes Region." *Papers of the
 Michigan Academy of Science, Arts and Letters* 39
 (1954): 399-406.

Shippen analyzes a woven bulrush mat housed in the
ethnographic collection of the Washington State Museum in
Seattle, Washington. The provenience of the mat is
uncertain. Museum records indicate it was collected in
about 1869 in Minnesota. The weaving technique is the over-
one-under-one style, with the use of two sets of warps and
the crossing of the two sets.

260. Skinner, Alanson. "Ethnology of the Ioway Indians."
 Bulletin of the Public Museum of the City of Milwaukee
 5.4 (1926): 181-354.

Woven reed mats and woven bags are discussed on pages
285-286.

261. _____. "Observations on the Ethnology of the Sauk
 Indians. Part III, Notes on Material Culture." *Bulletin
 of the Public Museum of the City of Milwaukee* 5.3
 (1925): 119-180.

On page 136, Skinner notes that the Sauk were familiar
with nettle, basswood inner bark, and cedar inner bark to
make twine for bags. Several Sauk woven yarn and vegetable
fiber bags of characteristic design are illustrated.

262. _____. *Material Culture of the Menominee*. Indian Notes

and Monographs, Miscellaneous Series, Museum of the
American Indian, Heye Foundation, no. 20. New York:
Museum of the American Indian, Heye Foundation, 1921.

Skinner describes and illustrates the various types of
woven bags and mats made by the Menominee.

263. Smith, Huron H. "Ethnobotany of the Menomini Indians."
 Bulletin of the Public Museum of the City of Milwaukee
 4.1 (1923): 1-174.

Although devoted primarily to the medicinal uses of
plants, the use of vegetable fibers and vegetable dyes in
basketry is briefly discussed. Miscellaneous uses of plants
in basketry is also discussed.

264. _____. "Ethnobotany of the Meskwaki Indians."
 Bulletin of the Public Museum of the City of Milwaukee
 4.2 (1928): 175-326.

Although devoted primarily to the medicinal uses of
plants, the use of vegetable fibers and vegetable dyes in
basketry is briefly discussed. Miscellaneous uses of plants

in basketry is also discussed.

265. _____. "Ethnobotany of the Ojibwa Indians." *Bulletin of the Public Museum of the City of Milwaukee* 4.3 (1932): 327-525.

Although devoted primarily to the medicinal uses of plants, the use of vegetable fibers and vegetable dyes in basketry is briefly discussed.

266. _____. "Ethnobotany of the Forest Potawatomi." *Bulletin of the Public Museum of the City of Milwaukee* 7.1 (1933): 1-230.

The Potawatomi made baskets and bags from the bark fiber of the white cedar and from the bark fiber of the linden. Splint baskets were made from the wood of the black ash.

267. Stowe, Gerald C. "Plants Used by the Chippewa." *The Wisconsin Archaeologist* 21.1 (1940): 8-13.

Stowe briefly states that red cedar was used for making mats, and tamarack roots were used in weaving bags.

268. Wadsworth, Beula Mary. "A Vanishing Art of the Chippewas." *Michigan History Magazine* 21.1 (Winter 1937): 69-88.

The Chippewa regarded the birch tree as sacred. Their mythical deity, Winabojo, "blessed the birch tree to the good of the human race." Many undecorated utilities were made from birch bark. Makuks, varying in size, were made from the bark of moderate size birch trees. Sweet grass was used by the Chippewa in coiled basketry. The stimulation of trade because of the use of quill decoration caused a tremendous increase in tourism. The demand for Indian crafts depleted the resources of raw materials, especially birch trees. Indian women only made a few ash splint baskets during the winter months for spending money.

269. White, John K. "Twined Bags and Pouches of the Eastern Woodlands." *Handweaver & Craftsman* 20.3 (Summer 1969): 8-10, 36-37.

Twined bags and pouches in the eastern United States ranged in size from three-by-five inches to almost three feet square. Three main types of these bags are identified. Type A is woven with a plain warp and plain wefts. Type B is woven with a colored warp and a plain weft. Type C is woven with a plain warp and a colored weft.

270. Whiteford, Andrew Hunter. "Fiber Bags of the Great Lakes Indians." *American Indian Art Magazine* 2.3 (1977): 52-64; and 3.1 (1977): 40-47, 90.

Whiteford describes and illustrates the various types of fiber bags made by Indians of the Great Lakes. In the past, fiber bags were made by most of the tribes of the Great Lakes area, and the Osage, Omaha, and Ioway of the Prairie area. Manufacture of these bags appears to have ended about 1900. In some instances, fiber panel bags were replaced by distinctly different bags made of wool yarn.

271. _____. "The Origins of Great Lakes Beaded Bandolier Bags." *American Indian Art Magazine* 11.3 (Summer 1986): 32-43.

Whiteford describes four very similar bandolier bags, which are considred important because of their style, possible documentation, and early dates. He relates the bags to each other and earlier styles of shoulder bags.

272. _____. "Tapestry-Twined Bags, Osage Bags and Others." *American Indian Art Magazine* 3.2 (Spring 1978): 32-39.

Whiteford suggests that the yarn bags of the western Great Lakes and those of the Prairie area developed from the same prehistoric sources. At a later date, they were still affected by close interaction. He demonstrates that at the outer edge of their geographic distribution, Chippewa bags of the northern Woodlands continued to be distinctive in designs and in some twining techniques from the Osage and Omaha bags of the Prairie area.

273. Willoughby, Charles C. "Coiled Basketry." *Science* 16 (1902): 31-32.

Noting the paucity of prehistoric basketry remains in burials east of the Rocky Mountains, Willoughby suggested that contemporary tribes be studied for evidence of earlier types of coiled basketry. He cites specimens of coiled basketry in the Peabody Museum at Cambridge, which were obtained from the Ojibwa Indians. These baskets were made of sweet grass.

Plains

274. Anonymous. "Basket Makers in Oklahoma." *El Palacio*
 27.11 and 12 (1929): 187-188.

 Briefly mentions the discovery of Basketmaker artifacts
in a cave near Kenton, Oklahoma. Fragments of baskets were
found.

275. Baerreis, David A. "Spiro Focus Basketry." *The Museum
 of the University of Oklahoma, Circular* 2 (1947): 1-12.

 Baerreis discusses the basketry techniques represented
at three sites: Spiro, Norman, and Hughes.

276. Brown, James A. "The Artifacts." *Spiro Studies,* no. 4.
 Norman: University of Oklahoma, Stovall Museum of
 Science and History, 1976.

 Brown describes fragmentary basketry remains from Spiro
Mound. He suggests that "one should look to the Chitimacha
basketry of the Mississippi Lowland to recognize aspects of
what was present at Spiro."

277. Cooke, Anne M. "The Material Culture of the Northern
 Ute." Master's thesis, Yale University, 1937.

278. Culin, Stewart. "Games of the North American Indians."
 Annual Report of the Bureau of American Ethnology 24.
 Washington, D. C.: Government Printing Office, 1907.

 Various types of baskets used in the games of North
American Indians are discussed.

279. Dillingham, Betty Ann Wilder. "Oklahoma Kickapoo."
 Ph.D. dissertation, University of Michigan, 1963.

 A few of the older women still used the old basketry
techniques to weave mats for the scaffolds inside the house,

but these are rare today. Rarer still are baskets them-
selves, there being no one known to Dillingham who made them
in Oklahoma, although there were some in use that had been
brought up from Mexico.

280. Douglas, Frederic H. *An Hidatsa Burden Basket*. Denver
 Art Museum, Material Culture Notes, no. 14. Denver:
 Denver Art Museum, 1941; reprint ed., *Material Culture
 Notes* (Denver: Denver Art Museum, 1969), pp. 80-86.

 This basket was collected by Edward S. Curtis among the
Hidatsa at Fort Berthold, North Dakota in 1908. Douglas
states that the basket cannot be positively identified as
Hidatsa because the Mandan and Arikara made baskets which
were nearly identical.

281. Dutton, Bertha P. "Martin Basketry Collection." *El
 Palacio* 49.6 (1942): 126-127.

 Dutton describes the Jicarilla Apache basket collection
purchased by the Museum of New Mexico from Dr. T. P. Martin
of Taos, New Mexico.

282. Ewers, John C. *Blackfeet Crafts*. Indian Handcrafts,
 no. 9. Washington, D. C.: United States Department of
 the Interior, Branch of Education, 1945.

 Although some of the Blackfeet men began to make bas-
kets during the Great Depression, Ewers does not mention
basketry among their crafts.

283. Farr, William E. *The Reservation Blackfeet, 1882-
 1945. A Photographic History of Cultural Survival*.
 Seattle: University of Washington, 1984.

 Although the Blackfeet had no basket making tradition,
one of the moonlight school instructors, Mae Vallance,
showed the men how to make baskets; and it came to be a
masculine diversion for some during the years of the Great
Depression. There is a photograph of John Little Blaze, No
Coat, and Sure Chief making baskets in front Heart Butte
Round Hall in 1932. For additional information see *Material
Culture of the Blackfoot Indians*, Anthropological Papers,
American Museum of Natural Histry, no. 7, part 2. New York:
American Museum of Natural History, 1912.

284. Frison, George, James M. Adovasio, and Ronald C.
 Carlisle. "Coiled Basketry from Northern Wyoming."
 Plains Anthropologist 31.112 (1986): 163-167.

 Frison, Adovasio, and Carlisle discuss the coiled
basketry remains from numerous archaeological sites in
northern Wyoming.

285. Gilmore, Melvin R. "Arikara Basketry." *Indian Notes,
 Museum of the American Indian, Heye Foundation*

2.2. New York: Museum of the American Indian, Heye
Foundation, 1925, pp. 89-95.

Gilmore describes several Arikara baskets made
especially for the Museum of the American Indian by an old
woman commonly known as Snow. He also provides information
about the various steps in making Arikara burden baskets
from the black willow (*Salix nigra* Marsh).

286. _____. "Arikara Fish-Trap." *Indian Notes, Museum of
the American Indian, Heye Foundation* 1.3. New York:
Museum of the American Indian, 1924, pp. 120-134.

Gilmore describes and illustrates a twined willow fish-
trap and a large fish basket used to dip the fish out of the
trap.

287. _____. "Some Native Nebraska Plants with Their Uses by
the Dakota." *Collections of the Nebraska Historical
Society* 7 (1913): 358-370.

Gilmore discusses the uses of plants native to Nebraska
by the Dakota Indians.

288. _____. "Uses of Plants by the Indians of the Missouri
River Region." *Annual Report of the Bureau of American
Ethnology* 33. Washington, D. C.: Government Printing
Office, 1919, pp. 43-154.

Gilmore identifies and discusses the various uses of
plants by the Indians of the Missouri River region.
However, no mention is made of basketry.

289. Gruhn, Ruth. "Notes on Material Culture from a Burial
Along the Snake River in Southwest Idaho." *Tebiwa:
Journal of the Idaho State University Museum* 4 (1961):
37-39.

This site is located in Canyon County, Idaho along the
Snake River. It may be Bannock.

290. Lowie, Robert H. "Crow Indian Art." *Anthropological
Papers, American Museum of Natural History* 21 (1922):
271-322.

There is no mention of basketry.

291. Miles, Charles. "Burden Baskets." *Hobbies: the Maga-
zine for Collectors* 78.9 (November 1973): 144-145.

Burden baskets were carried on the back, usually held
in place by a long strap or band which passed across the
forehead. Miles briefly describes the burden baskets of the
Northwest Coast tribes and the Plains Indians.

292. Schneider, Mary Jane. "An Investigation into the Ori-

gins of Arikara, Hidatsa, and Mandan Twilled Basketry."
Plains Anthropologist 29.106 (1984): 265-276.

Plains Indian basketry is generally divided into two
types: coiled gambling baskets of wide distribution and
twilled baskets used by the Arikara, Hidatsa, and Mandan wo-
men. Schneider examines the origins of the twilled baskets
used by the Northern Plains peoples based on historical re-
ferences, published descriptions, fieldnotes, and museum
specimens. Four hypotheses concerning possible origins are
proposed and tested. The assumption that the basket making
techniques of these tribes originated in the Southeast is
examined and rejected. Hypotheses concerning Caddoan or Eu-
ropean origins for the basketry are also rejected. Evidence
for local origin is presented.

293. Smith, Victor J. "Some Unusual Basketry and Bags from
the Big Bend Caves." *Bulletin of the Texas Archeologi-
cal and Paleontological Society* 13 (1941): 133-151.

Smith provides a general description of the widely dis-
tributed split-stitch type of basket. A basin-shaped con-
tainer is considered to be a basic utensil for all of the
Greater Big Bend Cave Dweller groups. Various other forms
and techniques of basketry in this area are discussed, in-
cluding variations from split-stitch, twined, netting, and
checker.

294. Weltfish, Gene. "Coiled Gambling Baskets of the Pawnee
and Other Plains Tribes." *Indian Notes, Museum of the
American Indian, Heye Foundation* 7.3. New York: Museum
of the American Indian, Heye Foundation, 1930, pp. 277-
295.

Coiled gambling baskets were used in dice games by se-
veral Plains tribes. They are usually small coiled recepta-
cles about six inches in diameter and two or three inches
deep. Weltfish suggests that the Plains tribes are essenti-
ally non-basket making peoples. Except for the plaited
burden baskets of the Arikara and Hidatsa, small gambling
baskets had been the only baskets collected from these
groups. Weltfish learned in 1929 that a few Pawnee women
still made gambling baskets. Weltfish concluded, after com-
paring these baskets with other Plains tribes, that either
there are two types--a Pawnee and a Shoshone; or the Plains
gambling baskets can be considered a single technical com-
plex.

295. Wilson, Frederick. "Hidatsa Basket-making." Field
Report--Fort Berthold Reservation, vol. 29, pp. 1-27.
Gilbert L. Wilson Papers, Minnesota Historical Society.

Frederick, the brother of Gilbert L. Wilson, carefully
observed and recorded the making of a Hidatsa basket by Buf-
falo Woman. His unpublished manuscript remains in the Gil-
bert L. Wilson Papers at the Minnesota Historical Society.

296. Wilson, Gilbert L. "Agriculture of the Hidatsa Indian,
 an Indian Interpretation." *Studies in the Social Sci-
 ences, The University of Minnesota*. Minneapolis: The
 University of Minnesota, 1917.

 An informant describes the use of the Scrotum basket.
This type of basket was made from the scrotum of the buffa-
lo, and was used for picking tobacco blossoms. A fresh
scrotum was taken, and a rim or hoop of choke-cherry wood
was bound around its mouth; choke-cherry limbs are flexible
and easily bent. The hoop was sewed in place with sinew
passing through the skin and around the hoop spirally. A
thong was bound at either end to opposite sides of the hoop,
and the whole was hung upon the drying stage, or at the en-
trance to the earth lodge in the sun. The skin was then
filled with sand until dry. When it was emptied, the thong
was removed, and a band, or leather handle, was bound on one
side of the hoop, at places a few inches apart, and the bas-
ket was ready for use. The informant's name was Goodbird.
A sketch made by Goodbird depicts the scrotum basket.

Great Basin

297. Adovasio, James M. "Basketry from Swallow Shelter (42Bo268)." In *Swallow Shelter and Associated Sites,* pp. 167-169. Edited by Gardiner F. Dalley. University of Utah Anthropological Papers, no. 96. Salt Lake City: University of Utah, 1976.

Adovasio describes seventeen pieces of identifiable coiled basketry recovered from Swallow Shelter in 1970. He concludes that, with one exception, basketry techniques from this site are typical of the eastern Great Basin.

298. _____. "Fremont Basketry." *Tebiwa: Journal of the Idaho State University Museum* 17.2 (1975): 67-76.

The Fremont Culture developed in what is now the state of Utah and specific contiguous areas from approximately A.D. 400 to 1300. Fremont basketry is considered as a unit to be the most distinct variety of prehistoric basketry in the entire Great Basin, with the exception of Lovelock wickerware. There are two sub-classes of basket weavers represented in Fremont basketry. These are coiling and twining. Included in this article is an index of descriptive technical terminology.

299. _____. "Hogup Cave Textiles." In *Hogup Cave,* pp. 133-153. Edited by C. Melvin Aikens. University of Utah Anthropological Papers, no. 93. Salt Lake City: University of Utah, 1970.

During the 1967-1968 excavations at Hogup Cave, 160 pieces of basketry were recovered. The collection included both twined and coiled specimens. Adovasio concludes that twining is the oldest textile technique in the Great Basin. Coiling appeared later, but became more popular. All varieties of coiling were simple variations of one-rod and welt; and most of the prehistoric textile techniques at Hogup Cave continued in use to the present in one or another of the

Great Basin and Southwestern groups.

300. _____. "The Origin, Development and Distribution of Western Archaic Textiles." *Tebiwa: Journal of the Idaho State University Museum* 13.2 (1970): 1-40.

Adovasio, who analyzed over 5,000 specimens of coiled, plaited, and twined basketry, identifies three major Western Archaic textile complexes. These are the Oregon Complex, the Western Nevada Complex, and the Eastern Basin Complex. Taken as a unit, the three complexes exhibit a variety of basic relationships to other later textile complexes in western North America. The three Western Archaic textile complexes may be considered as the major early centers and ultimate stimuli of most textile production in western North America.

301. _____. "Prehistoric Basketry." In *Great Basin*, pp. 194-205. Volume editor Warren L. D'Azevedo. *Handbook of North American Indians*, vol. 11. Edited by William C. Sturtevant. Washington, D. C.: The Smithsonian Institution, 1986.

Adovasio describes the prehistoric basketry of the Northern Basin Basketry Region, the Western Basin Basketry Region, and the Eastern Basin Basketry Region.

302. _____. "Prehistoric Basketry of Western North America and Mexico." In *Early Native Americans: Prehistoric Demography, Economy and Technology*, pp. 341-362. Edited by David L. Browman. Mouton: The Hague, 1980.

Adovasio considers basketry as coiled, twined, and plaited containers, regardless of flexibility, and matting of all types. Western North America refers to the continental United States west of the Mississippi River and also includes Mexico from the Rio Grande to the Yucatan Peninsula. Based on a first-hand examination of 30,000 examples of basketry from the above area, Adovasio discusses each region and provides a general overview of all areas where firm developmental sequences are available. He concludes that the manufacture of basketry was established in several parts of Western North America and Mexico by 8,000-7,000 B.C. California and the Great Plains are the exceptions. Available data for California is incomplete. Basketry was apparently introduced into the Great Plains at a fairly late date.

303. _____. "Prehistoric Great Basin Textiles." In *Irene Emery Roundtable on Museum Textiles 1974 Proceedings*, p. 141. Edited by Patricia L. Fiske. Washington, D. C.: The Textile Museum, 1975.

Adovasio identifies three major prehistoric Great Basin textile manufacturing centers. These are the Northern, Western, and Eastern Centers. In this area, textile manufacturing dates back to 9,000 B.C. Twining was the earliest

technique. Early coiling was restricted to the Eastern Basin, appearing there about 2,000 years earlier than in the other centers.

304. _____. "Prehistoric North American Basketry." In *Collected Papers on Aboriginal Basketry*, pp. 98-148. Edited by Donald R. Tuohy and Doris L. Rendall. Nevada State Museum Anthropological Papers, no. 16. Carson City: Nevada State Museum, 1974; reprint ed., 1983.

Adovasio presents a broad overview of the evolution of basketry manufacture in North America. In addition, he discusses the methodology of basketry analysis, cleaning and stabilizing basketry materials, and highlights the potential value of and problems associated with the study of basketry.

305. _____. "Some Comments on the Relationship of Great Basin Textiles to Textiles from the Southwest." *University of Oregon Anthropological Papers*, no. 1 (1971): 103-108.

Adovasio discusses the relationship of Great Basin textiles to materials in the Southwest. In the early 1960s, Alexander Lindsay and his associates discovered an early pre-Basketmaker II occupation in the Rainbow Plateau area of southern Utah and northern Arizona. The Desha Complex contained the earliest textiles in the southwestern area. Lindsay found eighteen pieces of closely coiled, one rod foundation basketry sewn with an interlocking stitch. Adovasio argues that this technique diffused southward from Utah. Southwestern textiles, he concludes, were local developments which were stimulated very early by diffusion from the eastern Great Basin. Southwestern basketry was later influenced by developments in Mexico, especially the appearance of bundle foundation coiling and twilling.

306. Adovasio, James M. and R. L. Andrews. "Material Culture of Gatecliff Shelter: Basketry, Cordage and Miscellaneous Fiber Constructions." In *The Archaeology of Monitor Valley 2. Gatecliff Shelter*, pp. 279-289. Edited by D. H. Thomas. Publications of the American Museum of Natural History, vol. 59. New York: American Museum of Natural History, 1983.

Adovasio and Andrews discuss thirty-five perishable artifacts excavated at Gatecliff Shelter and throughout Monitor Valley. They conclude that most of the basketry and the associated perishable material recovered from Monitor Valley are the products of prehistoric Shoshonean peoples.

307. Adovasio, James M., R. L. Andrews, and R. Carlisle. *Perishable Industries from Dirty Shame Rockshelter*. Tebiwa: Miscellaneous Papers of the Idaho State University Museum of Natural History, no. 7. Pocatello: Idaho State University, 1977.

The manufacture of basketry, sandals and cordage at Dirty Shame Rockshelter is discussed in terms of process and product.

308. Adovasio, James M., Rhonda L. Andrews, and Ronald C. Carlisle. "The Evolution of Basketry Manufacture in the Northern Great Basin." *Tebiwa: Journal of the Idaho State University Museum* 18.2 (1976): 1-8.

An analysis of recovered basketry specimens from Dirty Shame Rock Shelter, located in the northern Great Basin, provided the basis for a reconstruction of the major trends in the development of basketry in this region. The authors identified four sequent stages. In Stage I, basketry production began in the form of open and close simple twining with no decorative embellishment. During Stage II, diagonal twining appeared. In Stage III, the earlier trends continued, with the addition of "S" twist weft patterns. There were many types of decorative embellishment in the twining. In Stage IV, coiling appears only in minor quantities. It resembles the contemporary coiling from the western Nevada area.

309. Amsden, Charles. "Navajo Origins." *New Mexico Historical Review* 7 (1932): 193-209.

Shoshonean basketry is briefly mentioned.

310. Anonymous. "Basket Weaving: A Unique Art." *Weewish Tree* 1.5 (1973): 11-13.

Written for juveniles, this brief article contains an illustration of a Karok carrying basket and a basket made by Dat-So-La-Lee.

311. _____. "Basketmaker Cave in Utah." *El Palacio* 13 (1922): 52-54.

Discusses artifacts from Cave du Pont near Kanab, Utah.

312. _____. "The Basketry of Dat-So-La-Lee." *Nevada Magazine* 3 (1948): 8-9.

This is a brief description of Dat-So-La-Lee and her baskets.

313. _____. "Dat-So-La-Lee. Greatest of the Basket Makers." *Nevada Highways and Parks* 17 (1957): 18-19.

This is a brief commentary about Dat-So-La-Lee and her baskets. There is a photograph of her standing between two baskets.

314. _____. "An Introduction to the Old Indian Basket." *The Indian Trader* 4.6 (1973): 1, 16, 24-27.

Briefly mentions the work of Dat-So-La-Lee.

315. _____. "Mary Pepo, Paiute Basket Maker." *Indians* at *Work* 9.4 (December 1941): 19.

This is a photograph of Mary Ann Pepo, a Paiute basket maker.

316. _____. "The Most Beautiful Basket." *Masterkey* 25 (1951): 68.

Contains a note about Dat-So-La-Lee, along with a photograph of this famous Washoe basket maker.

317. _____. "Washoe Baskets." *Papoose* 1.4 (February 1903): 15-16.

Describes the basket work of Dat-So-La-Lee.

318. Bates, Craig D. "Beaded Baskets of the Paiute, Washo, and Western Shoshoni." *Moccasin Tracks* 5.1 (October 1979): 4-7.

Bates examines the introduction of the idea of covering a basket with glass seed beads in a netted fashion among the Paiute, Washoe, and western Shoshone.

319. Baumhoff, Martin A., and Robert F. Heizer. "Outland Coiled Basketry from the Caves of West Central Nevada." In *Current Views on Great Basin Archaeology*, pp. 49-59. University of California Archaeological Survey Reports, no. 42. Berkeley: University of California, 1958.

Baumhoff and Heizer, who had excavated specific types of basketry material from caves in west central Nevada, termed the specimens "Outland Coiled" basketry. There were three types of this fine coiled basketry, based upon foundation structure and stitching techniques. The "rod-bundle foundation, split stitch type" was decorated with feathers. The "rod-bundle, interlocking stitch" and "single-rod foundation, interlocking stitch" were not decorated with feathers. All three types were grouped together by Baumhoff and Heizer. They argued that this type of fine coiled basketry originated outside Nevada, most likely in California.

320. Bernstein, Bruce. "Panamint Shoshone Coiled Basketry: A Definition of Style." *American Indian Art Magazine* 4.4 (Autumn 1979): 69-74.

Bernstein defines the traditional (at the time of contact) coiled basketry style of the Panamint Shoshone.

321. _____. "Panamint-Shoshone Basketry 1890-1960: The Role of Basket Materials in the Development of a New Style." *American Indian Basketry* 5.3 (1985): 4-11, 29.

Panamint-Shoshone basketry began to change in the early 1900s. By 1930, these changes in materials, shapes, designs and functions were completed. Bernstein distinguishes three phases in Panamint-Shoshone baskets: traditional (1890-1910), transitional (1910-1930), and late (1930-1960). He concludes that although Panamint-Shoshone baskets appeared to have changed dramatically, the materials and weaving techniques were basically unchanged, while only the shapes and designs were altered.

322. Brave, Joanna. "Basketry of the Paiute and Washoe Indians." *Indians at Work* 4.3 (September 15, 1936): 45-46.

Brave briefly describes the types of baskets made by the Paiute and Washoe. Dat-So-La-Lee is mentioned.

323. Cohn, C. Amy. "Arts and Crafts of the Nevada Indians." *Nevada Historical Society, Biennial Reports*, no. 1 (1909): 75-79.

Basketry and other items of material culture are described.

324. Cohodas, Marvin. "The Breitholle Collection of Washoe Basketry." *American Indian Art Magazine* 9.4 (1984): 38-49.

Cohodas describes and illustrates Washoe Indian baskets in the private Breitholle Collection. Most of the baskets were made by Louisa Keyser and Tootsie Dick.

325. _____. "Dat So La Lee's Basketry Designs." *American Indian Art Magazine* 1.4 (Autumn 1976): 22-31.

Cohodas demonstrates that Dat-So-La-Lee developed two radically different solutions during her career concerning the compositional unity of her *degikup* baskets. During her classic period, Dat-So-La-Lee imposed an open, infinite, and checkerboard-like arrangement on the surface of the basket. In her late period, she massed the simpler and more solid motifs into groups of bands which incorporated the background space, forming a definite design.

326. _____. "Dat So La Lee and the 'Degikup'." *Halcyon: a Journal of the Humanities* 4 (1982): 119-140.

Abe Cohn and his Emporium Company in Carson City, Nevada marketed the *degikup*, fine-coiled baskets made by Dat-So-La-Lee (Louisa Keyser), 1895-1935. Contrary to Cohn's advertising, the baskets were not part of a long preserved Washoe tradition, but were adaptations of Washoe and Pomo designs.

327. _____. *Degikup: Washoe Fancy Basketry 1895-1935*. Van-

couver: Fine Arts Gallery, University of British Columbia, 1979.

This catalog contains a well-written text and photographs and descriptions of hundreds of Washoe baskets. In addition to providing an excellent history of Washoe basketry, Cohodas highlights the work of nine famous weavers, including the most famous of all Washoe weavers, Dat-So-La-Lee.

328. _____. "Lena Frank Dick: An Outstanding Washoe Basket Weaver." *American Indian Art Magazine* 4.4 (1979): 32-41, 90.

Cohodas explores the life and career of Lena Frank Dick (1889-1965), a largely unknown but exceptional basket weaver from Coleville, California.

329. _____. "Sarah Mayo and Her Contemporaries: Representational Designs in Washoe Basketry." *American Indian Art Magazine* 6.4 (Autumn 1981): 52-59, 80.

Cohodas discusses Sarah Mayo's introduction of representational designs among the Washoe basket makers in about 1905. This style was in accord with the innovative nature of Washoe fancy basketry style. Cohodas discusses the work of Sarah Mayo, and Maggie James and Lillie James who were two contemporary weavers.

330. _____. "Washoe Basketry." *American Indian Basketry* 3.4 (1983): 4-30.

Washoe basketry attained its peak of technique and style between 1895 and 1935. The harsh years of the Great Depression, the loss of jobs, the welfare system, and attendance in the public educational system caused a decline in traditional Washoe culture. The recorded history of Washoe basketry focuses on three areas: Carson Valley, Antelope Valley, and Carson City. The Washoe used coiling and twining techniques to make a variety of baskets. Coiled basketry became the focus of the fancy curio style, and was developed into a sophisticated art style by Dat-So-La-Lee. Cohodas discusses the relationship between Dat-So-La-Lee and Abram Cohn and Amy Cohn. Washoe basketry is discussed, with an emphasis on forms, techniques, styles, and historical developments.

331. _____. "The Washoe Florescence 1895-1935." *Vanguard* 8.5 (1979): 6-10.

Cohodas briefly summarizes the development of Washoe basketry between 1895-1935. The achievements of Dat-So-La-Lee are discussed.

332. _____. "Washoe Innovators and Their Patrons." In *The Arts of the North American Indian: Native Traditions*

in Evolution, pp. 203-220. Edited by Edwin L. Wade. New York: Hudson Hills Press, 1986.

Washoe fancy basketry, promoted by collectors and dealers of Indian curios, owed very little to traditional techniques, forms, or designs. Cohodas demonstrates that differences in basketry style often reflected differences in life-style and patronage of the basket makers. He discusses the contributions of Dat-So-la-Lee, Sarah Mayo, Maggie James, Tootsie Dick, and Lena Frank Dick.

333. Cressman, L. S., with the collaboration of Frank C. Baker, Paul S. Conger, Henry P. Hansen, and Robert F. Heizer. *Archaeological Researches in the Northern Great Basin*. Carnegie Institution of Washington, Publication 538. Washington, D. C.: Carnegie Institution of Washington, 1942.

Coiled and twined baskets from the northern Great Basin are thoroughly discussed. The number of twined basketry specimens vastly out-numbered the coiled specimens.

334. D'Azevedo, Warren and Thomas Kavanaugh. "The Trail of the Missing Basket." *Indian Historian* 7.4 (1974): 12-13.

D'Azevedo and Kavanaugh narrate the search for a ceremonial basket given to the State Legislature of Nevada in 1914, which was accompanied by a petition from a tribe of Washoe Indians requesting aid.

335. Dick, Herbert W. *Bat Cave*. The School of Research, Monograph, no. 27. Santa Fe: The School of American Research, 1965.

Fourteen basketry specimens were recovered from Bat Cave. There were two complete baskets and twelve charred fragments. With the exception of one twilled basket, all of the baskets were coiled.

336. Emporium Company. *How the L. K. Baskets are Made: Dat-So-La-Lee, Her Life and Work*. Los Angeles: Le Berthon, 1905.

This is a very early work about Louisa Keyser and her baskets.

337. _____. *The Queen of Basketry: Louisa Keyser*. San Francisco: Francis Valentine Company, 1900.

Describes the basket work of Louisa Keyser.

338. Fenenga, Franklin. "A Washo Pine Nut Camp in Douglas County, Nevada." *Journal of California Anthropology* 2 (1975): 205-213.

Fenenga discusses the discovery in 1939 of Indian implements in a contemporary Washoe pine nut camp in Douglas County, Nevada, and describes the weave structure of baskets used for gathering pine nuts.

339. Fowler, Catherine S. and Lawrence E. Dawson. "Ethnographic Basketry." In *Great Basin*, pp. 705-737. Volume editor Warren L. D'Azevedo. *Handbook of North American Indians*, vol. 11. Edited by William C. Sturtevant. Washington, D. C.: The Smithsonian Institution, 1986.

Fowler and Dawson discuss the traditional baskets of the Great Basin groups used at the pre- or immediate post-contact period. They illustrate the common core of forms and techniques within the various Great Basin groups.

340. Gifford, Edward W. "Northeastern and Western Yavapai." *University of California Publications in American Archaeology and Ethnology*, no. 34, pp. 247-354. Berkeley: University of California, 1936.

Basketry is briefly discussed on pages 281-283.

341. Gigli, Jane G. "Dat-So-La-Lee, Queen of the Washoe Basketmakers." In *Collected Papers on Aboriginal Basketry*, pp. 1-27. Edited by Donald R. Tuohy and Doris L. Rendall. Salt Lake City: Nevada State Museum, 1974; reprinted 1983.

The story of Dat-So-La-Lee, the most famous of Washoe basket makers, is briefly told. Gigli discusses the design of baskets, weaving materials, and the method of construction of Dat-So-La-Lee's baskets. This article originally appeared as Jane Green Hickson, *Dat-So-La-Lee, Queen of the Washo Basket Makers*, Nevada State Museum, Popular Series, no. 3. Salt Lake City: Nevada State Museum, 1967.

342. Goodman, Stacy. "Material Culture: Basketry and Fiber Artifacts." In *The Archaeology of Hidden Cave, Nevada*, pp. 262-298. Edited by David H. Thomas. Anthropological Papers of the American Museum of Natural History, no. 61.1. New York: American Museum of Natural History, 1985.

A total of 122 basketry fragments were recovered from Hidden Cave. These fragments included twined, coiled, and plaited weaving techniques. The basketry from Hidden Cave is representative of the various techniques known to occur in the western Great Basin.

343. Goodrum, Janet. "The Famous Great Basin Piute Mush Basket." *Pacific Historian* 21 (1977): 245-247.

This mush basket is one of the most interesting in the western United States. Its design is based on the origin beliefs of the Paiute people. This type of basket is also

used by the Navajo and Apache.

344. Gordon, G. B. "The Richard Waln Meirs Collection."
 Museum Bulletin, University of Pennsylvania 10 (1919):
 26-28.

 Washoe baskets are part of the Meirs Collection. Two
illustrations and mention of raw materials and an interpre-
tation of designs are included in the discussion.

345. Harrington, Mark R. "Unique Among Baskets." *Masterkey*
 29 (1955): 174.

 This is a notice about a donation by Maxine M. Rapp of
a Chemehuevi and Southern Paiute basketry collection to the
Southwest Museum. Illustrated is a Chemehuevi basketry hat.

346. _____. "A Use for Paiute Beaded Baskets." *Masterkey*
 36.4 (1962): 142.

 A note in this beaded basket presented to the Southwest
Museum indicates that it was used in a Paiute puberty cere-
mony. The note reads: "The female child budding into wo-
manhood at the age of about thirteen years is confined in
the house (or campoodie) four days without food or water.
On the fourth day as the members of the tribe are indulging
in the coming-out dance the beaded basket is thrown in the
midst of the participants to be caught and preserved as a
souvenir of the event. On the fourth day the girl is doused
with bucketsful of cold water, making her strong and hearty,
a full fledged Indian woman ready to perform all designed
tasks."

347. Herold, Joyce. "Havasupai Basketry: Theme and Varia-
 tion." *American Indian Art Magazine* 4.4 (Autumn 1979):
 42-53.

 Herold discusses the developing themes and variations
in basketry in the past 100 years among the Havasupai.

348. _____. "One Hundred Years of Havasupai Basketry." *Pla-
 teau* 53 (1982): 14-21.

 Herold describes the basic forms of Havasupai basketry
and discusses their study by ethnographers since the tribe
first attracted anthropological attention in the 1880s.

349. Hewitt, Nancy J. "Fiber Artifacts." In *Cowboy Cave*,
 pp. 49-74. Edited by Jesse D. Jennings. University of
 Utah Anthropological Papers, no. 104. Salt Lake City:
 University of Utah Press, 1980.

 Hewitt discusses and illustrates seventy-three pieces
of basketry recovered from Cowboy and Walter Caves. All
pieces were fragmentary; consequently, no vessel shapes
could be determined.

350. James, George Wharton. "Basketmakers of California at Work." *The Basket* 1 (1903): 2-18.

James discusses Washoe, Northern Paiute, and Southern Paiute baskets.

351. Jett, Stephen C. *Interwoven Heritage: A Bicentennial Exhibition of Southwestern Indian Basketry and Textile Arts, Featuring the C. Hart Merriam Collection of Baskets and the Stephen C. Jett Collection of Navajo Weaving.* Davis: University of California, Davis, Memorial Union Art Gallery, 1976.

Jett describes the C. Hart Merriam Collection of baskets which was acquired by the Department of Anthropology at the University of California, Davis in 1960. Most of the collection consists of basketry from the Pacific Coast states and Nevada. This is a catalog of the exhibit.

352. Lamb, Frank W. *Indian Baskets of North America.* La Pine: Rubidoux Publications, 1972; 1976; 1981; and 1985.

Baskets of the Great Basin are discussed on pages 77-91.

353. Loeb, Barbara. "Mirror Bags and Bandolier Bags: A Comparison." *American Indian Art Magazine* 6.1 (Winter 1980): 46-53, 88.

Loeb, comparing bandolier bags with classic mirror bags generally attributed to the Crow Indians, attempts to pinpoint a sub-group of beadwork that looks like Crow but can be documented as being Plateau or Great Basin in origin. She suggests that the bandolier bag is a Plateau-Great Basin product.

354. Loud, Llewellyn and Mark R. Harrington. "Lovelock Cave." *University of California Publications in American Archaeology and Ethnology* 25 (1929).

After 250 tons of bat guano had been removed from Lovelock Cave in west central Nevada, L. L. Loud conducted an archaeological investigation. Over 1,500 fragments of basketry and 1,400 of matting were recovered. In 1924, Mark R. Harrington conducted further excavations under the auspices of the Museum of the American Indian, Heye Foundation. Wicker, coiled and twined basketry are discussed on pages 60-70.

355. Lummis, Charles F. "A California Illustrator. L. Maynard Dixon and His Work." *The Land of Sunshine* 10.1 (1898): 4-11.

On page 6 there is an illustration of a "Digger Basket-

Weaver."

356. MacNaughton, Clara. "Nevada Indian Baskets and Their
 Makers." *Out West* 18.4 (April 1903): 433-439 and 18.5
 (May 1903): 579-584.

This is a discussion about Washoe basketry, with some
attention given to Dat-So-La-Lee.

357. Myles, Myrtle T. "Washo Baskets." *Overland Monthly*
 88.9 (September 1930): 265, 287.

Myles briefly mentions a Washoe basket maker working on
a basket. She refers to the artistry of Dat-So-La-Lee and
the carelessness of less-skilled basket makers among the
Washoe. She includes an illustration of several Washoe bas-
kets.

358. Nusbaum, Jesse. *A Basket Maker Cave in Kane County,
 Utah.* Indian Notes and Monographs, Miscellaneous Ser-
 ies, Museum of the American Indian, Heye Foundation,
 no. 29. New York: Museum of the American Indian, Heye
 Foundation, 1922.

Nusbaum describes and illustrates approximately thirty
fragments of coiled basketry. It is a two-rod bundle tech-
nique. Also discussed are numerous remnants of mats.

359. Orr, Phil C. "Notes on the Archaeology of the Winne-
 mucca Cave, 1952-58." In *Collected Papers on Aboriginal
 Basketry*, pp. 47-59. Edited by Donald R. Tuohy and
 Doris L. Rendall. Nevada State Museum Anthropological
 Papers, no. 16. Carson City: Nevada State Museum,
 1974; reprinted 1983.

Orr provides radiocarbon dates for the human habitation
of a group of caves on the northeast shore of Lake Winnemuc-
ca. Included are basketry fragments of Catlow twine and
two-strand cordage and a piece of matting.

360. Patterson, Edna B. "Mary Hall: Western Shoshone Bas-
 ketmaker." *Quarterly, Northeastern Nevada Historical
 Society* 85.4 (1985): 102-115.

Patterson provides biographical details about Mary
Hall, and describes her baskets. The craftwork of Hall's
daughters is also discussed.

361. Reagan, Albert E. "The Basket Makers and the People of
 the Ancient Culture of the Fremont River in Utah."
 Northwest Science 7 (1933):

Reagan investigated the relationship between the Bas-
ketmaker Culture and the Fremont Culture of the Fremont Ri-
ver in Utah. He delineated the features of these ancient
Fremont people, and termed their culture as Basketmaker IV.

Reagan suggested that the term Basketmaker be changed to Utioux, and the stages of that culture be designated as Utioux I, Utioux II, Utioux III, and Utioux IV.

362. Rossbach, Ed. "Thinking About Historical Baskets."
 Fiberarts 11.1 (January-February 1984): 32-33, 70.

Rossbach, reflecting on the aspects of survival of primitive peoples living in extremely harsh environments, briefly describes two books which present this theme: *The Survival Arts of the Primitive Paiutes* and *Basketry of the Papago and Pima*.

363. Rozaire, Charles E. "An Analysis of Woven Materials from Seven Caves in the Lake Winnemucca Area, Pershing County, Nevada." In *Collected Papers on Aboriginal Basketry*, pp. 60-97. Edited by Donald R. Tuohy and Doris L. Rendall. Nevada State Museum Anthropological Papers, no. 16. Carson City: Nevada State Museum, 1974; reprinted 1983.

Rozaire discusses basketry specimens recovered by Phil C. Orr and James W. Calhoun between 1952 and 1958 from seven caves on the northeastern shore of Lake Winnemucca. The basketry items were organized on the basis of weaving technique and according to function and form. The assemblage contains twining, coiling, and plaiting basketry. The basic techniques are, in turn, sub-divided into such categories as basketry, bags, matting, and sandals.

364. _____. "The Chronology of Woven Materials from the Caves at Falcon Hill, Washoe County, Nevada," pp. 182-186. In *Miscellaneous Papers on Nevada Archaeology*. Edited by Doris L. Rendall and Donald R. Tuohy. *Miscellaneous Paper*, 8. *Nevada State Museum Anthropological Papers*, no. 14. Carson City: Nevada State Museum, 1969.

Eleven caves and shelters were discovered in Falcon Hill at the northwest edge of Lake Winnemucca. In 1961 Richard Shutler of the Nevada State Museum unearthed more than 600 fragments of finger woven basketry, bags, and matting. Rozaire describes the chronology of the coiled, twined and plaited basketry.

365. Rudy, Sara Sue. "Textiles." In *Danger Cave*, pp. 235-264. Edited by Jesse D. Jennings. University of Utah Anthropological Papers, no. 27. Salt Lake City: University of Utah, 1959.

Rudy describes 148 fragments of basketry recovered from Danger Cave. Fifteen manufacturing techniques were identified. Twining is the oldest basketry technique in Danger Cave. Coiling appeared later and until the last occupational level was never as popular as twining.

366. Slater, Eva. "Panamint Shoshone Basketry 1920-1940 at the Bowers Museum." *American Indian Art Magazine* 11.1 (Winter 1985): 58-63, 75.

Slater discusses an exhibition of Panamint Shoshone basketry from the period of 1920 to 1940 at the Bowers Museum. The exhibit introduced the work of six weavers and emphasized the importance of Aurelia McLean, a collector, who documented their work.

367. Stern, Norton D. "Abram Cohn of Carson City, Nevada, Patron of Dat-So-La-Lee." *Western States Jewish Historical Quarterly* 15.4 (1983): 291-297.

Material for this study was gathered by Susan B. Clark, a resident of Carson City, Nevada. The Editor, Stern, of the *Western States Jewish Historical Quarterly*, assembled the material and wrote the historical narrative. He discusses Cohn's business relationship with Dat-So-La-Lee. Abram Cohn was a Jewish merchant who supported the famed Washoe basket maker Dat-So-La-Lee. Dat-So-La-Lee began making baskets for sale in Cohn's store in 1895. Her style was an adaptation of Pomo artistry with Washoe lightweight construction. Cohn's support extended to providing housing and medical care as well as promoting Dat-So-La-Lee in her work. Her baskets are now in the collections of the Smithsonian Institution, the Nevada State Museum, and several other repositories and private collections.

368. Tuohy, Donald R. "A Cache of Fine Coiled, Feathered, and Decorated Baskets from Western Nevada." In *Collected Papers on Aboriginal Basketry*, pp. 28-46. Edited by Donald R. Tuohy and Doris L. Rendall. Nevada State Museum Anthropological Papers, no. 16. Carson City: Nevada State Museum, 1974; reprinted 1983.

In 1958, M. A. Baumhoff and R. F. Heizer published an article about what they termed "Outland Coiled" basketry which had been excavated from caves in west central Nevada. They argued that this fine coiled basketry originated outside Nevada, probably in California. Tuohy, analyzing complete specimens of four coiled basketry caps (or hats), and two coiled bowls, re-examined the question as to whether or not fine coiled basketry having a three-rod apex split-rod foundation, split-stitches, and feather decoration should be given a separate taxonomic status. He concluded that this type of basketry originated in western Nevada.

369. _____. "Stone Age Missles from a Modern Test Site." *Masterkey* 15.1 (1941): 10-12.

Tuohy describes the remains of basketry found in the Ranier Rockshelter at the Nevada Test Site near Mercury, Nevada.

370. Tuohy, Donald R. and Barbara Palmbi. "A Basketry Im-

pressed Shoshoni Pottery Vessel from Central Nevada."
Tebiwa: Journal of the Idaho State University Museum
15.1 (1972): 46-48.

The Shoshone pottery ware vessel was found in central
Nevada. The basketry impression indicates an open work,
simple twilled winnowing basket with the stitches slanted
down to the left.

371. U.S. Department of the Interior. *Paiute-Washoe-
Shoshone Beaded Baskets and Bottles.* Browning: Museum
of the Plains Indian and Crafts Center, 1987.

Describes an exhibit of the beaded baskets and bottles
of Norm De Lorme and Bernadine De Lorme.

372. Walker, Edwin F. "Finding an Old Paiute Mush Basket."
Masterkey 15.1 (1941): 10-12.

Walker relates the finding of a painted basket near the
Mohave Desert Rockshelter. The basket was twined, an unusu-
al weave for this area. An x-ray photograph revealed indu-
rated acorn-meal mush on the basket.

373. Waltrip, Lela and Rufus Waltrip. *Indian Women.* New
York: David McKay, 1964.

Contains a chapter about Dat-So-La-Lee. The book is
written for juveniles.

374. Wardle, H. Newell. "American Indian Baskets, a Dat-So-
La-Lee Basket." *Museum Bulletin, University of Pennsyl-
vania* 7 (1939): 10-13.

Wardle describes a basket made by Dat-So-La-Lee owned
by the University Museum at the University of Pennsylvania.

375. _____. "Brock Collection of Baskets." *Museum Bulletin,
University of Pennsylvania* 3.3 and 4 (1932): 98-102.

Wardle describes the John W. Brock Collection of Indian
baskets, including one made by Dat-So-La-Lee, presented to
the University Museum.

376. Weltfish, Gene. *The Origins of Art.* Indianapolis: The
Bobbs-Merrill Company, 1953.

Great Basin basketry is briefly discussed.

377. Wheat, Margaret M. *Survival Arts of the Primitive Pai-
utes.* Reno: University of Nevada Press, 1967.

Northern Paiute crafts, including house construction,
fish drying, basket making, pine nut processing, and other
crafts, are discussed. The manufacture of a tule bag, wil-
low baskets, and a willow cradleboard are described.

Southwest

378. Adair, John. "The Changing Economy of Southwest Indian Arts and Crafts." *New Mexico Quarterly* 29.1 (1959): 97-103.

Adair argues that any assessment of Indian arts and crafts of today must consider the position of the artists in the context of their own rapidly changing society. The shift from a subsistence economy to a wage and cash economy had a profound influence on Indian artisans. Indian weavers, potters, silversmiths, and painters are now pawns in the wage economy. The true artists live on the growing edge of any society; they are inventors of new aesthetic forms which become the arts of tomorrow.

379. Adovasio, James M. "The Evolution of Basketry Manufacture in Northeastern Mexico, Lower and Trans-Pecos Texas." In *Papers on the Prehistory of Northeastern Mexico and Adjacent Texas*, pp. 93-102. Edited by J. F. Epstein, T. R. Hester and C. Graves. The University of Texas at San Antonio Center for Archaeological Research Special Report, no. 9. San Antonio: The University of Texas at San Antonio, 1980.

Adovasio concludes that the evolution of basketry in lower and trans-Pecos Texas parallels developments in the adjacent northeastern Mexico. Twining is evident by mid-8,000 B.C., and is supplemented soon after by single-rod coiling and plaiting. The early coiling in both areas was in the form of parching trays.

380. _____. "Prehistoric Basketry of Western North America and Mexico." In *Early Native Americans: Prehistoric Demography, Economy and Technology*, pp. 341-362. Edited by David L. Browman. Mouton: The Hague, 1980.

Adovasio considers basketry as coiled, twined, and plaited containers, regardless of flexibility, and matting

of all types. Western North America refers to the continental United States west of the Mississippi River and also includes Mexico from the Rio Grande River to the Yucatan Peninsula. Based on a first-hand examination of 30,000 examples of basketry from the above area, Adovasio discusses each region and provides a general overview of all areas where firm developmental sequences are available. He concludes that the manufacture of basketry was established in several parts of western North America and Mexico by 8,000-7,000 B.C. California and the Great Plains are the exceptions. Available data for California is incomplete. Basketry was apparently introduced into the Great Plains at a fairly late date.

381. _____. "Some Comments on the Relationship of Great Basin Textiles to Textiles from the Southwest." *University of Oregon Anthropological Papers*, no. 1. (1971): 103-108.

Adovasio discusses the relationship of Great Basin textiles to materials in the Southwest. In the early 1960s, Alexander Lindsay and his associates discovered an early pre-Basketmaker II occupation in the Rainbow Plateau area of southern Utah and northern Arizona. The Desha Complex contained the earliest textiles in the southwestern area. Lindsay found eighteen pieces of closely coiled, one rod foundation basketry sewn with an interlocking stitch. Adovasio argues that this technique diffused southward from Utah. Southwestern textiles, he concludes, were local developments which were stimulated very early by diffusion from the eastern Great Basin. Southwestern basketry was later influenced by developments in Mexico, especially the appearance of bundle foundation coiling and twilling.

382. Adovasio, J. M. and J. D. Gunn. "Basketry and Basketmakers at Antelope House." *Kiva* 41.1 (1975): 71-80.

Preliminary analysis of the large and somewhat atypical Pueblo III basketry assemblage from Antelope House suggests the possibility of isolating individual basket makers and groups of basket makers within the Antelope House population.

383. _____. "Style, Basketry and Basketmakers." In *The Individual in Prehistory: Studies of Variability in Style in Prehistoric Technologies*, pp. 137-153. Edited by J. N. Hill and J. D. Gunn. New York: Academic Press, 1977.

Adovasio and Gunn hypothesize that basketry attributes can be emphasized in combination with quantified motorskill data to isolate the work of individual basket makers within a prehistoric or ethnographic basketry assemblage. To test this hypothesis, twenty-nine Washoe baskets made by known individual weavers were subjected to detailed attribute analysis. These included baskets made by Dat-So-La-Lee, a wea-

ver named Suzie, and specimens from the Parish Collection of the Nevada State Museum made by an anonymous weaver. An analysis of these baskets showed three distinct groups. In order to ascertain if the analysis could be used successfully on archaeological basketry specimens, two complete and twenty fragments of basketry from Antelope House were tested. Three distinct clusters were noted.

384. Adovasio, J. M., R. C. Carlisle, and R. L. Andrews. "An Evolution of Anasazi Basketry: A View from Antelope House." *New World Archaeology* 2.5 (1978): 1-5.

Adovasio, Carlisle and Andrews, relying on archaeological data from Antelope House, discuss the evolution of Anasazi basketry.

385. Adovasio, J. M., and R. L. Andrews; with an Introduction to the Walpi Archaeological Project by E. Charles Adams; edited by R. C. Carlisle. "Basketry and Miscellaneous Perishable Artifacts from Walpi." In *Textiles, Basketry and Shell Remains from Walpi*, pp. 1-93. Edited by K. P. Kent, J. M. Adovasio, R. Andrews, J. D. Nations, and J. L. Adams. Walpi Archaeological Project-Phase II, no. 6. Flagstaff: Museum of Northern Arizona, 1980.

Adovasio and Andrews describe forty-nine complete and fragmented specimens of basketry recovered during the excavations at Walpi, a Hopi pueblo on First Mesa in northeastern Arizona.

386. Allen, Laura Graves. "Wicker, Plaiting and Coil." *Plateau* 53 (1982): 5-7.

Allen describes the manufacturing techniques, materials and environmental constraints in traditional Hopi basket making.

387. Amsden, Charles. *The Ancient Basketmakers*. Southwest Museum Leaflet, no. 11. Los Angeles: The Southwest Museum, 1939.

The general characteristics of Basketmaker Culture are detailed. Amsden discusses sites in Utah, Arizona, Colorado, and Nevada. These sites include du Pont Cave and White Dog Cave in Utah. There are brief comments about the southern Paiute. The basketry of the Basketmakers is discussed on pages 20-21.

388. _____. "Arts and Crafts of the Southwestern Indians." *The Masterkey* 15.3 (1941): 74-80.

Amsden briefly relates the importance of basketry among the tribes in the Southwest and California.

389. _____. *Prehistoric Southwesterners from Basketmaker to*

Pueblo. Los Angeles: The Southwest Museum, 1949.

Amsden discusses the various uses and types of basketry produced by the Basketmakers.

390. Anonymous. "American Indian Basketry." *Design* 39.6
 (1937): 15-17.

Offers a brief overview of Indian basketry, with emphasis on the Southwest. The most ancient fragments of pottery show the marks of the *osier*, a basket in which the clay was pressed and molded into shape. The *Tos*, a basket waterproofed with pine gum to impart a sweet flavor to the water, is also discussed.

391. _____. "Another Camel Basket." *The Masterkey* 39.3
 (1965): 103.

Although nothing is known about the maker or provenience of this basket, it is typical of Cahuilla Indian basketry. It is illustrated on the cover of this issue.

392. _____. "The Apache and Their Basketry." *The Indian
 Trader* 4.4 (1973): 1, 5-6, 22-23, 30-33.

This is a brief description of modern Apache basketry.

393. _____. *Basket Making Among the Indians of the South-
 west*. Santa Fe: New Mexico Association on Indian Af-
 fairs, 1936.

This publication also appeared in the *Indian Art Series*, no. 2 (1936): 1-4. It is a popular work with general comments and a specific note about Hopi women's work.

394. _____. *The Basket Weavers: Artisans of the Southwest*.
 Flagstaff: Museum of Northern Arizona Press, 1982.

This publication is volume 53, number 4 of *Plateau*. This special issue contains articles about Hopi, Havasupai, and Western Apache basketry.

395. _____. "Basketry from the Rio Grande Classics." *Arizo-
 na Highways* 51.7 (July 1975): 6-13.

Describes the various books about American Indian basketry reprinted by the Rio Grande Press in Glorieta, New Mexico.

396. _____. "The Beautiful Baskets of Arizona's Paiutes."
 Sunset 175 (October 1985): 76-82.

Describes the revival of basket making among the San Juan Paiute of Arizona.

397. _____. "Hopi Baskets for Everyday Use." *Arizona High-*

ways 51.7 (July 1975): 37.

Discusses the efforts of Fermina Banyacya to teach a workshop on Hopi baskets at the Oraibi Day School.

398. _____. *Illustrated History of Indian Baskets and Plates Made by California Indians and Many Other Tribes.* Susanville: 1915; reprint ed., Orange Cove, CA: Leo K. Brown, 1967; and Reedly, CA: Leo K. Brown, 1972.

All of the baskets illustrated in this volume were exhibited in 1915 at the Panama-Pacific International Exposition. The emphasis was on the basketry of the northern California tribes. Included, however, are some excellent examples of baskets from southern California, the Southwest, and the Northwest Coast and Arctic regions.

399. _____. "Indian Baskets." *Design* 34.2 (1932): 48-49.

There is no text, just two photographs of baskets from the Southwest.

400. _____. "Navaho Pottery and Basketry." *The Masterkey* 26.3 (1952): 109.

States that the Southern Paiute of Navajo Mountain and The Gap make baskets for the Navajo.

401. _____. "Pima Basketry." *Papoose* 1.2 (1902): 31.

This is a very brief comment about Pima basketry.

402. _____. "Versatile Basket Makers of the Papago." *The Indian Trader* 4.3 (1973): 1, 26-31.

Discusses modern basket making of the Papago Indians.

403. _____. "Western Fair Will Compare Styles of Indian Basketry." *Design* 40.3 (October 1938): 26.

Discusses the types of Indian basketry to be exhibited at the Golden Gate International Exposition in 1939.

404. Bahti, Tom. *An Introduction to Southwestern Indian Arts and Crafts.* Flagstaff: KC Publications, 1964.

Bahti explores all facets of Indian artistry and crafts, including basketry, in the Southwest. There are several color photographs of some of their finest work.

405. Baldwin, Gordon C. "Prehistoric Southwestern Basketry." *Kiva* 5 (1940): 25-28.

Baldwin presents a typology of Pueblo basketry.

406. Balenti, Michael R. "Indian Basketry and Pottery." *The Indian Craftsman* 2 (1909): 26-30.

The manufacture of water jugs by covering a wicker frame with a coat of mud which was later baked is noted among the Zuni, Navajo, Hopi, and Havasupai.

407. Bandelier, Adolph F. and Edgar L. Hewett. *Indians of the Rio Grande Valley*. Albuquerque: University of New Mexico Press, 1937; reprint ed., New York: Cooper Square Publishers, Inc., 1973.

Bandelier and Hewett state: "Basketry was and is woman's art. From it probably developed bead work and the weaving of textiles such as belts, blankets, and cloth for protection from the elements and for decorative purposes. Basketry is the mother of a group of the most exquisite of arts, the practice of which from time immemorial by woman has, more than any other one thing, developed the superiority in taste, the desire for perfection in color and texture, the love for handiwork that have made her the homemaker." They offer very general comments about the Basketmaker Culture.

408. Bartlett, Katherine. "Hopi Yucca Baskets." *Plateau* 21.3 (1949): 33-41.

Little attention had been given to the shallow plaited baskets of the Hopi. Yucca baskets (*teuchaya* in Hopi) are also known as ring baskets, winnowing trays, and yucca sifters. Bartlett describes the Yucca baskets of the Hopi Indians.

409. _____. "How to Appreciate Hopi Handicrafts." *Museum Notes, Museum of Northern Arizona* 9.1 (1936): 1-8.

Basketry, mainly coiled and utility baskets, is discussed on pages 3-4.

410. _____. "Notes on the Indian Crafts of Northern Arizona." *Museum Notes, Museum of Northern Arizona* 10.7 (January 1938): 21-24.

The basketry of the Paiute, Apache, Yavapai, and Havasupai is discussed on pages 21-24.

411. Bateman, Paul. "Culture Change and Revival in Pai Basketry." Master's thesis, Northern Arizona University, 1972.

Bateman discusses the basketry of the Havasupai, Yavapai, and Walapai Indians of the Southwest.

412. Beals, Ralph L. *Material Culture of the Pima, Papago, and Western Apache, with Suggestions for Museum Displays*. Berkeley: Department of the Interior, Na-

tional Park Service, 1934.

Basketry is briefly discussed on pages 21-27.

413. Beaty, Janice J. "Yuccas and Their Use." *Pacific Discovery* 17.2 (March-April 1964): 18-24.

Beaty discusses the making of baskets from the Yucca plant by the Basketmakers, and the Hopi, Navajo, Pima, and Papago.

414. Beaver, William T. "Navaho Pottery and Basketry at Shonto in 1952." *The Masterkey* 26.3 (1952): 109.

Beaver notes that the Navajo near the Shonto Trading Post at Tolea, Arizona were still manufacturing their own pottery and basketry. He suggests that Paiute basketry near Navajo Mountain would in all probability die out sooner than that of pottery.

415. Beck, Carol. "Bowers Museum, Santa Ana." *Journal of the West* 18 (1979): 107.

Beck describes a traveling exhibit of 100 Indian baskets from the Bowers Museum, which represented twenty-six areas of North America.

416. Bedford, Clay P. *Western North America Indian Baskets from the Collection of Clay P. Bedford*. San Francisco: California Academy of Sciences, 1980.

The Clay P. Bedford basket collection contains examples from many different areas, but he selected for this exhibit at the California Academy of Sciences specific baskets from the western corridor of North America. Bedford provides descriptions of the basketry technique of each basket in the exhibit.

417. Bell, W. H. and Edward F. Castetter. *The Utilization of Yucca, Sotol and Beargrass by the Aborigines in the American Southwest*. Bulletin of the University of New Mexico Biological Series, no. 5. Albuquerque: University of New Mexico Press, 1941.

Bell and Castetter note and describe the uses of various plants by southwestern Indians to make baskets and to weave mats.

418. Bluhm, Elaine. "Cordage, Sandals, and Textiles." In *Caves of the Reserve Area*, pp. 159-179. Edited by P. S. Martin, J. B. Rinaldo, and E. Bluhm. Fieldiana: Anthropology, no. 42. Chicago: Field Museum of Natural History, 1954.

Bluhm describes over 300 pieces of cordage, knots, and cords or fiber from several caves of the Reserve Area. Only

one basket fragment was found in O Block Cave. It was a
two-rod-and-bundle, bunched foundation coiled basket.

419. Boas, Franz. "The Decorative Art of the North American
 Indians." *Popular Science Monthly* 63 (1903): 481-498.

 Boas argues that the decorative designs used by primi-
tive people are not only decorations but symbols of definite
ideas. Various basketry designs of Indians from the North-
west Coast, Plateau, and Southwest are used to support this
argument.

420. Bowen, Thomas. "Seri Basketry: A Comparative View."
 Kiva 38 (1973): 141-173.

 Various scholars have long recognized that Seri basket-
ry shares many of the characteristics of Papago basketry.
It has been suggested by some, however, that the Seri bas-
ketry tradition may have originated in southern California,
primarily because Seri baskets, like those of southern Cal-
ifornia tribes, are coiled in a clockwise direction. Bowen
compares traditional Seri basket technology with that of
several nearby areas and considers the question of historic
ties with the basketry traditions of those areas.

421. Breazeale, J. F. *The Pima and His Basket.* Tucson:
 Arizona Archaeological and Historical Society, 1923;
 reprint ed., Chadron, Nebraska: Fur Press, 1984.

 Breazeale, who worked for two years on the Pima Reser-
vation, describes the way of life of the Pima and discusses
in great detail their basketry.

422. Breunig, Robert. "Cultural Fiber: Function and Sym-
 bolism in Hopi Basketry." *Plateau* 53.4 (1982): 8-13.

 Breunig investigates the nomenclature and symbolism of
basketry types and design motifs of traditional Hopi bas-
kets.

423. Brown, Clara S. "The Art of Indian Basketry." *The
 Catholic World* 68.403 (1898): 52-59.

 Brown interviewed Mrs. Belle M. Jewett, a noted col-
lector from Lamanda Park, California. Jewett described many
of the baskets in her collection, and provided anecdotes of
her collecting adventures. Jewett was also trying to find
an institution willing to accept the collection.

424. Brown-Kampden, Catherine. "The Maze of Life Design of
 the Pima-Papago." *The Masterkey* 52 (1978): 67-70.

 Through one basket, Brown-Kampden relates the signifi-
cance of a basketry design, the Maze of Life, for the Pima
and Papago Indians of southwestern Arizona. She interpets
its meaning through mythology.

425. Brugge, David M. "Pima Bajo Basketry." *Kiva* 22.1 (1956): 7-11.

Modern Spanish nomenclature in Sonora recognizes two principal types of basketry: the *cora* and *huari*. The *cora* is any coiled basket. The *huari*, which is more widespread, is of twilled, or occasionally checker weave. Brugge discusses the manufacture and use of the *huari*.

426. Burckhalter, David. "The Power of Seri Baskets: Spirits, Traditions, and Beauty." *American West* 19.1 (February 1982): 38-45.

In the early tradition of the Seri Indians, baskets were identified with the supernatural, and spirits gave directions for their proper handling. When a Seri woman made a new basket, she adhered to specific rituals and taboos in order to please these spirits. Lupe Comito is currently one of the many Seri women who are preserving the tribal tradition of basket making. Burckhalter describes and illustrates the making of these coiled baskets.

427. Burdick, Arthur J. "The Basket Maker." *The Craftsman* 9.1 (October 1905): 105.

There is brief mention of an unidentified Southwest Indian basket maker, accompanied by a photograph on the opposite page.

428. _____. *The Mystic Mid-Region; The Deserts of the Southwest*. New York: G. P. Putnam's Sons, 1904.

This book contains a brief reference to the Hopi, one of which states that the cobweb pattern in a Hopi basket indicates it is to be used for making offerings to the spider woman.

429. Burgh, Robert F. "Mesa Verde Coiled Basketry." *Mesa Verde Notes* 7.2 (1937): 7-14.

Burgh notes that remains of coiled basketry are not plentiful at Mesa Verde. The Mesa Verde Museum housed twenty-seven specimens. Burgh attempts a classification of the basketry and to identify the basket remains with Basketmaker and Pueblo Indians of the San Juan River drainage.

430. Bushnell, G. H. S. *Ancient Art of the Americas*. New York and Washington, D. C.: Frederick A. Praeger, 1965.

Southwestern basketry is briefly mentioned.

431. C. F. R. "Two Collections of American Indian Baskets." *The Bulletin of the Cleveland Museum of Art* 17 (1930): 199-201.

Describes the donation of the American Indian basket collections of Mrs. Horace Kelley and Mrs. Lionel A. Sheldon. The baskets are primarily from the Southwest, California, and the Northwest Coast.

432. Cain, Harvey Thomas. "Indian Basketry in Arizona." *Arizona Highways* 51.7 (July 1975): 2-5, 44.

This article is excerpted from Cain's *Pima Indian Basketry*. See next entry.

433. _____. *Pima Indian Basketry*. Phoenix: Heard Museum of Anthropology and Primitive Art, 1962.

This is a catalogue of the classic basketry of the Pima Indians.

434. Campbell, Elizabeth W. C. "A Museum in the Desert." *The Masterkey* 3 (1929): 5-10.

Campbell describes ollas and baskets from the Mohave Desert area.

435. Carlson, Roy L. *Basket Maker III Sites near Durango, Colorado*. University of Colorado Studies, Series in Anthropology, no. 8. Boulder: University of Colorado Press, 1963.

Carlson determined basketry shapes, sizes, and techniques from the form of impressions left on pottery vessels. He was unable to establish direct evidence of the type of foundation used, but suggests that with the specific type of un-interlocked stitch used the foundation probably was either two-rod-and-bundle or three-rod types found in Basketmaker basketry.

436. Castetter, Edward F. and Ruth M. Underhill. *The Ethnobiology of the Papago Indians*. Bulletin of the University of New Mexico, no. 275. Albuquerque: University of New Mexico, 1935.

See especially the chapter "Plant and Animal Materials Used in Basketry and Weaving" on pages 53-59. Castetter and Underhill discuss wrapped weaving, coil without foundation, plaiting, and coiling.

437. Chapman, K. M. "Decorative Art of the Indians of the Southwest." *Bulletin, Laboratory of Anthropology* 1 (1934): 1-11.

This is a list of publications containing illustrations from basketry, costumes, ornaments, etc.

438. _____. "Sun Basket Dance at Santa Clara." *El Palacio* 18.3 (1925): 45-46.

The Sun Basket Dance is a ceremony of the Winter
People, whose duty it is to see to the spreading of seeds,
and whose part in the spiritual work of the Pueblo is done
when the shoot has appeared above ground to be ripened and
garnered through the prayer-dancing of the Summer People.
Each girl carries a basket decorated on the inside with an
orange-colored Sun-symbol and on the edge with long fringes
of red-dyed Angora wool. During the dance, these baskets
are swung in a double arc, depicting a realistic picture of
the sun.

439. Clark, Ann. *The Little Indian Basket Maker*. Los Ange-
 les: Melmont Publishers, 1957.

 A little Papago Indian girl learns to plait a mat, the
first step in becoming a basket maker. This book is written
for young children.

440. Coffin, Edwin F. *Archaeological Explorations of a Rock
 Shelter in Brewster County, Texas*. Indian Notes and
 Monographs, Museum of the American Indian, Heye Founda-
 tion, no. 48. New York: Museum of the American Indian,
 1932.

 Coffin describes a small pouch made by folding a small
checker-weave mat in the middle and stitching the ends and
one edge together. Also mentioned are several fragments of
coiled basketry and netting.

441. Collier, Charles. "The Success of the Macy Sale of In-
 dian Arts and Crafts." *Indians at Work* 2.12 (February
 1, 1935): 31-32.

 Indian crafts were placed in the Rug Department at R.
H. Macy and Company in New York. These crafts were arranged
in the manner of an Indian Trading Post. Included were
rugs, pottery, baskets, and silverware.

442. Collings, Jerold L. "Arizona's Treasury of Prized In-
 dian Baskets." *Arizona Highways* 51.7 (July 1975): 16-
 35.

 Collings emphasizes the aesthetic aspects of American
Indian basketry. "Indians...saw in basketry an opportunity
for artistic expression never imagined by their European
subjugators," he states. After contact, the quality and
quantity of basketry declined. Collings cites the break-
down of long established customs and values, the relocation
of some groups to areas where access to needed basketry ma-
terials was limited, and some basket making tribes coming
under the influence of the economic system of White society.

443. _____. "Profile of a Chemehuevi Weaver." *American In-
 dian Art Magazine* 4 (1979): 60-67.

Collings discusses the basket making techniques and materials of Maggie Painter (circa 1900-1963), one of the last of the full-blooded Chemehuevi basket weavers on the Colorado River Indian Reservation in Arizona.

444. Colton, M. R. F. "The Arts and Crafts of the Hopi Indians." *Museum Notes, Museum of Northern Arizona* 11 (1938): 1-24.

The three distinct types of basketry produced on the Hopi Mesas--coil work, wicker work, and plaited yucca--are briefly discussed on pages 15-16.

445. _____. "Technique of the Major Hopi Crafts." *Museum Notes, Museum of Northern Arizona* 3.12 (1931): 1-7.

On page 6, Colton identifies three distinct types of basketry produced on the Hopi Mesas--coiled, wicker, and plaited yucca. The coil type is made exclusively on the Second Mesa in the villages of Shungopovi, Shipanlovi, and Mishongovi. The wicker work is characteristic of the Third Mesa--in the villages of Oraibi, Bacabi, Hotevilla, and Moencopi. The plaited yucca type is general.

446. Coolidge, Dane and Mary Roberts Coolidge. *The Navajo Indians*. Boston: Houghton Mifflin Company, 1930.

The Coolidges provide a detailed description of the Navajo wedding basket. A ceremonial basket, containing cooked cornmeal without much flavoring is brought in and set down with the white line pointed to the east. The Father of the bride takes yellow corn pollen and draws a line of it across the basket from east to west and back again, stopping just at the spirit opening, and a line of corn pollen is drawn from north to south and back again. He then draws a circle around the rim of the basket, beginning just south of the opening and going sunwise around it, but leaving the spirit line unclosed. This pollen is for happiness. It has been dusted from the feathers of a pair of bluebirds or yellow warblers. The bluebirds are caught on their nest and held by the legs over a cloth. As they flutter, the corn pollen is dropped on their wings and they shake it off again. Then the birds are released and the good-luck pollen is gathered up from the cloth and kept. Sometimes a Corn Song, to the yellow and white corn, is sung while the pollen lines are drawn across the basket. The boy reaches out and takes a pinch of the mush from the east side of the basket and eats it. The girl dips from the same place and eats, and they do the same on the south, the west, and the north sides and then from the middle. After they eat more, and after they have finished, the relatives take what is left. A bowl of water is set down south of the basket for the bride and groom to drink from. Afterwards, the feast is served.

447. Crawford, Virginia. "Artistic Basketry of the North

American Indian." *The Bulletin of the Cleveland Museum of Art* 73.7 (September 1986): 278-297.

The basketry collection of the Cleveland Museum of Art emphasizes the western part of North America. Approximately one-half of the collection was donated in 1917 by William Albert Price and his wife. Crawford discusses the variety of form and design found in American Indian basketry. Baskets from the museum's collections are used to illustrate the text.

448. Culin, Stewart. "American Indian Games." *American Anthropologist* 5.1 (January-March 1903): 58-64.

Culin argues that all Indian games are derived from religious ceremonies, and discusses aspects of Hopi baskets which he identifies as the sources for some Hopi games.

449. _____. *Games of the North American Indians.* Annual Report of the Bureau of American Ethnology, no. 24. Washington, D. C.: Government Printing Office, 1907.

Various types of baskets used in the games of North American Indians are described.

450. Cummings, Byron. *First Inhabitants of Arizona and the Southwest: An Authoritative Study of the Lives, Customs, Arts and Crafts of Prehistoric Dwellers in the Great Southwest.* Tucson: Cummings Publisher, 1953.

Textiles--basketry, sandals, furs, and feather blankets--are discussed on pages 97-130.

451. Curtis, William C. "A Unique Indian Basket." *The Basket* 2 (1904): 183-184.

This article is reprinted from the April 1904 issue of *The Southern Workman.* Curtis describes and illustrates an Indian cradle basket. It is oval in form. The bottom is in the form of a half-turn of the spiral channel of an augur, which allows the basket to rock evenly and easily on the edges of the spiral groove.

452. Davisson, Lori. "The Apaches at Home. A Photographic Essay." *Journal of Arizona History* 14.2 (1973): 113-132.

There is very little mention of basketry, but several photographs of Apache baskets are presented.

453. de Lemos, Pedro. "Southwest American Indian Weaving from Prehistoric Periods to the Present Times." *School Arts* 41.3 (November 1941): 87-99.

This article is profusely illustrated, but has very little text. It shows different forms of weaving in the

Southwest.

454. Dedera, Don. "Basket Making in Arizona." *Arizona Highways* 49 (June 1973): 32-46.

This is a popular summary of the current state of basket making in Arizona. Included are photographs of a few recently made Hopi baskets.

455. _____. "Bringing Back the Basketmakers." *The Humble Way* 11.3 (1972): 2-8.

Dedera includes a general section on modern Hopi basketry with several handsome color photographs of Hopi baskets.

456. DeWald, Terry A. "Basket Shopping in Papagoland." *Arizona Highways* 55.11 (November 1979): 38-42.

DeWald briefly describes and illustrates modern Papago basketry, and discusses recent efforts by collectors to obtain these baskets.

457. _____. *The Papago Indians and Their Basketry*. Tucson: DeWald, 1979.

Basketry is discussed on pages 28-47. The Papago manufactured three types of baskets: *kiahas* (carrying baskets), plaited baskets, and coiled baskets. In some cases, it is difficult to distinguish between an old Pima and Papago basket. Papago baskets usually had large coils and were sewn together tighter and harder than the Pima baskets. Pima baskets were more refined, delicate, smoother, and thin-walled. The materials and techniques of Papago basketry are discussed and illustrated in detail.

458. Dodge, K. T. "White Mountain Apache Baskets." *American Anthropologist* 2.1 (January-March 1900): 193-194.

Dodge describes the manufacture of the bowl basket (*tsa*) and the olla-shaped basket (*toose*).

459. Douglas, Frederic H. "Apache Basketry." *Indians at Work* 2.16 (April 1, 1935): 21-23.

Douglas briefly discusses the major types of Apache basketry.

460. _____. "Apache Baskets." *Enjoy Your Museum* 46 (1935): 1-15.

See entry **459**.

461. _____. *Apache Baskets*. Pasadena: Esto Publishing Company, 1935.

See entry **459**.

462. _____ . *Apache Indian Coiled Basketry.*
Denver Art Museum, Indian Leaflet Series, no. 64.
Denver: Denver: Denver Art Museum, 1934.

Douglas discusses the coiled basketry of the Mescalero,
Jicarillo, and western bands of Apache.

463. _____ . "Circular Designs in Indian Art." *School Arts*
34.7 (March 1935): 397-400, 418-424.

This is a general discussion with several references to
Hopi designs on basketry.

464. _____ . *Hopi Indian Basketry.* Denver Art Museum, Indian
Leaflet Series, no. 17. Denver: Denver Art Museum,
1931.

Douglas discusses the wicker, coiled, and twilled
basketry of the Hopi. A conservative group split from the
tribe and founded the village of Hotevila. They began a
revival of native dyes for their baskets.

465. _____ . *Pima Indian Close Coiled Basketry.* Denver Art
Museum, Indian Leaflet Series, no. 5. Denver: Denver
Art Museum, 1930.

Douglas discusses the various forms of close coiled
basketry made by the Pima Indians living on the Salt River
and Gila River reservations.

466. _____ . *Southwestern Twined, Wicker and Plaited Basket-
ry.* Denver Art Museum, Indian Leaflet Series, nos.
99/100. Denver: Denver Art Museum, 1940.

Douglas discusses the twined, wicker, plaited, and
twilled basketry of the Southwestern tribes.

467. _____ . *Types of Southwestern Coiled Basketry.* Denver
Art Museum, Indian Leaflet Series, no. 88. Denver:
Denver Art Museum, 1939.

Douglas discusses the coiled basketry of the South-
western tribes.

468. Dunnington, Jean. "Emily Quanimptewa--Hopi Basket
Maker." 5.3 (1985): 22-25.

Dunnington briefly discusses the coiled baskets of
Emily Quanimptewa.

469. Dutton, Bertha P. "Valuable Basket Collection Pre-
sented to Museum." *El Palacio* 57.6 (1950): 191-192.

Dutton describes the H. F. Robinson basket collection

which had been donated to the Museum of New Mexico.

470. Ellis, Florence H. and Mary Walpole. "Possible Pueblo, Navajo and Jicarillo Basketry." *El Palacio* 66.6 (1959): 181-198.

In view of scholarly interest in the baskets of the prehistoric southwestern Indians found in archaeological sites, the paucity of published information on the baskets of their cultural descendants, the modern Pueblos, was notable. Two reasons are presented: (1.) most Pueblo ethnographers were more concerned with kinship structures and religious rites than with material culture; and (2.) the last quarter of the nineteenth century saw almost complete disappearance of coiled basket making in all pueblos, except Hopi.

471. Evans, Glen L. and T. N. Campbell. *Indian Baskets (Part of Paul T. Seashore Collection).* Austin: Texas Memorial Museum, 1952; second edition, Austin: Texas Memorial Museum, 1970.

This booklet describes and illustrates part of the Paul T. Seashore Collection in the Texas Memorial Museum in Austin. Most of the baskets were obtained by Seashore between 1930 and 1950, and are primarily from western North America. The second edition contains minor editorial changes and a new format.

472. Fewkes, Jesse W. "Hopi Basket Dances." *Journal of American Folklore* 12.45 (April-June 1899): 81-96.

Fewkes describes the different Hopi Basket dances (Lalakonti) at Walpi and the three pueblos of the Middle Mesa and at Orabai. Only one of the three pueblos at East Mesa observed the Lalakonti.

473. Field, Clark. "Pima Basketry." *The Arizona Archaeologist* 4 (1969): 21-23.

Few anthropologists were aware that basket making by the Pima tribe was almost extinct in 1926. Field contacted Bert Robinson, a noted authority on Southwest Indian baskets, about obtaining Pima baskets for his collection. Robinson responded that "no more were to be had." The three remaining weavers felt that they could earn more money doing other things. After Robinson was killed in an automobile accident, Field purchased several Pima baskets from his collection, and placed them in the Philbrook Art Center in Tulsa, Oklahoma. This brief article includes a photograph and identification of the Pima baskets.

474. Fishler, Stanley A. "Symbolism of a Navajo 'Wedding' Basket." *The Masterkey* 28.6 (1954): 205-215.

Fishler discusses the relationship of basketry symbols

to mythology and symbolism. The wedding baskets are from
twelve to fourteen inches in diameter and from two to three
inches in depth. The design is formed by some five concen-
tric circles separated by the various colors in sequence:
white, black, brown, black, white.

475. Fox, Nancy. "Collections of the Laboratory of Anthro-
 pology Museum of New Mexico." *American Indian Art Maga-
 zine* 8.2 (1983): 56-64.

Fox describes the basket collections of the Laboratory
of Anthropology at the Museum of New Mexico. In 1932, Isa-
bel Kelly (who had been working among the Southern Paiute)
assembled a special collection, which included much baske-
try. Alfred Kroeber gathered together an extensive collec-
tion of Walapai basketry. The basketry collection was sig-
nificantly ehanced by donations from Michaeol Harrison of
Santa Fe.

476. Gerstner, Patsy Ann. "Baskets and Blankets." *The Ex-
 plorer* 4.3 (May-June 1962): 22-24.

Gerstner illustrates a collection of baskets donated to
the Cleveland Museum of Natural History by Warren H.
Corning. The baskets are from Arizona and California.

477. Gifford, Edward W. "Indian Basketry." In *Introduction
 to American Indian Art, Part II.* New York: The
 Exposition of Indian Tribal Arts, Inc., 1931; reprint
 ed., Glorieta, New Mexico: Rio Grande Press, 1970; and
 1979.

This is one of a series of pamphlets which was later
bound into a two-volume set, entitled *Introduction to Amer-
ican Indian Art.* Gifford presents an overview of the Indian
basketry of California, the Northwest Coast, the Southwest,
and the Atlantic and Gulf Coast States.

478. Gogol, John M. "Kirkland Collection of Contemporary
 Papago Willow Basketry." *American Indian Basketry* 3.3
 (1983): 9-11.

Gogol describes the Papago willow basketry collection
of Dennis and Neva Kirkland of Casa Grande, Arizona. The
Kirklands have encouraged Papago weavers of horsehair
baskets to attempt more complicated designs. The future of
willow basketry among the Papago is uncertain. The deaths
of old weavers, the scarcity of materials, and the great
amount of time required to produce a willow basket have
resulted in a serious decline in this basketry tradition.

479. _____. "Papago Horsehair Basketry." *American Indian
 Basketry* 3.3 (1983): 4-8.

The use of horsehair by the Papago to make miniature
baskets is a recent development. It appears to have been an

outgrowth of the tourist industry which developed in the
Southwest in the decades after the turn of the century.
Most of the older horsehair baskets were made by the Pima,
but today the Papago produce the majority of this type of
basketry. Most of the weavers are young Papago women, who
have developed new directions in design, size, and refine-
ment. The work of Norma Antone, Rose Poola, Doreen Garcia,
and Elizabeth Juan is described and illustrated.

480. _____. "Papago Indian Basketry." *American Indian
Basketry* 2.1 (1982): 8-9.

The basketry of the Papago, especially their miniature
baskets, is briefly described.

481. _____. "Pima Indian Basketry." *American Indian
Basketry.* 2.3 (1982): 4-7.

Madeline Lewis and Hilda Manuel, well-known and active
Pima basket makers, demonstrate the use of traditional
materials and techniques.

482. Gooding, John D. *Durango South Project: Archaeo-
logical Salvage of Two Late Basketmaker III Sites in
the Durango District.* Anthropological Papers of the
University of Arizona, no. 34. Tucson: University of
Arizona Press, 1980.

Briefly notes and describes the charred base of a
coiled basket.

483. Grabhorn, Nelson H. H. *Ethnic and Tourist Arts:
Cultural Expressions from the Fourth World.* Berkeley:
University of California Press, 1976.

Basketry from California is mentioned on pages, 15, 34,
and 103 and basketry of the Seri is noted on pages 122-124.

484. Griffith, James S. *Legacy of Conquest: the Arts of
North West Mexico.* Colorado Springs: Taylor Museum of
the Colorado Springs Fine Arts Center, 1967.

The basketry of the Seri, Tarahumara, and the Pima Bajo
is briefly described on page 26.

485. Guernsey, Samuel J. *Basket-Maker Caves of Northeastern
Arizona.* Papers of the Peabody Museum of American Ar-
chaeology and Ethnology, no. 8. Cambridge: Peabody
Museum of American Archaeology and Ethnology, 1921.

Basketry remains from excavated caves in northeastern
Arizona are discussed and illustrated.

486. _____. *Explorations in Northeastern Arizona. Report on
the Archaeological Fieldwork of 1920-1923.* Cambridge:
Peabody Museum of American Archaeology and Ethnology,

1931.

Basketry from the Broken Roof Cave is briefly discussed on page 70 and is illustrated in Plate 13.

487. Gunnerson, Dolores A. *The Jicarilla Apache: A Study in Survival*. De Kalb: Northern Illinois University Press, 1974.

Gunnerson discusses on pages 154-158 the origin of the word, Jicarilla, which means "little basket" in Spanish. The Spaniards may have given them this name because of their skill in making baskets.

488. Guy, Herbert. "Arts and Crafts: Baskets, Beads and Buckskin." *Arizona Highways* 53 (1977): 10-19.

Guy observes that contemporary Apache Indian crafts can be divided into three categories: authentic reproductions of original functional articles, original articles which have undergone change due to market pressure, and new forms developed from exclusive native resources. Apache Indian basketry is the most popular craft. Guy discusses coiled plaques, shallow dishes, and ollas; and twined baskets in the form of burden baskets and water carriers.

489. Hall, Sharlot M. "The Story of a Pima Record Rod." *Out West* 26.5 (1907): 413-423.

On page 422 is a photograph of a basket with camels and attendants in the design.

490. Harrington, Mark R. "A Rare Old Pueblo Basket." *The Masterkey* 24.3 (1950): 95.

Harrington briefly narrates the finding of an old and rare Pueblo basket in a curio shop in Palm Springs.

491. Harrison, Gayle. "Coiled and Plaited Basketry from Southeastern Periphery of Greater Arizona." Master's thesis, University of Arizona 1969.

The coiled and plaited basketry from the southeastern periphery of the Greater Southwest is examined and compared with the basketry from the Anasazi area. The basis for this comparison were temporal position and cultural affiliation, quantity and condition, size and form, technique and decoration. Harrison concludes that there is only a rather distant relationship to the San Juan material. Coiled specimens from the periphery are technically less complex, forms are generally simple and limited, and decoration is almost non-existent. Plaited specimens appear to be more abundant and in Chihuahua are constructed in a very complex way. The material is similar to early specimens from the Tehuacan Valley and the Great Basin. She suggests that this demonstrates a "strong internal consistency within an early,

widespread archaic culture in western North America."

492. Hart, Elizabeth. "Arts and Crafts of the Pima Juris-
diction." *Indians at Work* 2.19 (May 15, 1935): 16-18.

Hart notes that Pima basketry and Maricopa pottery are
two crafts which have survived within the Pima jurisdiction.
She states that Pima basketry is dying out, and describes
efforts to teach basket weaving through 4-H Clubs.

493. Harvey, Byron and Suzanne de Berge. *Hopi Miniature
Baskets*. Phoenix: Arequipa Press, 1969.

In 1963, Byron Hunter (a trader) urged a Hopi weaver to
make miniature baskets. A fire at his trading post de-
stroyed all but fifteen of the 100 baskets which were pro-
duced. Byron Harvey similarly requested that 100 miniature
baskets be woven. These two collections of baskets provide
the material for this study. All of the baskets were woven
by Hopi women from the Second Mesa village of Shongopovi,
Arizona. Because miniature baskets have not found their way
into either the social or economic lives of the Hopi, they
will probably remain a novelty.

494. Hatcher, Evelyn Payne. "Navaho Art: A Methodological
Study in Visual Communication." Ph.D. dissertation,
University of Minnesota, 1967.

Hatcher provides a technique to describe objectively
the formal qualities of any work of art by using a rating
scale, with six main categories. These are layout, repeti-
tion and balance, lines, color, perspective, and composi-
tion. Samples of Navajo art, including sixteen baskets,
were used. She concludes that systematic formulations at
descriptive and interpretive levels and the provision of
logical alternatives are significant methodological tools.

495. Henderson, A. C. "Indian Artists of the Southwest."
The American Indian 2 (1945): 21-27.

Basketry is briefly mentioned.

496. Hendrickson, James and Richard S. Felger. "Microanaly-
sis and Identification of a Basket Fragment from So-
nora, Mexico." *Kiva* 38.3 and 4 (1973): 173-177.

A basket fragment found in a cave between Guaymas and
Hermosillo, Sonora was analyzed to determine the identifi-
cation of plant material used for construction. Microanaly-
sis showed that the fragment is composed of young xylem of
Jathropha Cuneata, the traditional basket material of the
Seri.

497. Herold, Joyce. "Basket Weaver Individualists in the
Southwest Today." *American Indian Art Magazine* 9
(1984): 45-53.

Herold discusses the history, concepts and techniques of the Havasupai basket weavers of Arizona, and compares examples of their work since circa 1900.

498. _____. "The Basketry of Tanzanita Pesata." *American Indian Art Magazine* 3.2 (1978): 26-31, 94.

Herold describes the baskets of Tanzanita Pesata (1885-1968), a renowned Jicarilla Apache basket maker. She emphasizes the aesthetic qualities of Jicarilla Apache baskets, even though it is "usually ranked as middling."

499. Hewett, E. L. "Native American Artists." *Art and Archaeology* 13.3 (March 1922): 103-113.

Although basketry is not discussed in the text, Hewett includes a modern painting of the "Basket Ceremony" by Fred Kabotis. This is a food ceremony with the women arranged as a ceremonial basket, symbolizing the cycle of woman's life from childhood to old age. There is another painting of the "Basket Ceremony" by Awa Tsireh which depicts the gift of fertility to the women of the tribe.

500. Hill, W. W. Edited and annotated by Charles H. Lange. *An Ethnography of Santa Clara Pueblo New Mexico*. Albuquerque: University of New Mexico Press, 1982.

Baskets were used for both utilitarian and ceremonial purposes at Santa Clara Pueblo. With few exceptions, however, they were imported from other tribes. One older informant stated that he had never seen a basket made in the village, and that they were obtained from the Hopi, Apache, or Navajo. All available evidence indicates that the basket making had been obsolete for a considerable time. The craft seems never to have been a flourishing one, and only those baskets needed for local use were produced. Traditional processes of basket making were obtained from the informants, but the information is extremely fragmentary.

501. Hodge, Frederick W. "A Pima Dromedary Basket." *The Masterkey* 14.3 (1940): 98-101.

Camels and dromedarians were introduced into the Southwest in 1856. Hodge describes a small basket of Pima Indian workmanship into which is woven as decoration three dromedaries and their attendants. When the basket was made is in question.

502. Hopkins, Jean. *Southwestern Indian Art, Summary Charts and Bibliography*. n.p.: 1962.

Southwestern basketry is included.

503. Hough, Walter. "Archaeological Field Work in Northeastern Arizona. The Museum-Gates Expedition of 1901."

Annual Report of the Smithsonian Institution for 1901, Report of the National Museum, pp. 287-358. Washington, D. C.: Government Printing Office, 1903.

On page 339, several specimens of coiled and wicker basketry discovered during the excavations at Kokopnyama are described.

504. _____. "A Cache of Basket Maker Baskets from New Mexico." Smithsonian Institution United States National Museum. Proceedings of the United States National Museum 81.10 (1932): 1-3.

A joint expedition of the Smithsonian Institution and the Peabody Museum of Yale University excavated in 1929 a cave in Dana Ana County, New Mexico. During the investigation, a cache of baskets was discovered. An oval bowl, a large coiled basket, a carrying basket, and a shallow bowl with a flat bottom and steep sides are described and illustrated.

505. _____. "The Hopi Indian Collection in the United States National Museum." Smithsonian Institution United States National Museum. Proceedings of the United States National Museum 54 (1918): 235-296.

Hopi basketry is discussed on pages 263-270.

506. Houlihan, Patrick T. Indian Basket Designs of the Greater Southwest. Salt Lake City: Utah Museum of Fine Arts, 1976.

This exhibition, "Indian Basket Designs of the Greater Southwest," examined the design styles woven into the baskets made by the numerous weavers in New Mexico, Arizona, west Texas, southern Colorado, Utah and Nevada. Specific tribes represented were the Chemehuevi, Eastern Apache, Western Apache, Hopi, Navajo, Yavapai, Walapai, Havasupai, Paiute, Southern Ute, Pima, Papago, Pueblo, Seri, and Tarahumara.

507. Hudson, Elizabeth M. "Design Contributions of the Pima Indians as Evidenced in Their Basketry." Master's thesis, University of Southern California, 1936.

508. Hurst, C. T. "Eight Years in the Tabeguache and Dolores County of Colorado." Southwestern Journal of Anthropology 3 (1947): 367-370.

Hurst discusses basketry remains found in Tabeguache Cave from the Basket Maker II culture.

509. James, George Wharton. "Basket Makers of the Palomas Apaches." Sunset Magazine 11 (1903): 146-153.

James provides information about the basketry of the

Palomas Apache.

510. _____. *Indian Basketry; and How to Make Indian and Other Baskets*. Pasadena: Printed Privately by the Author, 1901.

During his lifetime, George Wharton James was a health food faddist, editor, publisher, expert on basketry, pottery, weaving, photography, and Indians of the Southwest. In his account of Indian basketry, James relied uncritically and extensively on mythology, hearsay, personal observations and other published sources. Nevertheless, *Indian Basketry* is interesting to read; and it certainly influenced a generation of Americans interested in basketry and Indians in the Southwest. In a recent issue of *Masterkey* 60.1 (Spring 1986), the various facets of James' life have been explored. See "Stephen G. Maurer, "In the Heart of the Great Freedom: George Wharton James and The Desert Southwest;" Paul R. Arreola, "George Wharton James and the Indians;" and Enrique Cortes, "George Wharton James: Advocate for the Golden State."

511. _____. "Palomas Apache and Their Baskets." *The Basket* 1.3 (1903): 43-52.

This article is reprinted from *Sunset Magazine*. James uses the term Palomas Apaches, instead of Yuma Apaches, to identify a group who lived in the Short Horn Range of mountains near the Gila River. The baskets of the Palomas Apache were characterized by fine stitches, beautiful shape, colored splints, and quality design. James describes the manufacture of these Apache coiled baskets.

512. _____. *Practical Basketmaking*. Seattle: Shorey Book Store, 1967.

Drawing upon illustrations and descriptions from his *How to Make Indian and Other Baskets* and *Indian Basketry*, James provides models and instructions for the practical weaver to make various types of Indian baskets, many of which are from the Southwest.

513. James, Harry C. *The Hopi Indians: Their History and Their Culture*. Caldwell: The Caxton Printers, Ltd., 1956.

Baskets of the Second Mesa and Third Mesa are briefly discussed on pages 152-154.

514. Jeancon, Jean Allard, and Frederic H. Douglas. *The Navajo Indians*. Denver Art Museum, Indian Leaflet Series, no. 21. Denver: Denver Art Museum, 1931.

Navajo basketry is briefly discussed.

515. Jett, Stephen C. *Interwoven Heritage: A Bicentennial*

Exhibition of Southwestern Indian Basketry and Textile Arts, Featuring the C. Hart Merriam Collection of Baskets and the Stephen C. Jett Collection of Navajo Weaving. Davis: University of California, Davis, Memorial Union Art Gallery, 1976.

Jett describes the C. Hart Merriam Collection of baskets which was acquired by the Department of Anthropology at the University of California, Davis in 1960. Most of the collection consists of basketry from the Pacific Coast states and Nevada. Basketry from the Southwest is included.

516. Jones, Joan Megan. *Native Basketry of Western North America. The Condell Collection of the Illinois State Museum.* Springfield: Illinois State Museum, 1978.

The Condell Collection of basketry in the Illinois State Museum contains many examples of the major styles of basketry made by tribes of western North America--from the Arctic southward along the coasts of Alaska, British Columbia, the western United States, and into the Southwest. Most of the baskets in the Condell Collection were made during the latter part of the nineteenth century and early part of the twentieth century. Thomas Condell had purchased them from collectors, dealers, and the Indians themselves. In some cases, entire private collections were obtained.

517. Judd, Neil M. "Hunting Baskets in Arizona." *Explorations and Fieldwork of the Smithsonian Institution in 1931*, pp. 125-132. Washington, D. C.: Government Printing Office, 1932.

Judd relates his unsuccessful efforts to locate a rock shelter containing four old Indian baskets which had been discovered earlier by a local hunter.

518. Kaemlein, Wilma R. *An Inventory of Southwestern American Indian Specimens in European Museums.* Tucson: Arizona State Museum, 1967.

This is an inventory of specimens of material culture of southwestern Indians in the museums of Europe and Great Britain. The material is cross-indexed according to tribe or region; and there is a summary of specimens listed by tribe or region.

519. _____. "A Prehistoric Twined-Woven Bag from the Trigo Mountains, Arizona." *Kiva* 28.3 (1963): 1-13.

Kaemlein describes a prehistoric bag filled with grass seeds, squash seeds, and beans found in the Yuma area. The bag was compared to a modern Yuma bag. She concludes that the modern bag may have resulted from a prehistoric weaving tradition. A radiocarbon 14 date of 603 B.P. +/- 140 was obtained from the grass seeds.

520. Kassel, Ruby B. "Crafts of the Papago." *School Arts* 38.2 (October 1938): 49-50.

 The Papago were actively using and selling many of their crafts in the 1930s. Basketry, by far, was the most important and original of the crafts. Kassel describes the close coiled basketry of the Papago.

521. Kent, Kate Peck. *Montezuma Castle Archeology Part 2: Textiles.* Southwestern Monuments Association Technical Series, no. 3.2. Gila Pueblo, Globe, Arizona: Southwestern Monuments Association, 1954.

 Kent examines matting and a bag uncovered during excavations at Montezuma Castle Monument, Camp Verde, Arizona.

522. Ketchum, William. *Western Memorabilia: Collectibles of the Old West.* New York: Rutledge Books, 1980.

 There are over 500 illustrations, including Indian baskets, with prices listed for each object.

523. King, L., K. Johnson, and B. Rosenman. *The Desert: Indian Art of the Southwest. Textiles, Pottery and Baskets from the Collection of Earle B. Delaittre.* Minneapolis: University Gallery, 1976.

 Describes the various baskets from the Southwest in the collection of Earle B. Delaittre.

524. Kissel, Mary L. *Basketry of the Papago and Pima.* Anthropological Papers of the American Museum of Natural History, no. 17. New York: American Museum of Natural History, 1916; reprint ed., Glorieta, New Mexico: Rio Grande Press, 1972.

 Kissel investigates the finding of a distinct differentiation between Papago and Pima coiled basketry. She suggests the possible evolution of two techniques in the region: wrapped and latticed-wrapped weaving and formation coiling. She also notes the presence of the plaited center on coiled basketry, and suggests that plaiting was an earlier form of weaving than foundation coiling.

525. Kistler, Larry L. "Ethnobotanical Studies on Baskets of Pima, Papago and Chemehuevi Indians." Master's thesis, Claremont College, 1968.

526. Kluckholn, Clyde, W. W. Hill, and Lucy Wales Kluckholn. *Navaho Material Culture.* Cambridge: The Belknap Press of Harvard University, 1971.

 Relying primarily on the work of Tschopik, the authors describe and illustrate the carrying basket, pitched basket bottle, basket dish, basketry hat, and ceremonial baskets of the Navajo.

527. Koenig, Seymour H. *Sky, Sand, and Spirits; Navaho and Pueblo Indian Art and Culture*. Yonkers, New York: Hudson River Museum, 1972.

Koenig organized this exhibition of Navajo and Pueblo arts and crafts for the Hudson River Museum. Several baskets from each of the tribes is illustrated and described in this catalog.

528. Krieger, Herbert W. "Aspects of Aboriginal Decorative Art in America." *Annual Report of the Smithsonian Institution for 1930*, pp. 519-556. Washington, D. C.: Government Printing Office, 1931.

Krieger illustrates woven bags (sally bags) of the Nez Perce, Okinagon, and Salish Indians. Coiled baskets of the Panamint and Tulare Indians of California and the Pomo and Apache of the Southwest are also mentioned.

529. Lamb, Frank W. *Indian Baskets of North America*. La Pine: Rubidoux Publication, 1972; 1976; 1981; and 1985.

Baskets of the Southwest are discussed on pages 93-121.

530. Lange, Charles H. *Cochiti: A New Mexico Pueblo, Past and Present*. Austin: University of Texas Press, 1959.

Basket making is virtually a lost art at Cochiti. In 1959, only a few individuals practiced weaving, and they were seldom active in this craft. Both men and women made baskets, which was apparently the case in the past. All of the baskets were wide, shallow, and loosely woven. Materials used included the long leaves of the amole, or soapweed (*Yucca Glauca*). A rod of willow, bound into a hoop, served as the rim foundation. Lange closely describes the making of this type of basket. After the leaves had been soaked in water to make them pliable, they were laid on a flat surface. They were interwoven at right angles to one another in a simple twill. The weaver usually placed his feet on the finished portion to hold the leaves in place while he completed the remainder. Finally, the hoop was incorporated, with the yucca leaves being bent upward and trimmed off evenly to form a simple decorative fringe on the outside. The baskets were neither painted nor dyed. This was the only form of basket made at Cochiti, according to Lange's informants. Traditionally, the baskets were used to gather salt, but in modern times they have been used for washing grain and as general containers.

531. Latour, A. "The Textile Crafts of the North American Indians." *Ciba Review* 90 (February 1952): 3247-3254.

Latour mentions the skill of the Hopi in basket making.

532. Leifgreen, Dan. "The Incredible Seri Basket." *The Indian Trader* 14.4 (April 1983): 9-10.

Leifgreen describes and illustrates a large coiled basket made by Ernestine Morales.

533. Lummis, Charles F. "Reviving an Ancient Craft." *Out West* 23.6 (1905): 539-543.

Lummis observed that it "is an unwelcome and disquieting fact that civilization almost invariably destroys the native arts and crafts, and gives us poor substitutes in their place. The first domestic arts in America have been, for many years, periously near extinction. The still older art of basketry--the first artistic craft in America--is suffering almost as much." The Sequoya League and the Southwest Society were early attempts to arrest the extinction of basketry. They bought baskets from Indian basket makers for traditional aesthetic quality only.

534. Manley, Ray J. *Ray Manley's Southwestern Indian Arts and Crafts*. Tucson: Ray Manley Photography, 1975.

This booklet contains Jerold Collings' "Baskets." It contains mostly photographs of various baskets, with a short discussion about Hopi and Papago basketry.

535. Marquis, Arnold. *A Guide to America's Indians: Ceremonials, Reservations and Museums*. Norman: University of Oklahoma Press, 1974.

The basketry of the Basketmakers is discussed on pages 14-16.

536. Martin, George C. *Archaeological Exploration of the Shumla Caves. Report of the George C. Martin Expedition*. Big Bend Basket Maker Papers, no. 3. San Antonio: Southwest Texas Archaeological Society of the Witte Memorial Museum, n.d.

The George C. Martin Expedition explored several cave shelters of the Rio Grande region west of the Pecos River in 1933. Nine caves in the Shumla district were investigated. The Shumla Caves contained complete and fragmentary basketry specimens. On pages 55-59, Martin describes these basketry remains.

537. _____. *The Big Bend Basket Maker*. Big Bend Basket Maker Papers, no. 1. San Antonio: Southwest Texas Archaeological Society of the Witte Memorial Museum, n.d.

Martin describes several basketry fragments from the Witte Memorial Museum assigned to the Big Bend Basketmaker culture.

538. Mason, Otis T. *Aboriginal American Basketry: Studies in a Textile Art Without Machinery*. Annual Report of the U. S. National Museum for 1902. Washington, D. C.: Government Printing Office, 1904.

Mason discusses the basketry of the Southwest tribes on pages 489-524. For further details about Mason's classic study see **49**.

539. Matthews, Washington. "The Basket Drum." *American Anthropologist* 7.2 (1894): 202-208.

The Navajo purchased most of their baskets from other tribes. Basket making among the Navajo declined because of the emphasis given to weaving baskets. One form and pattern of basket, however, continued to be made in the tribe because of its importance in their sacred rites. The most significant use of this basket is as a drum. Matthews describes the manufacture of the basket drum and the drumstick.

540. Mauldin, Barbara. *Traditions in Transition: Contemporary Basket Weaving of the Southwestern Tribes*. Santa Fe: Museum of New Mexico Press, 1984.

This exhibit demonstrates that basket weaving continues to be vigorously practiced among American Indians in the Southwest. Mauldin indicates that coiled basket weaving is no longer practiced among the Mescalero Apache; and it is almost extinct among the Western Apache and the Pima. Contemporary basket makers are discussed.

541. McGreevy, Susan Brown and Andrew Hunter Whiteford. *Translating Traditions: Basketry Arts of the San Juan Paiute*. Santa Fe: Wheelwright Museum, 1985.

This profusely illustrated sixty-four page catalog presents the history and current state of basket making among the San Juan Paiute of northern Arizona.

542. _____. "Translating Tradition: Basketry Arts of the San Juan Paiutes." *American Indian Art Magazine* 11.1 (Winter 1985): 30-37.

McGreevy and Whiteford provide information about the exhibition of San Juan Paiute basketry at the Wheelwright Museum in Santa Fe. They discuss the various styles and designs found on contemporary baskets.

543. McKee, Barbara, Edwin McKee, and Joyce Herold. *Havasupai Baskets and Their Makers: 1930-1940*. Flagstaff: Northland Press, 1975.

Edwin McKee worked for the National Park Service in Grand Canyon. During his stay, his wife began to collect baskets from local Havasupai basket makers. With the assis-

tance of Joyce Herold, their collection was studied and de-
scribed.

544. McKee, Edwin D. "Havasupai Basketry." *Grand Canyon Na-
ture Notes* 8 (1933): 130-135.

McKee briefly describes the basketry of the Havasupai.

545. McNickle, D'Arcy. *They Came Here First: The Epic of
the American Indian.* Philadelphia: J. B. Lippincott,
1949.

Basketmaker and Pueblo Indian basketry is discussed
briefly on pages 46-53, 59, 72, and 113.

546. Miles, Charles. "Indian Basketry." *Hobbies: The Maga-
zine for Collectors* 54.3 (May 1949): 140-141, 161.

Miles offers some simple suggestions to those interes-
ted in collecting Indian baskets. He discusses the uses for
basketry, methods of construction, ethnic divisions in the
western part of North America, and materials.

547. Mills, George Thompson. *Navaho Art and Culture.* Colo-
rado Springs: Taylor Museum of the Colorado Springs
Fine Arts Center, 1959.

Unfortunately, there is no mention of basketry.

548. Mitchell, John R. "A History of Basketry Technology in
Pueblo Area." Master's thesis, University of New Mexi-
co, 1960.

Mitchell attempts to assimilate the scattered informa-
tion about Greater Southwest baskets in order to examine the
technologicval development of basketry in the Pueblo area.
Independent invention, diffusion, trade, and persistence are
considered to determine the differences and similarities
expressed in baskets in the Pueblo area from 46 A.D. to 1959
A.D.

549. Mohr, Albert and L. L. Sample. "Twined Water Bottles
of the Cuyama Area." *American Antiquity* 20 (1955): 345-
354.

Mohr and Sample describe eighteen twined water bottles
from archaeological contexts. All of the sites, except one,
are in the Sierra Madre Mountains of northern Santa Barbara
County. Cuyana and Great Basin material are compared.

550. Moore, Harvey C. "Comparative Notes on the Basket
Types." *Southwestern Journal of Anthropology* 4.3
(1948): 337-343.

Moore discusses the relationship of southwestern
basketry and South American basketry.

551. Mori, Jocelyn I. "Changes in Hopi Material Culture."
Ph.D. dissertation, University of Missouri, 1972.

This study examined the stability of the material
culture of the Hopi. Four museums were visited and their
collections of Hopi artifacts were studied. The initial
phase included an analysis of all dated Hopi material cul-
ture specimens in selected categories: plaited basketry,
coiled basketry, wicker basketry, sashes, rattles, and de-
corated pottery. The data for the first portion of the
analysis were based on the physical properties of the spe-
cimens: measurements, color differences, design attributes,
and form. From this data a series of conclusions were drawn
concerning the changes in the physical aspects of the items
through time. Mori also considered whether correlations ex-
isted between these physical changes and particular histori-
cal events of possible change-producing potential. These
results were inconclusive. No specific event appeared to
lead to a definite type of change. Instead, there were
historical periods--time of tourist influx, boarding
schools, missionary efforts, for example--which apparently
caused reverberations of change in items after a time lag.
Mori also hoped to determine what general conclusions con-
cerning technological change could be generated from the
Hopi data. She considered the rate of change, differences
in change between male and female produced and used items or
religious and secular items, relation between material cul-
ture and other aspects of the culture in terms of change,
stability of form, function, and use through time, cultural
mechanisms for stability, and extent of specific diffusion
from White society.

552. Mori, Joyce and John Mori. "Modern Hopi Coiled Baske-
try." *The Masterkey* 46.4 (1972): 4-17.

The women of the Second Mesa in northeastern Arizona
specialize in coiled basketry. Baskets are produced on a
part-time basis for daily use, for ritual purposes, for
gifts, and for income from the tourist trade. The Moris de-
scribe the basket making process and the problems of con-
tinuing the craft. Training the younger generation is in-
creasingly difficult. Despite the relatively high retail
price of a Hopi basket, the return to the basket maker is a
very low hourly wage. Tourists do not find baskets appeal-
ing and must be educated concerning the amount of work and
skill required to make one.

553. Morris, Earl H. "Tomb of the Weaver." *Natural History*
57 (1948): 66-71.

In Arizona's "Canyon of the Dead," a mummy of an Indian
was found with baskets left with him for survival in the af-
terworld.

554. Morris, Earl H. and Robert F. Burgh. *Anasazi Basketry,*

Basket Maker II through Pueblo III: A Study Based on Specimens from the San Juan River Country. Carnegie Institution of Washington, Publications, no. 533. Washington, D. C.: Carnegie Institution of Washington, 1941.

This is a thorough analysis of Anasazi basketry and the coiling technique.

555. _____. *Basket Maker II Sites near Durango, Colorado.* Carnegie Institution of Washington, Publications, no. 604. Washington, D. C.: Carnegie Institution of Washington, 1954.

Morris and Burgh describe twenty coiled baskets, six of which were more or less intact. The details of weaving are treated according to separate basket-wall techniques. Forms and other features are also discussed.

556. Morris, Elizabeth Ann. "Basketmaker Caves in the Prayer Rock District, Northeastern Arizona." Ph.D. dissertation, University of Arizona, 1959.

See next entry.

557. _____. *Basketmaker Caves in the Prayer Rock District, Northeastern Arizona.* Tucson: University of Arizona Press, 1980.

Earl H. Morris of the Carnegie Institution of Washington, D. C. excavated in 1930 and 1931 the archaeological remains discussed in this volume. The cave sites in the Prayer Rock District of northeastern Arizona produced considerable well-preserved Basketmaker material. Only a small portion of the objects have been reported. This study provides an analysis of the entire collection of Basketmaker remains excavated by Earl H. Morris. The basketry from the Prayer Rock District was discussed in *Anasazi Basketry* by Morris and Burgh in 1941. Only a summary review is included in this volume to show the range of materials recovered and the provenience of the specimens.

558. _____. "Seventh Century Basketmaker Textiles from Northern Arizona." In *Archaeological Textiles*, pp. 125-129. Edited by Patricia Fiske. Washington, D. C.: The Textile Museum, 1974.

Morris focuses on the textiles of the Basketmaker Culture from Broken Flute, Obelisk, Pocket and Ram's Horn caves in the Prayer Rock cave group in the northeast corner of Arizona. The woven baskets from which the Basketmaker culture is named are in the American Museum of Natural History in New York and the University of Colorado Museum in Boulder.

559. Moseley, M. Edward. "The Discovery and Definition of

Basketmaker: 1890 to 1914." *The Masterkey* 40 (1966): 140-154.

The discovery of the Basketmaker Culture has been frequently credited to Richard Wetherill. Moseley demonstrates that Charles McLloyd and C. C. Graham first recognized the existence of two prehistoric cultures in the Southwest. While Wetherill's role was that of promulgator, McLloyd and Graham were able to offer a definition which elucidated specific attributes of Basketmaker artifacts. The first controlled excavation of Basketmaker sites was undertaken by Alfred V. Kidder and Samuel J. Guernsey in 1914. Kidder and Guernsey established that Basketmaker and Pueblo were a single cultural continuum.

560. Moser, Edward. "Seri Basketry." *Kiva* 38 (1973): 105-140.

Basketry has been a traditional Seri craft at least since the late seventeenth century. Although very little information prior to the twentieth century has survived, it is evident that the Seri have been receptive to new techniques and ideas from outside sources, both Indian and non-Indian. Intense contact with outsiders in recent years, which is based in part on the development of a market for Seri baskets, has led to rapid change in Seri social and economic structure. Basket sales have appreciably contributed to the partial adoption of a cash economy and buyer demand in turn has stimulated changes in Seri basketry. Moser describes Seri baskets and the techniques of their manufacture from both traditional and modern perspectives. The functional role of baskets in traditional Seri culture is discussed with an emphasis on the web of beliefs and ritual activities which surround their manufacture and use.

561. Narsa, Mida. "Basketry of the Pima Tribe." *Indian's Friend* 23 (1911): 2.

This is a reprint of the article which appeared in *The Native American* 12.20 (May 1911): 256-257. See next entry.

562. _____. "Pima Basketry." *The Native American* 12.20 (May 1911): 256-257.

Narsa, a Pima Indian, briefly describes the steps in making a basket. She notes on page 257 that "Of late years few baskets have been made owing to the poor prices received from the curio dealers, but it is hoped that the industry will be encouraged by the white people that this native art may not be lost."

563. Navajo Arts and Crafts Guild. *The Story of the Navajo Arts and Crafts Guild*. Albuquerque: W. Anderson Print Company, 1970.

The creation of the Navajo Arts and Crafts Guild is

discussed, and its influence on modern basket makers is briefly dealt with.

564. Navajo School of Indian Basketry. *Indian Basket Weaving*. Los Angeles: Navajo School of Indian Basketry, 1903; reprint ed., New York: Dover Publications, 1971.

This book, prepared by the Navajo School of Indian Basketry, explains and illustrates how to make various Indian baskets. Emphasis is on the Southwestern tribes.

565. Newman, Sandra C. *Indian Basket Weaving: How To Weave Pomo, Yurok, Pima, and Navajo Baskets*. Flagstaff: Northland Press, 1974.

This is an extensive and comprehensive discussion of baskets produced by the Pomo, Yurok, Pima, and Navajo. Newman lived among tribal members, learning basketry techniques firsthand.

566. Oglesby, C. *Modern Primitive Arts of Mexico, Guatemala and the Southwest*. New York: Whittlesey House, McGraw-Hill Book Company, 1939.

Oglesby discusses the basketry of the Hopi on pages 48-67.

567. O'Kane, Walter Collins. *Sun in the Sky*. Norman: University of Oklahoma Press, 1950.

O'Kane briefly describes the process of making a Hopi coiled basket on pages 142-149.

568. Orchard, William C. "An Unusual Pomo Basket." *Indian Notes, Museum of the American Indian, Heye Foundation* 2. New York: Museum of the American Indian, Heye Foundation, 1925 pp. 102-109.

Orchard describes a large Pomo basket, which had been subjected to long use. The basket was donated to the Museum of the American Indian by Harmon W. Hendricks.

569. Otis, R. *Indian Art of the Southwest; an Exposition of Methods and Practice*. Santa Fe: New Mexico Southwest Indian Fair, 1931.

Southwest Indian basketry is briefly discussed.

570. Pepper, George Hubbard. *The Ancient Basket Makers of Southeastern Utah*. American Museum of Natural History, Guide Leaflet, no. 6. New York: American Museum of Natural History, 1902.

This brief pamphlet served as a guide to Basketmaker relics on display at the American Museum of Natural History.

Pepper focused on material culture, with baskets being described in great detail.

571. _____. "The Ancient Basket Makers of Southeastern Utah." *The American Museum Journal* 2.4 (1902).

See previous entry.

572. Pike, Donald. "The People Who Have Vanished." *American West* 10.6 (1973): 40-47.

The Anasazi at Mesa Verde are discussed. The Basketmaker Culture is referred to on page 43.

573. Reagan, Albert B. "The Basket Makers and the People of the Ancient Culture of the Fremont River in Utah." *Northwest Science* 7 (1933): 52-55.

Reagan investigated the relationship between the Basketmaker Culture and the Fremont Culture of the Fremont River in Utah. After delineating the features of this ancient Fremont people, he termed their culture as Basketmaker IV. Because "the whole Basket Maker culture as it has been considered...is the culture of the Utioux (ancient Ute-Chemehuevi) branch of the Shoshonean family of Indians...," Reagan suggested that the term Basketmaker be changed to Utioux, and the stages of that culture be designated as Utioux I, Utioux II, Utioux III, and Utioux IV.

574. Reyman, Jonathan E., with Sandra Faikus, Sari Kessler, Laurie Ruedi, Anne Weirich, Susan Wexler. *A Catalogue of Native American Basketry at the LaSalle County Historical Society Museum Utica, Illinois*. Utica: Illinois State University, Anthropology Program, 1979.

Reyman discovered a collection of American Indian baskets in the LaSalle County Historical Society Museum in Utica, Illinois. The baskets were in need of cleaning and preservation. After restoration, an effort was made to identify the baskets. At least fifteen groups are represented by the various basketry specimens in the collection. Southwest groups include Apache, Havasupai, Hopi, Papago, and Walapai.

575. Reynolds, D. "Basket Weavers of the Southwest." *Design* 38 (1936): 24-27.

Basket making among the Southwestern tribes is briefly discussed.

576. Roberts, Frank H. H. "A Late Basket Maker Village of the Southwest." *Exploration and Fieldwork of the Smithsonian Institution in 1927*, pp. 165-172. Washington, D. C.: Government Printing Office, 1928.

Roberts notes that "baskets were the main containers, and it is probable that the funerary deposits were of mater-

ials which long since have crumbled into dust."

577. _____. *Ruins at Kiatuthlanna, Eastern Arizona.* Bulletin of the Bureau of American Ethnology, no. 100. Washington, D. C.: Government Printing Office, 1931.

Roberts discusses basketry and house remains of Zuni Indians at Kiatuthlanna, Arizona.

578. Roberts, Helen H. *Basketry of the San Carlos Apache Indians.* American Museum of Natural History, Anthropological Papers, no. 31.2. New York: American Museum of Natural History, 1929; reprint ed., Glorieta, New Mexico: Rio Grande Press, 1972.

This is a detailed study of San Carlos Apache basketry. More attention is given to coiled than twined basketry because Roberts believed the differences are not so definable in the twined work, which is also on the whole more crudely executed.

579. _____. "Double Coiling." *American Anthropologist* 18 (1916): 601-602.

Roberts discusses double coiling in San Carlos Apache basketry.

580. Robinson, Alambert E. *The Basket Weavers of Arizona.* Albuquerque: University of New Mexico Press, 1954.

A. E. "Bert" Robinson, former superintendent of the Pima Indian Agency in Arizona, discusses in detail the baskets of the Walapai, Havasupai, Chemehuevi, Hopi, Apache, Yavapai, Pima, and Papago.

581. _____. "The Basketmakers of Arizona." *Arizona Highways* 27.8 (1951): 30-39.

Robinson provides a general overview of basket making among the various tribes in Arizona.

582. Ross, E. H. "Basketry of the American Indian." *The Museum, Newark* n.s. 10 (1958): 14-27.

The Newark Museum began quite early to collect American Indian basketry. The baskets came primarily from the Cyrus O. Baker estate and the Gibson Collection. Using the museum's collections, Ross presents an overview of the Indian basketry of western North America.

583. Rossbach, Ed. "Thinking About Historical Baskets." *Fiberarts* 11.1 (January-February 1984): 32-33, 70.

Rossbach, reflecting on the aspects of survival of primitive peoples living in extremely harsh environments, briefly reviews two books which present this theme: *The*

Survival Arts of the Primitive Paiutes and *Basketry of the Papago and Pima.*

584. Rozaire, Charles E. *Indian Basketry of Western North America.* Los Angeles: The Bowers Museum, 1977.

This catalog accompanied a 1977 exhibition of American Indian baskets at the Bowers Museum.

585. _____. "Twined Weaving and Western North America Prehistory." Ph.D. dissertation, University of California, 1957.

Rozaire examines in detail twined weaving among the tribes inhabiting along the Pacific coast from the Aleutian Islands to northern California.

586. Sandlin, Scott. "Navajo Basketry: Its Origins are Obscure, but Tradition is Flourishing." *The Indian Trader* 14.10 (October 1983): 9-14, 17.

Sandlin examines the trading activities of John Fontz of Kirkland, New Mexico. He notes that the Navajo at one time were highly recognized for their basketry, but the craft declined in the 1940s because of taboos. Revival of basket making among the Navajo was by way of the Paiute.

587. Sapir, Edward. "An Apache Basket Jar." *Museum Journal, University of Pennsylvania* 1 (1910): 13-15.

Sapir points out that the bands of Apache in New Mexico and Arizona differ significantly in their basketry. Those in Arizona produce a finer quality of basketry. He describes and illustrates a jar-shaped basket made by the Arizona Apache.

588. Sayles, E. B. "Infant Burial in Carrying Basket." *Texas Archaeological and Paleontological Society, Bulletin* 13 (1941).

During a survey of Texas for Gila Pueblo, Sayles discovered an infant burial in the Rustler Hill region near Tayah. A twined carrying basket, supported by four yucca stalks and tied with yucca leaves to an oval frame formed by a bent twig, contained the infant burial. Cultural remains were identified as Hueco Cave Dweller.

589. Shreve, Margaret. "Modern Papago Basketry." *Kiva* 8.2 (1943): 10-16.

Shreve examined recent changes in Papago basketry. Some Papago basketry forms and techniques had gone completely out of use. Some had been altered, and some had appeared for the first time.

590. _____. "Modern Papago Basketry." Master's thesis, Uni-

versity of Arizona, 1943.

Shreve, in this study of modern Papago basketry, attempted to identify the changes which had occurred since contact with Europeans. Basketry was studied first as a trait within Papago culture, and then as a complex of technological, sociological, and economic traits.

591. Sides, Dorothy S. *Decorative Art of the Southwestern Indians*. Santa Ana: Fine Arts Press, 1936; reprint ed., New York: Dover Publications, 1961.

Sides collected a vast amount of material, especially from the Southwest Museum, to depict a comprehensive selection of the designs on pottery, basketry, and other artifacts of the Southwestern tribes.

592. Smith, Victor J. "The Relation of Southwestern Basket Maker to the Dry Shelter Cultures of the Big Bend." *Texas Archaeological and Paleontological Society, Bulletin* 4 (1932): 55-62.

Smith discusses the possible presence of a Basketmaker culture in the Big Bend area of Texas. He suggests that enough material had been accumulated to identify an older culture which extends from El Paso to the Devil's River. He employs the term "Big Bend Culture."

593. _____. "The Split Stitch Basket, a Distinguishing Culture Trait of the Big Bend in Texas." *Texas Archaeological and Paleontological Society, Bulletin* 7 (1935): 100-104.

Smith identifies the different culture traits between the Big Bend area in Texas and the southwestern Basketmakers. These include the use of small reed arrows in western Texas, some times fitted with blunt points; differences in sandal techniques; and differences in basketry technique. Attention is directed at basketry. Smith argues that the coiled bundle foundation with split stitch assembly is the typical and distinguishing feature of the Big Bend Culture.

594. Smith, William N. "Observations Regarding Seri Indian Basketry." *Kiva* 25.1 (1959): 14-17.

Since 1952 there had been a steady decline in the production of Seri baskets. Formerly every Seri woman past puberty owned a basket, usually self-produced. White schools and missionary activity, according to Smith, have resulted in a decline of basket making. It resulted in an increasing sense of cultural inferiority on the part of the Seri toward White culture in general.

595. Stevenson, James. "Illustrated Catalogue of the Collections Obtained from the Indians of New Mexico," pp. 423-465. *Annual Report of the Bureau of American*

Ethnology. no. 2. Washington, D. C.: Government Print-
ing Office, 1883.

Stevenson illustrates a Santa Clara pottery meal basket
on page 446.

596. Stewart, Omer C. "Navaho Basketry as Made by Ute and
Paiute." *American Anthropologist* 40.4 (1938): 758-759.

Stewart challenges Tschopik's statement that baskets
made by the Paiute and Ute for use in Navajo ceremonies were
"made according to Navaho ritual requirements." The only
requirement among the Ute and Paiute was that miniature bas-
kets had to be completed in one day.

597. _____. "The Navaho Wedding Basket." *Plateau* 10 (1938):
25-28.

Stewart provides one of the earliest accounts of the
manufacture of the Navajo wedding basket made by the Paiute
and Ute.

598. Stone, Margaret. "Basketmaker of the Hualpai." *Desert
Magazine* 6.1 (1943): 21-23.

This is a brief description of the baskets made by
Queenie of the Hualpai. They were coiled baskets made from
split willow and devil's claw.

599. _____. "Craftsman of the Pahutes." *Desert Magazine* 6
(1943): 5-8.

Stone discusses Mary Pepo, a northern Paiute basket
maker, and attempts by the Federal government to stimulate
production and sale of genuine Indian crafts to increase the
source of livelihood of many Indians.

600. Tanner, Clara Lee. *Apache Indian Baskets.* Tucson:
University of Arizona Press, 1982.

Tanner investigates in depth the basketry of the
Western Apache, Jicarilla, and Mescalero tribes. The
baskets of each of these tribes is described and illustrated
within the context of their evolution from different life
styles and cultural environments. The materials, forms,
techniques, and designs are thoroughly studied.

601. _____. "Basketry of the Modern Southwest Indians." *Kiva*
9 (1944): 18-26.

Tanner briefly discusses the basketry of the Walapai,
Havasupai, Yavapai, Chemehuevi, Southern Paiute, and Ute.

602. _____. *Indian Baskets of the Southwest.* Tucson: Uni-
versity of Arizona Press, 1983.

Tanner demonstrates the wide range of Southwest Indian basketry. The basketry of prehistoric Indians in the Southwest are examined. The differences among the contemporary basket makers of the Hopi, Papago, Pima, Yuma, Navajo, Paiutes, Utes, Chemehuevi, and Apache are fully discussed.

603. _____. "The Influence of the White Man on Southwest Indian Art." *Ethnohistory* 7 (1960): 137-150.

The impact of tourism, traders, and collectors on the basketry of the Hopi, Papago, Pima, and Apache is discussed.

604. _____. "Papago Burden Baskets in the Arizona State Museum." *Kiva* 30.3 (1965): 57-76.

Tanner describes the keehos (*kiahas*) made and used by the Papago and Pima Indians of southern Arizona. All-over and generally four-part designs were produced in the lace-like coil-without-foundation weave. These patterns were emphasized by rubbing red and blue coloring over them. Desert plants supplied materials for this all-purpose carrying basket.

605. _____. *Prehistoric Southwestern Craft Art*. Tucson: University of Arizona Press, 1976.

Chapter Two discusses "Materials, Technologies, Form, and Decoration." Prehistoric basketry from the Southwest is described.

606. _____. *Southwest Indian Craft Arts*. Tucson: University of Arizona Press, 1968.

Chapter Two discusses baskets.

607. _____. "Western Apache Baskets." *Plateau* 53 (1982): 23-32.

Tanner discusses the styles and designs of traditional Western Apache baskets of the Colorado Plateau.

608. Tanner, Clara Lee, and John F. Tanner. "Contemporary Hopi Crafts: Basketry, Textiles, Pottery, Kachinas." In *Hopi Kachina-Spirit of Life*. Edited by Dorothy K. Washburn. Seattle: University of Washington Press, 1980.

The Tanners provide a general overview of contemporary Hopi basket making.

609. Tanner, Clara Lee, and Richard Kirk. *Our Indian Heritage; Arts That Live Today*. Chicago: Follett Publishing Company, 1961.

Written for juveniles, this book describes and illustrates the baskets and basket makers of the major Southwest

tribes.

610. Tschopik, Harry. "Coiled Basketry Techniques in the Southwest." In *Artifacts of Perishable Materials*, pp. 94-130. University of New Mexico, Anthropology Series, no. 3. Albuquerque: University of New Mexico Press, 1939.

Tschopik describes three basketry specimens from Chaco Canyon, New Mexico. Two are close-coiled. The third, given more treatment, was tentatively identified as "a fragment of a 'bird's-nest' coiled storage basket of the general type reported from among the Pima, Yuma, and most southern California groups."

611. _____. "Navaho Basketry: A Study of Culture Change." *American Anthropologist* 42.3 (July-September 1940): 444-463.

Although three types of basketry were formerly made by the Navajo, only one form--the coiled basket tray--had persisted. Tschopik argued that while the form had remained stable, the use, meaning, and function of the coiled basket tray had changed. He concluded that because of the loss of utilitarian needs, baskets became "rarity objects."

612. _____. "Taboo as a Possible Factor Involved in the Obsolescence of Navaho Pottery and Basketry." *American Anthropologist* 40.2 (April-June 1938): 758-759.

Elaborate taboos associated with ceremonial objects discouraged potters and basket makers from practicing their art. Omer C. Stewart responded to this argument in "Navaho Basketry as Made by Ute and Paiute," *American Anthropologist* 40.4 (1938): 758-759.

613. Turnbaugh, Sarah Peabody. "Anasazi Yucca Ring Basket." Master's thesis, University of Rhode Island, 1983.

614. _____. "The Yucca Ring Basket of the Anasazi." *Shuttle, Spindle & Dyepot* 9.1 (1977): 101-102.

The yucca ring basket is the oldest known continuous form of plaited textile in North America. Turnbaugh uses the study of the yucca ring basket to investigate the culture of the Anasazi.

615. Van Roekel, Gertrude B. *Jicarilla Apaches*. San Antonio: The Naylor Company, 1971.

Van Roekel mentions the success of the Jicarilla arts and crafts shop, where beadwork, leatherwork, and basketwork were the specialties. She includes photographs of a "Display of Baskets at Indian Fair," "Margarita De Dios Weaving at the age of 76," and "Goot-cha-du Julian, early basket maker, 1863."

616. Vivian, G. "The Navaho Baskets." *El Palacio* 64.5 and 6 (1957): 145-155.

The two Navajo baskets discussed were part of a cache found on the Chacra Mesa east of Chaco Canyon. The baskets were identified as Navajo from their form and from their association with the Navajo pottery, and as of local manufacture from the fact that a bundle of similar basket making material was stored there.

617. Wadsworth, Beula Mary. "The Pima Decorative Basket." *School Arts* 38.2 (October 1938): 44-48.

The designs on Pima baskets are discussed and illustrated. Wadsworth notes that while some differentiation of available materials in the baskets of the Pima and Papago had resulted in a "recognizable heavy, cardboard construction to the Papago basket and a lighter, more flexible quality to the Pima," the close interaction of the two tribes has caused a mingling of designs.

618. Wallace, William J. "A Basket Weaver's Kit from Death Valley." *The Masterkey* 28 (1954): 216-221.

Wallace describes a cache of basket making materials from Mesquite Flat, Death Valley. The kit was found in a wooden box constructed during the historic period. He suggests that it is possibly of Shoshone origin.

619. Watkins, Frances E. "Another Basket Collection." *The Masterkey* 9.4 (1935): 120-122.

Watkins describes the addition of the basket collection of Martha A. Jenks, which was donated to the Southwest Museum. The Caroline Boeing Poole Collection consists of approximately 2500 baskets, woven for the use of the Indians who made them. They were not made for sale or trade. Many show actual signs of the uses for which they were intended; others are virtually new. There are no two baskets alike.

620. _____. "Crafts and Industries of the American Women of California and the Southwest." Ph.D. dissertation, University of Southern California, 1942.

Watkins studied the field of material culture as it related to the Indian women of California and the Southwest. Detailed information regarding basketry and other crafts was limited because they had reached such a high degree of excellence that specialization had developed within the tribal groups. Watkins attempts to ascertain the place of Indian women of California and the Southwest in the economic and industrial life of the various cultural groups.

621. Weltfish, Gene. "Cave-Dweller Twill-Plaited Basketry, Southern Chihuahua." Appendix to *Report on Archeology*

of Southern Chihuahua. Edited by Robert M. Zingy.
University of Denver, Contributions to Ethnography 2
(1940): 69-89.

Weltfish analyzes and compares the Cave-Dweller-twill-
plaited basketry of southern Chihuahua with that of the
modern Tarahumara, Papago, and Pima.

622. _____. "Preliminary Classification of Prehistoric
Southwestern Basketry." *Smithsonian Miscellaneous Col-
lections* 87.7 (1932): 1-47.

After surveying extant basketry remains from the South-
west, Weltfish attempted a major classification of the
basketry.

623. _____. "Problems in the Study of Ancient and Modern
Basket-Making." *American Anthropologist* 34.1 (1932):
108-117.

Weltfish develops a typological consideration of North
American prehistoric basketry and the historical problems
suggested by it. Five general types of prehistoric basketry
material are identified: Southwestern, Ozark Bluff Dwell-
ers, Lovelock, Snake River, and California Cave. Signifi-
cantly, parallels for the prehistoric technical types in all
five cases were found in modern areas closely contiguous to
the prehistoric sites.

624. West, Marguerite. "The Papoose Basket." *Westworld* 1.5
(September-October 1975): 42-43, 45-46.

In 1912, George and Margaret Dayton were living at an
inn about twenty-five miles from Vancouver, British Colum-
bia. Mrs. Dayton was experiencing labor pains, but they
were several miles from a doctor. An elderly Indian woman
happened to visit the inn. Although she was unable to speak
English, the husband managed to explain their predicament.
The Indian woman served as a mid-wife, and successfully
delivered the baby. The next day she returned with a
papoose basket as a gift for the infant.

625. Whiting, Alfred F. *Ethnobotany of the Hopi.* Bulletin
of the Museum of Northern Arizona, no. 15. Flagstaff:
Museum of Northern Arizona, 1950.

Next to pottery, baskets were perhaps the most useful
containers that the Hopi had in the old days, and in modern
times the sale of baskets and pottery is an important ele-
ment in the Hopi economy. The yucca plant is essential to
Hopi basketry. The local supply of yucca had been sorely
depleted due to increased demand for baskets. Sifter bas-
kets are made almost entirely from yucca. In the coiled
basketry made on the Second Mesa, strips of yucca leaf are
bound around a fill of galleta grass or occasionally the
blue grama. In the Third Mesa basketry, yucca served only

as a finishing binding to a wicker work made of the colored stems of rabbit brush or sumac. Another form of basketry was made of split stems of *Parryella filifolia*. Baskets were colored with a variety of native dyes. The bark of rabbit brush made an inferior green dye and the flowers yielded a bright yellow dye. Blue came from the blue bean as well as from indigo obtained originally from Mexico. Blue and yellow combined created a green. The seeds of cultivated sunflower and the purple corn yielded purple dyes. Pinon gum was involved in the preparation of a black dye which is made from either the bean or sunflower.

626. Williamson, A. "San Carlos Apache Basketry: A Vanishing Art." *Arizona Highways* 15 (August 1939): 12.

Williamson suggests that the basketry of the San Carlos Apache Indians was on the verge of extinction.

627. Williamson, Ten Broek. "The Jemez Yucca Ring-Basket." *El Palacio* 42.7, 8 and 9 (1936): 37-39.

This basket consists of two parts, a woven mat and a withe ring to which the mat is bound.

628. _____. "The Jemez Yucca Ring-Basket." *Indians at Work* 5.2 (1937): 33-35.

The yucca ring basket consists of two parts, a woven mat and a withe ring to which the mat is bound. Williamson describes the manufacture of this type of basket at Jemez Pueblo by Anna Maria Toya.

629. Zastrow, Leona M. "American Indian Women as Educators." *Journal of American Indian Education* 18.1 (October 1978): 6-10.

By teaching children in the manner in which they themselves were taught by their elders, female Papago, Pima, and Pueblo artists are continuing the role of traditional tribal arts, including basketry, among their people. This use of traditional materials is occasionally innovative, but usually affects traditional design.

California

630. Abel-Vidor, Suzanne with Sandra Metzler. "The Pomoan Peoples and Their 'Basketry Marvels'." *The Sun House* (n.d.): 5-7.

In this article about the Pomo Indians and their baskets, Abel-Vidor provides ethnohistorical information about the Pomo Indians, while Metzler discusses the Sun House collection of Pomo baskets.

631. Allen, Elsie. *Pomo Basketmaking: A Supreme Art for the Weaver*. Healdsburg, CA: Naturegraph Publishers, 1972.

Elsie Allen, a fourth generation Pomo basket maker, narrates to her granddaughter stories about her unusual life. In addition, she shows in great detail how the Pomo made their baskets. Detailed descriptions, accurate drawings, and photographs (some showing Elsie Allen at work) provide the necessary information to allow others to make these baskets.

632. Amsden, Charles. "Arts and Crafts of the Southwestern Indians." *The Masterkey* 15.3 (1941): 74-80.

Amsden briefly relates the importance of basketry among the tribes in the Southwest and California.

633. Anonymous. "A Beautiful Basket." *Papoose* 1.2 (January 1903): 30.

Describes and illustrates a Tulare basket in the collection of J. W. Burdick.

634. _____. "California Baskets." *Papoose* 1.2 (1902): 32-33.

Briefly describes Indian baskets from California.

635. _____. "California Baskets Added to Office Collec-
tion." *Smoke Signals* 1.7 (May 1953): 11-12.

Describes various California Indian baskets purchased
by the Indian Arts and Crafts Board in Washington, D. C.

636. _____. "California Museums Feature Unique Basketry Ex-
hibits." *The Indian Trader* 13.2 (February 1982): 19-21.

This is a review of *Rods, Bundles, and Stitches: A
Century of Southern California Indian Basketry*, the catalog
of an exhibit at the Riverside Museum.

637. _____. *Illustrated History of Indian Baskets and
Plates Made by California Indians and Many Other
Tribes*. Susanville, 1915; reprint ed., Orange Cove,
California: Leo K. Brown, 1967; Reedley, California:
Leo K. Brown, 1972.

All of the baskets illustrated in this volume were ex-
hibited in 1915 at the Panama-Pacific International Exposi-
tion. The baskets were owned by T. A. Roseberry of Susan-
ville, California. The emphasis was on the basketry of the
Northern California tribes. Included, however, are some
excellent examples of baskets from southern California, the
Southwest, the Northwest Coast, and the Arctic regions.

638. _____. "Indian Weaving at the Golden State Fair." *Arts
and Decoration* 50.1 (1939): 25.

Illustrates baskets exhibited at the Golden State Fair.
Included is a photograph of a Pomo woman weaving a twined
basket.

639. _____. "A Marvel in Basketry." *Papoose* 1.5 (April
1904): 23.

Describes a Pomo incurve basket.

640. _____. "A Mission Indian Basket Maker." *Indians* at
Work 9.3 (November 1941): 18.

This is a photograph of a Mission Indian basket maker.
There is no text.

641. _____. *Plimpton Collection of Pacific Coast Indian
Basketry. A Collection Numbering 260 Baskets, and
Representing 84 Tribes & Localities*. West Newton: n.d.

This was one of the finest collections of Pomo and
Tulare baskets in the United States. There are forty-five
Pomo baskets, including the excellent examples of feather
work. There are also twenty Tulare baskets, and several
examples of Kern, Yokuts, and Mono baskets. The Salish and
Alaska tribes are extensively represented.

642. _____. "Pomo Basket Exhibit." *The American Indian* 1.4 (Summer 1944): 30.

Briefly mentions an exhibit of Pomo Indian baskets at the San Francisco Museum.

643. _____. "Two Rare Chumashan Baskets." *Indian Notes, Museum of the American Indian* no. 5. New York: Museum of the American Indian, Heye Foundation, 1928, pp. 266-267.

Describes two coiled baskets made by the Chumash Indians. One of the baskets is illustrated in the text. Thea Heye obtained the baskets for the Museum of the American Indian.

644. _____. "Western Fair Will Compare Styles of Indian Basketry." *Design* 40.3 (October 1938): 26.

Discusses types of Indian basketry to be exhibited at the Golden Gate International Exposition in 1939.

645. Apostol, Jane. "Saving Grace." *Westways* 68 (1976): 22-24.

Apostol discusses the collecting which Grace Nicholson did for various domestic and foreign museums, concentrating on the more than 20,000 Indian baskets which she gleaned from California Indians from 1901 to 1913.

646. Baer, Kurt. "California Indian Art." *The Americas* 16.1 (1959/1960): 23-44.

Basketry is briefly mentioned.

647. Bailey, Richard C. *Collector's Choice; The McLeod Basket Collection.* Bakersfield, California: Kern County Historical Society, 1951.

Bailey relates the story of Edwin McLeod, a collector of Yokuts baskets. Most of the baskets are in the Lowie Museum of Anthropology.

648. Barrett, Samuel A. "Basket Designs of the Pomo Indians." *American Anthropologist* 7.4 (October-December 1905): 648-653.

The Pomo had a tremendous variety of basketry. Barrett questioned informants from the Northern, Central, and Eastern dialects spoken by the Pomo. The questions concerned the 840 patterns shown on photographs of 321 Pomo baskets. These baskets were from the collections of the Museum of the Department of Anthropology of the University of California, the Konigliches Museum fur Volkerkunde of Berlin, and from Roland B. Dixon's "Basket Designs of the Indians of Northern

California."

649. _____. "Material Aspects of Pomo Culture." *Bulletin of the Public Museum of the City of Milwaukee* 20.2 (1952): 261-508.

There is a brief section which discusses Pomo basketry.

650. _____. "The Material Culture of the Klamath Lake and Modoc Indians of Northeastern California and Southern Oregon." *University of California Publications in American Archaeology and Ethnology* 5 (1907-1910): 239-293.

Basketry is discussed on pages 253-257.

651. _____. "Pomo Indian Basketry." *University of California Publications in American Archaeology and Ethnology* 7.3 (1908): 3-276.

There was a tremendous variety in basketry among the Pomo Indians of California. Barrett was particularly interested in the designs and ornamentation. Information was obtained from the Northern, Central, and Eastern groups of Pomo Indians.

652. _____. "The Washoe Indians." *Bulletin of the Public Museum of the City of Milwaukee* 2.1 (1917).

Material culture, especially basketry, is the thrust of this study of the Washoe Indians of the Sierra Nevada. The photographs emphasize baskets--most of which are in the collections of the Milwaukee Public Museum.

653. Barrows, D. P. *The Ethnobotany of the Coahuilla Indians of Southern California.* Chicago: University of Chicago Press, 1900.

Barrows provides an informative analysis of Cahuilla Indian basketry.

654. Bates, Craig D. "Baskets! Baskets! How Collectors Have Influenced the Production and the Design of Baskets Among Indian Peoples of California." *Moccasin Tracks* 9.5 (January 1984): 4-9.

Bates considers the impact that collectors have had through time on the manufacture of baskets among the Indian tribes of California. He also examines the various ways the basket makers responded to this demand for baskets. There are several black and white photographs of prominent basket makers and their wares.

655. _____. "The Big Pomo Basket." *American Indian Basketry* 3.3 (1983): 12-14.

Bates describes a four feet in diameter Pomo coiled

basket in the Museum of the American Indian. The maker and purpose of the basket was unknown. Bates discovered a lengthy article with a photograph of this basket in the *California Indian Herald* 2.2 (February 1924). The article is reprinted, with a few notes about its accuracy.

656. _____. *Coiled Basketry of the Sierra Miwok.* San Diego Museum papers, no. 15. San Diego: San Diego Museum, 1982.

Bates presents a detailed analysis of the traditional and contemporary basket making activities of the Sierra Miwok. He demonstrates that Miwok coiled basketry is one of the most diversified basket making traditions in California.

657. _____. "Ethnographic Collections at Yosemite National Park." *American Indian Art Magazine* 7.3 (1982): 28-35.

The ethnographic collection of the National Park Service in Yosemite National Park represents a major repository of the material culture of the Indian tribes of central California. Bates describes the baskets and discusses the development of the museum housing these collections.

658. _____. "Lucy Telles, A Supreme Weaver of the Yosemite Miwok Paiute." *American Indian Basketry* 2.4 (1982): 23-29.

Lucy Telles, the daughter of Bridgeport Tom and his wife Louisa, created innovative design styles which changed forever the basketry of the Yosemite Miwok/Paiute. Her baskets used two-color, realistic and geometric motifs in an alternating arrangement.

659. _____. "Lucy Telles, Outstanding Weaver of the Yosemite Miwok-Paiute. *Pacific Historian* 24.4 (1980): 396-403.

Bates provides a brief biography of Lucy Telles, and discusses her development of a new basketry style, which used traditional techniques and materials blended with new designs and forms. One of Lucy Telles' favorite shapes was a refinement of the traditional semi-globular Miwok gift basket form. She flattened the upper shoulder of this basket and copied the bottleneck treasure baskets of the Yokuts and Western Mono. Her baskets made in this style are coiled on a three-rod foundation of scraped willow roots.

660. _____. "Made for Sale: Baskets from the Yosemite-Mono Lake Region of California." *Moccasin Tracks* 7.4 (1981): 4-9.

The Southern Sierra Miwok near Yosemite and the Mono Lake Paiute of the Mono Basin, while having distinct traditional cultures, had during the nineteenth century intermarried extensively and eventually formed a new culture that

was a blending of the two. Bates discusses the shared features, especially in coiled basketry, of the Mono Lake Paiute and the Southern Sierra Miwok.

661. _____. "Making Miwok Baskets." *American Indian Basketry* 4.1 (1984): 15-18.

Jennifer Bates, a Northern Miwok, has been one of the very active weavers of coiled baskets during the past decade. Bates discusses and illustrates the gathering and preparing of materials and the weaving of coiled baskets.

662. _____. "Miwok-Paiute Basketry 1920-1929: Genesis of an Art Form." *American Indian Art Magazine* 4.4 (1979): 54-59.

Bates analyzes the combining of the weaving traditions of the Yosemite area Miwok Indians and the Mono Lake area Paiute Indians. He emphasizes the work of Lucy Telles.

663. _____. "Tabuce: A Mono Lake Paiute Woman." *Moccasin Tracks* 9.6 (February 1984): 4-8.

Maggie "Tabuce" Howard was a Paiute woman of the Mono Lake-Yosemite region of California. In 1926, the National Park Service built the Yosemite Museum. Part of this complex was an authentic Yosemite Indian village. Tabuce was employed to construct acorn storehouses. For over twenty years, she demonstrated to park visitors various traditional crafts and domestic activities. Bates discusses her basket making skills.

664. _____. "Yosemite Miwok/Paiute Basketry: A Study in Cultural Change." *American Indian Basketry* 2.4 (1982): 4-22.

Miwok/Paiute families in the Yosemite Valley made a coiled basket which was a blending of the Mono Lake Paiute and Southern Miwok styles. It was usually three-rod construction, non-interlocking stitch, and weft usually in split shoots. Considerable information about this type of basketry comes from the Captain Sam family, especially the daughters, Leanna and Louisa. About 1910, a new style of basketry began in the Mono Lake and Yosemite region. Lucy Telles and Emma Murphy are noted for producing this style of work. Bates discusses the growth and eventual decline of this style of basketry.

665. _____. "Yosemite Miwok Basketry: The Late 19th Century." *American Indian Basketry* 4.1 (1984): 4-14.

Relying on paintings, photographs, written accounts, and collections of baskets, Bates examines the basketry styles of the Yosemite Miwok. He demonstrates that Miwok women in Yosemite National Park deviated less from traditional basketry patterns than did the neighboring Miwok-

Paiute.

666. Bates, Craig D. and Brian Bibby. "Collecting Among the Chico Maidu: The Stewart Culin Collection at the Brooklyn Museum." *American Indian Art Magazine* 8.4 (1983): 46-53.

Bates and Bibby describe and illustrate approximately 150 items collected from the Chico Maidu by Stewart Culin. At that time, Culin was the curator of the Brooklyn Museum. A Maidu cooking basket, a storage basket, and a historical photograph of Mary Keg'a'ala Azbill and her son are included.

667. _____. "Maidu Weaver: Amanda Wilson." *American Indian Art Magazine* 9.3 (1984): 38-43, 69.

Bates and Bibby discuss and illustrate the baskets made by Amanda Wilson, a Maidu Indian weaver from the village of Michopdo near Chico, California.

668. Bates, Craig D. and Bruce Bernstein. "Regional Variation in Maidu Coiled Basketry Materials and Technology." *Journal of California and Great Basin Anthropology* 4 (1982): 187-202.

Regional differences in the style and technology of the baskets of the Maidu Indians of California often coincided with the native social and political order of autonomous villages.

669. Baumhoff, Martin A. "Appendix: Carbonized Basketry from the Thomas Site," pp. 9-11. *Reports of the University of California Archaeological Survey, Papers in California Archaeology*, no. 19. Berkeley: University of California, 1953.

Sixteen pieces of coiled basketry recovered from the Thomas Site, apparently from a single basket, are discussed. The foundation was a single rod and was sewn with a single interlocking stitch.

670. _____. "Catlow Twine from Central California." *University of California Archaeological Survey, Annual Reports* 38 (1957): 1-5.

The Catlow Twine basketry technique has a wide occurence in western North America. This particular technique does not occur ethnographically in central California, but has been found in archaeological contexts. Baumhoff describes a specimen of Catlow Twine basketry found in a cave near Altamont, Alameda County, California.

671. Bean, Lowell John and Katherine Siva Saubel. *Temalpakh: Cahuilla Indian Knowledge and Usage of Plants.* Banning: Malki Press, 1972.

Cahuilla basketry is discussed on pages 23-25. Cahuilla baskets are known for their closeness of weave, elaborate designs, and interfacing of natural and dyed colors in design backgrounds. Baskets were made for ritual and ceremonial functions; and also for household and gathering use. Forms included shallow flaring bowls, large deep baskets, flat plates, woman's cap, and small bottleneck-like receptacles. Basket making among the Cahuilla is almost extinct.

672. Bedford, Clay P. *Western North America Indian Baskets from the Collection of Clay P. Bedford*. San Francisco: California Academy of Sciences, 1980.

The Clay P. Bedford basket collection contains examples from many different areas, but he selected for this exhibit at the California Academy of Sciences specific baskets from the western corridor of North America. Bedford provides descriptions of the basketry technique of each basket in the exhibit.

673. Benson, Foley C. *From Straw Into Gold: Selected Indian Basketry Traditions of the American West*. Santa Rosa: Santa Rosa Junior College Jesse Peter Memorial Museum, 1986.

From Straw Into Gold describes an exhibition of basketry held at Santa Rosa Junior College's Jesse Peter Memorial Museum. The basket collection was donated to the college by the Sonoma County Historical Society. The collection contains basketry from twenty-six tribes, mainly from the western states. Most of the baskets were collected between 1895 and 1930. The basketry of the Pomo is discussed at length. Attention is also given to the basketry of the southern and northern California tribes.

674. Bernstein, Bruce. "Panamint Shoshone Basketry." *American Indian Art Magazine* 7 (1982): 68-74.

Bernstein discusses the techniques, tools, materials, and designs which distinguish coiled baskets of the Panamint Shoshone Indians in Inyo County, California made for sale between 1890 and 1910.

675. Branstetter, Katherine. "Achumawi Basketry." Master's thesis, University of California, 1967.

676. _____. "A Wiyot Fancy Basket." *Journal of California and Great Basin Anthropology* 2.2 (1980): 266-269.

A fancy basket, also known as a treasure, trinket, or gift basket, is a decorated basket of no obvious work function. It was an aboriginal type for most basket weaving cultures of California. It was made to store small items or to be presented as a gift and an example of a woman's pride in her work.

677. Brown, Clara S. "The Art of Indian Basketry." *The Catholic World* 68.403 (1898): 52-59.

Brown interviewed Mrs. Belle M. Jewett, a noted collector from Lamanda Park, California. Jewett described many of the baskets in her collection, and provided anecdotes of her collecting adventures. Jewett was also trying to find an institution willing to accept the collection.

678. Brown, Vinson and Douglas Andrews. *The Pomo Indians of California and Their Neighbors*. Healdsburg: Naturegraph Publishers, 1969.

Pomo basketry is briefly discussed on pages 34-36.

679. C. F. R. "Two Collections of American Indian Baskets." *The Bulletin of the Cleveland Museum of Art* 17 (1930): 199-201.

Describes the donation of the American Indian basket collections of Mrs. Horace Kelley and Mrs. Lionel A. Sheldon to the Cleveland Museum of Art. The baskets are primarily from the Southwest, California, and the Northwest Coast.

680. Carr, Jeanne C. "Among the Basket Makers." *The Californian* 2.5 (October 1892): 597-610.

Carr describes and illustrates some of the major types of baskets from the Pacific coast area. She discusses the art of basketry in Japan, and compares it with the basketry of the Indian tribes along the Pacific coast.

681. Carson, Ann, compiler. *Basketry Techniques and Methods Utilized by Mono and Foothill Yokuts Groups*. n.p., n.d.

The descriptions and illustrations of the basketry of the Mono and Foothill Yokuts were extracted from Robert F. Heizer, volume editor. *California*, volume 8. *Handbook of North American Indians*. Edited by William C. Sturtevant. Washington, D. C.: The Smithsonian Institution, 1978; Sandra Corrie Newman, *Indian Basket Weaving: How to Weave Pomo, Yurok, Pima, and Navaho Baskets* (Flagstaff: Northland Press, 1974; and Sonja Wilson, *Plant Associations and Resources of the Kerkhoff and Shaver Lake Areas*.

682. Chase, Don M., Carl Purdy, and Clara MacNaughton. *The Basket Maker Artist*. Sebastopol, California: D M Chase, 1977.

Chase reprints Carl Purdy's "The Pomo Baskets and Their Makers," *Out West* 16 (1902) and Clara MacNaughton's "Nevada Indian Baskets and Their Makers," *Out West* 18.4 and 5 (1903). Chase discusses briefly the work of Dat-So-La-Lee, and the baskets of the Yurok and neighboring tribes.

683. Chestnut, Victor K. "Plants Used by the Indians of Mendocino County, California." *Contributions from the U. S. National Herbarium* 7.3 (1902): 295-408.

Various plants used by the Indians in the Round Valley Indian Reservation and at Ukiah are identified and discussed. The making of sedge-root baskets receives extended treatment. There is a photograph of Pomo Indian baskets made of sedge root.

684. Cohodas, Marvin. "Lena Frank Dick: An Outstanding Washoe Basket Weaver." *American Indian Art Magazine* 4 (1979): 32-41, 90.

Cohodas explores the life and career of Lena Frank Dick (1889-1965), a largely unknown but exceptional basket weaver from Coleville, California.

685. Connor, J. "The Old Basket-Weaver of San Fernando." *Overland Monthly* 31.181 (1898): 28-32.

Connor relates his efforts to purchase an "authentic" Indian basket from an elderly Indian woman.

686. Connor, J. Torrey. "Confessions of a Basket Collector." *The Land of Sunshine* 5.1 (1896): 3-10.

Connor describes in detail and with photographs the basket collection of Belle M. Jewett of Lamanda Park, California. Connor states: "Before collecting became epidemic, there was always the chance of picking up a real 'find' in some out-of-the-way spot; but the curio dealer has cornered about everything that has escaped the prowling collector, and nowadays you bargain for your basket over the counter."

687. Craig, Steve. "The Basketry of the Ventureno Chumash." *Archaeological Survey, University of California* 9 (1967): 78-149.

Craig uses the ethnographic and linguistic notes of John P. Harrington to describe Ventureno Chumash basketry. Included are photographs of baskets and fragments of baskets from archaeological sites in the Santa Monica Mountains.

688. _____. "Ethnographic Notes on the Construction of Ventureno Chumash Baskets; from the Ethnographic and Linguistic Field Notes of John P. Harrington." *Archaeological Survey, University of California* 8 (1966): 197-214.

Craig, using John P. Harrington's ethnographic field notes, describes the manufacture of Ventureno Chumash baskets.

689. Crawford, Virginia. "Artistic Basketry of the North American Indian." *The Bulletin of the Cleveland Museum*

of Art 73.7 (September 1986): 278-297.

The basketry collection of the Cleveland Museum of Art emphasizes the western part of North America. Approximately one-half of the collection was donated in 1917 by William Albert Price and his wife. Crawford discusses the variety of form and design found in American Indian basketry. Baskets from the museum's collections are used to illustrate the text.

690. Cummins, Marjorie W. *The Tache-Yokuts Indians of the San Joaquin Valley. Their Lives, Songs, and Stories.* Fresno: Pioneer Publishing Company, 1978; second edition, revised and enlarged, 1979.

On pages 26-27, there are two illustrations and a brief discussion about Tache-Yokuts baskets.

691. Curtin, L. S. M. *Some Plants Used by the Yuki Indians of Round Valley, Northern California.* Southwest Museum Leaflets, no. 27. Los Angeles: The Southwest Museum, 1957.

Curtin lists the various plants used by the Yuki Indians of Round Valley to make baskets.

692. Dalton, O. M. "California: Basket Work. Note on a Specimen of Basketwork from California Recently Acquired by the British Museum." *Man* 1.17 (1901): 23-24.

Among the items in the ethnographic collection of Reverend Selwyn C. Freer which was donated to the British Museum were several baskets from California and Oregon. One basket in particular is described and illustrated. It is a twined basket attributed to the Umpqua Indians.

693. Davis, Edward H. "Diegueno Basketry and Pottery." *Pacific Coast Archaeological Society Quarterly* 3 (1967): 58-64.

Davis briefly discusses Diegueno Indian basketry.

694. Davis, Emma L. and William Allan. *Diegueno Coiled Baskets.* San Diego Museum of Man, Ethnic Technology Notes, no. 1. San Diego: San Diego Museum of Man, 1967.

Davis and Allan describe a small but well-documented sample of fifty-one basket bowls and jars made by Diegueno women on Inaja Reservation in San Diego County, California. These baskets were collected between 1875 and 1900 by the parents and family of Mr. Charles Kelly.

695. Dawson, Lawrence E. "The Indian Basketry." In *Indians of California.* San Francisco: The Book Club of California, 1973.

Dawson provides a brief overview of Indian basketry in California.

696. Dawson, Lawrence E. and James Deetz. "A Corpus of Chumash Basketry." *Archaeological Survey, University of California, Annual Report* 7 (1965): 193-275.

Dawson and Deetz discuss the early history of Chumash basketry, materials and techniques of manufacture, design elements, and relationship with neighboring tribes.

697. Deetz, James F. "Basketry from the James-Abel Collection." *Museum Talk, Santa Barbara Museum of Natural History* 38.2 (1963).

This is a brief summary of basketry collected from caves in the Sierra Madre Mountains between the Sisquol and Cuyana Rivers in Santa Barbara County, California.

698. Degenhart, Pearl C. "Hupa Indian Basket Designs." *School Arts* 30 (1931): 629-631.

This is a brief description of Hupa basket designs. Design motifs on Hupa baskets are illustrated in the text.

699. _____. "Pine Needle Baskets." *School Arts* 50.9 (May 1951): 317.

A Hupa Indian basket maker demonstrated her skills to the students of Areata High School. After her visit, the students asked to weave a Hupa basket. The necessary materials were not available, and the techniques proved to be too difficult for the students. Long pine needles were substituted.

700. Dixon, Roland B. "Basketry Designs of the Indians of Northern California." *Bulletin of the American Museum of Natural History* 17 (1902): 1-32.

Dixon discusses markings on Pomo, Maidu, Pit River, Wintu, Moquelumnan, and Yanan basketry.

701. _____. "Basketry Designs of the Maidu Indians of California." *American Anthropologist* 2.2 (April-June 1900): 266-276.

These basket designs were collected from the northern group of Maidu Indians of California. Dixon was able to obtain explanations for approximately twenty designs, which were divided into animal designs, plant designs, and those representing objects.

702. _____. "The Shasta." *Bulletin of the American Museum of Natural History* 17 (1907): 398-403.

Dixon states that "in earlier times, as now, the Shasta relied to a great extent on other tribes for their baskets. At the present day, scarcely a single basket is made by the Shasta; and all that they use, or sell to collectors, are bought from the Karok and other lower Klamath peoples."

703. Douglas, Frederic H. *The Main Divisions of California Indian Basketry.* Denver Art Museum, Indian Leaflet Series, nos. 83 and 84. Denver: Denver Art Museum, 1939.

Because of the number and variety of basketry types among the California Indians, Douglas offers only a broad outline of the various major groupings into which all California basketry falls.

704. Du Bois, Cora. "Wintu Ethnography." *University of California Publications in American Archaeology and Ethnography* 36 (1939): 131-139.

Basketry of the Wintu is discussed on pages 131-139.

705. DuBois, Constance Goddard. "Manzanita Basketry, A Revival." *Papoose* 1.7 (June 1903): 21-27.

DuBois describes baskets made by Diegueno Mission Indians.

706. Dunn, Mary E. "The Maidu Indians of Plumas County. Their Homes, Customs and Language." *Plumas Memories* 8 & 34 (October 1979): 1-29.

The basketry of the Maidu is discussed briefly on pages 9-11.

707. Dwiggins, Don. "Gathering of the Clams." *Westways* 68 (1976): 46-49, 77.

Dwiggins discusses the influence which clam shell patterns had on the designs which Chumash Indians used in their basket making. He includes extensive information about varieties of clams found along the southern California coast.

708. Eisenhart, Linda Lichliter. "Karok Basketry: Mrs. Phoebe Maddux and the Johnson Collection." Master's thesis, George Washington University, 1981.

Eisenhart discusses the basketry of the Karok tribe of northwestern Californa. She relies on the field notes of John P. Harrington, which were based on several extensive visits among the Karok between 1925 and 1929. Karok basket types, weaving technology, materials, and designs are analyzed, in part, with information obtained by Harrington from Phoebe Maddux, his informant.

709. Elsasser, Albert B. "Basketry," pp. 626-641. In *California.* Volume editor Robert F. Heizer. *Handbook of*

North American Indians, volume 8. Edited by William C. Sturtevant. Washington, D. C.: The Smithsonian Institution, 1978.

Elsasser argues that it is possible to describe California Indian basketry as a single unit, even though there were great numbers of specific differences evident from group to group. Despite these differences, there are certain features with a comprehensive regional distribution. The techniques, materials, types, and usages of basketry of the California tribes are described.

710. Elsasser, Albert B. and Robert F. Heizer. "The Archaeology of Bowers Cave, Los Angeles County, California." *Archaeological Survey, University of California* 59 (1965): 1-45.

Basketry is discussed on pages 4-12. There were nine baskets in the Bowers collection. Five are probably storage baskets. The other four are a small, bowl-shaped basket, one tray, and two straight-sided bowls. Only one basket is decorated.

711. Evans, Glen L. and T. N. Campbell. *Indian Baskets (Part of Paul T. Seashore Collection).* Austin: Texas Memorial Museum, 1952; second edition, 1970.

This booklet describes and illustrates part of the Paul T. Seashore Collection in the Texas Memorial Museum in Austin. Most of the baskets were obtained by Seashore between 1930 and 1950, and are primarily from western North America. The second edition contains minor editorial changes and a new format.

712. Field, Virginia, et al. *The Hover Collection of Karuk Baskets.* Eureka: Clarke Memorial Museum, 1985.

The Clarke Memorial Museum contains an excellent collection of Hupa, Yurok, and Karok Indian basketry. This volume offers a comprehensive study of the culture of the Karok Indians of northwestern California. The Hover Collection, comprised mostly of baskets, is described and photographed. There are individual chapters which discuss the Hover family, the basket makers, the weaving process, the materials used in Karok basketry, and the designs.

713. Forde, C. Darryll. "Ethnography of the Yuma Indians." *University of California Publications in American Archaeology and Ethnology* 28 (1931).

Baskets of the Yuma are briefly discussed on pages 124-125.

714. Foreman, Louise. "Baskets! Baskets! Baskets!" *The Masterkey* 41.4 (1967): 143-147.

This is a brief description of the Carolyn Boeing Poole basket collection in the Southwest Museum.

715. Frohman Trading Company. *Alaska, California and Northern Indian Baskets and Curios, Wholesale and Retail.* Portland: Binford & Mort, 1977; reprint of 1902 edition.

This is a catalog, embellished with excellent photographs, of the baskets offered for sale by the Frohman Trading Company of Portland, Oregon.

716. Gamble, Geoffrey, Janette Gamble and Cecilia Silva. "Wikchamni Coiled Basketry." *Journal of California and Great Basin Anthropology* 1.2 (1979): 268-279.

The authors offer a sketch of the basic techniques and procedures involved in the making of coiled baskets among the Wikchamni, members of the Yokuts linguistic family of the San Joaquin Valley of California.

717. Gerstner, Patsy Ann. "Baskets and Blankets." *The Explorer* 4.3 (May-June 1962): 22-24.

Gerstner illustrates a collection of baskets donated to the Cleveland Museum of Natural History by Warren H. Corning. The baskets are from Arizona and California.

718. Gifford, Edward W. "Indian Basketry." In *Introduction to American Indian Art, Part II*. Oliver La Farge and others. New York: The Exposition of Indian Tribal Arts, Inc., 1931; reprint ed., Glorieta, New Mexico: Rio Grande Press, 1970; and 1979.

This is a collection of essays first issued in 1931 as an ephemera publication of the Exposition of Indian Tribal Arts, Inc., in New York City. It was later bound into a two-volume set, entitled *Introduction to American Indian Art*. There are illustrated examples of all forms of American Indian crafts. Gifford presents an overview of the Indian basketry of California, the Northwest Coast, the Southwest, and the Atlantic and Gulf Coast states. There is also an extensive bibliography.

719. _____. "The Northfork Mono." *University of California Publications in American Archaeology and Ethnology* 31 (1932).

Western Mono basketry suggests Yokuts basketry in that it excels Miwok basketry in fineness of weave. According to the Northfork Mono, Eagle gave each group its own type of baskets. Based on specimens in the University of California Museum of Anthropology, Western Mono basketry is distinctive in two ways: single rod coiling is absent and diagonally twined cooking baskets are common.

720. Gifford, Edward W. and W. E. Schenck. "Archaeology of the Southern San Joaquin Valley, California." *University of California Publications in American Archaeology and Ethnology* 23.1 (1926): 99-108.

In their discussion of the archaeology of the southern portion of the San Joaquin Valley of California, Gifford and Schenck describe fragments of twined basketry bags of string, asphaltum-covered soft twined basketry bags, tule mats, netting, and netting bags.

721. Gilham, F. M. *Pomo Indian Baskets*. n.p. n.d.; reprint ed., Orange Cove, California: Leo K. Brown, n.d.

F. M. Gilham of northern California was a dealer in Indian baskets. This is a catalog of Pomo Indian baskets offered for sale by Gilham. There are photographs and descriptions of the baskets.

722. Goddard, Pliny Earle. "Life and Culture of the Hupa." *University of California Publications in American Archaeology and Ethnology* 1 (1903).

Basket making among the Hupa is discussed on pages 38-48.

723. Gogol, John M. "Pomo and Wintun Basketry." *American Indian Basketry* 3.1 (1983): 4-9.

Mabel McKay, one of the best known living Pomo weavers, is shown making a traditional Pomo coiled single rod basket.

724. Goodrum, Janet. "Acorns & Baskets." *Pacific Historian* 16 (1972): 18-34.

Goodrum discusses the culture of California Indians, especially the harvesting and processing of acorns and the use of baskets in this activity.

725. Goulding, James M. "My Indian Basket." *Out West* 21.2 (1904): 175-176.

This is a poem.

726. Grabhorn, Nelson H. H. *Ethnic and Tourist Arts: Cultural Expressions from the Fourth World*. Berkeley: University of California Press, 1976.

Basketry from California is mentioned on pages, 15, 34, and 103; and basketry of the Seri is noted on pages 122-124.

727. Grant, Campbell. "Chumash Artifacts Collected in Santa Barbara County, California," pp. 1-44. *Reports of the University of California Archaeology Research Facility*, no. 63. Berkeley: University of California Archaeology

Facility, 1964.

Basketry is discussed on pages 7-11. There are nine examples of basketry in the James-Abel Collection. Two are large storage baskets (one with decorations); one is a dish-shaped, decorated basket; two are asphaltum-lined water bottles; one is a large olla-shaped basket; one is a sieve; and two are gambling trays.

728. Gugliemetti, June E. "California Indian Baskets." *Smoke Signals* 1.5 (November 1952): 10-12.

Gugliemetti describes a visit to the Hupa, Yurok, and Karok tribes of northern California to purchase baskets.

729. _____. "Mono Carrying Basket." *Smoke Signals* 1.8 (August 1954): 9.

Gugliemetti describes the cooking baskets of Polly Pomona and Annie Wentz, both Mono Indians.

730. _____. "Trip to See and Purchase Pomo Indian Baskets." *Smoke Signals* 1.2 (February 1952): 14-15.

Gugliemetti describes visits to various Pomo Indian villages to purchase baskets.

731. Hall, Joan H. "The S. L. Herrick Basket Collection." *Riverside Museum Associates Report* 3.3 (1966): 6.

Hall describes the S. L. Herrick basket collection in the Riverside Museum.

732. Hamy, Ernest T. "La Corbeille de Joseph Dombey." *Societe des Americanists de Paris, Journal* 5 (1908): 157-161.

The basketry collection of Joseph Dombey is briefly described.

733. Harrington, Mark R. "A Remodeled Basket." *The Masterkey* 16.4 (1942): 141-142.

Harrington hypothesizes the remodeling of an ancient basket found in a cave by an Indian woman near Supe in Ventura County, California.

734. _____. "Unique Among Baskets." *The Masterkey* 29 (1955): 174.

This is a notice about a donation by Maxine M. Rapp of a Chemehuevi and Southern Paiute basketry collection to the Southwest Museum. A Chemehuevi basketry hat is illustrated.

735. Hegner. "Baskets from a Cave in Saline Valley, Inyo County, California." *The Masterkey* 6 (1932): 4.

This is a photograph of the baskets by Hegner.

736. Heizer, Robert F. "The Archaeology of Central California I: The Early Horizon." *Anthropological Records, University of California Publications* 12.1 (1949).

In an area where basket making had an ethnographic climax, it is of some interest to determine the historical depth of the trait and the ancient weaves used. For the Late Horizon there is abundant archaeological evidence of basketry in the form of carbonized remains and impressions on baked-clay objects. No charred basketry was encountered in any Early Horizon site then excavated.

737. _____. "One of the Oldest Known California Indian Baskets." *The Masterkey* 42 (1968): 70-74.

Heizer describes an oval coiled basket decorated with encircling rows of shell beads and red feathers which he found in 1960 in the Joseph Dombey collection housed in the Musee de l' Homme, Paris. It is suggested that the basket came from the area between San Francisco and Bodega Bay, that it may have been made by a Pomo Indian or by any one of four other tribes, and that it was made earlier than 1785.

738. _____. "A San Nicolas Island Twined Basketry Water Bottle," pp. 1-3. *Reports of the University of California Archaeological Survey*, no. 50. *Papers on California Archaeology*, no. 76. Berkeley: The University of California Archaeological Survey, 1960.

The basketry analysis presented here is based upon a photograph of a San Nicolas Island twined specimen which had been in the collections of the California Academy of Sciences in San Francisco, but which was destroyed in the fire following the 1906 earthquake.

739. Henderson, Rose. "Pomo Basket Makers." *The Southern Workman* 55.2 (1926): 75-79.

Henderson makes a general comment about Pomo Indian baskets. Several individual Pomo basket makers are identified and some of their baskets are illustrated.

740. Herold, Joyce. "Chumash Baskets from the Malaspina Collection." *American Indian Art Magazine* 3.1 (1977): 68-75.

The baskets described by Herold were collected in 1791 as part of the Malaspina Expedition in an attempt to study the local Indians of the Pacific coast in a scientific manner. They were stored in the Museo Arqueologico in Spain, and finally were returned to the United States for a tour of museums in 1977-1978. A catalogue devoted to this tour was published. See Michael Weber, Donald, C. Culter, et al. *The*

Malaspina Expedition: In the Pursuit of Knowledge (Santa Fe: Museum of New Mexico Press, 1977).

741. _____. "The Yokuts Gambling Tray." *American Indian Art Magazine* 1.1 (Autumn 1975): 10-15.

Among the Yokuts, the women played a game--called *Huuchuish*--which required the use of dice. Herold describes and illustrates the close coiling technique in the construction of these gambling trays.

742. Heye, George G. "Chumash Objects from a California Cave," pp. 193-198. *Indian Notes and Monographs, Museum of the American Indian, Heye Foundation*, no. 3. New York: Museum of the American Indian, 1926.

Heye describes seven baskets and two "haliatis shell drinking cups" from a cave in El Blanco Canyon in the Sespe Mountains in Ventura County, California. There are illustrations of the artifacts.

743. Hodge, Frederick W. "A San Fernando Basket." *The Masterkey* 28.6 (1954): 239-240.

Mary Austin donated baskets made by the Fernandeno Indians of San Fernando Mission, California. General Edward F. Beale, who had originally collected the basket in question, said it had been used to wash out gold at the Mission a year or two before gold was discovered by Sutter.

744. Holmes, William H. "Anthropological Studies in California," pp. 161-187. *Report of the United States National Museum for 1900*. Washington, D. C.: Government Printing Office, 1902.

Although baskets are not specifically discussed in the text, there are thirty-five plates showing baskets and basket makers from various California tribes. Holmes mentions the baskets of Todd's Valley Indians, carrying baskets of the Pomo Indians, and winnowing baskets of the Tulare Indians.

745. _____. *Handbook of Aboriginal American Antiquities*. Bulletin of the Bureau of American Ethnology, no. 60. Washington, D. C.: Government Printing Office, 1919.

California Indian basketry is mentioned on page 116.

746. _____. "A Study of Textile Art in Its Relation to Development of Form and Ornament," pp. 189-252. *Annual Report of the Bureau of American Ethnology*, no. 6. Washington, D. C.: Government Printing Office, 1888.

There is a brief discussion concerned primarily with western baskets, especially the Apache and California tribes.

747. Howe, C. "Preliminary Report on a Cave in Simi
 Valley." *Archaeological Survey Association of Southern
 California, Newsletter* 2.1 (1954): 12-13.

 Test excavations at this cave site produced basketry
fragments. The site was badly damaged the following week by
pothunters.

748. Hudson, D. Travis and Janice Timbrook. "Six Chumash
 Baskets: An Important New Acquisition." *Museum Talk,
 Santa Barbara Museum of Natural History* 48.4 (1974):
 95-102.

 There are only about 220 known Chumash baskets in ex-
istence. Most of these baskets are in collections outside
California. Six previously unknown and unstudied Chumash
baskets are described and illustrated.

749. Hudson, Joy W. "Pomo Basket Makers." *Overland Monthly*
 21.126 (June 1893): 561-578.

 Hudson provides a brief historical overview of the
Pomo, and describes methods of making Pomo baskets. All
Digger Indian baskets, according to Hudson, may be correctly
classified under just two categories: baskets made to sell
and baskets made not to sell. To a "basket crank," a sala-
ble basket possesses no attractions. "Inferior material,
faulty patterns, spaces between stitches, exposed ends of
threads--each and all proclaim carelessness. And when an
unsymmetrical outline is added to these, his cup of contempt
overflows." Deterioration in basket excellence must be ex-
pected in the decadence of their makers, he continued. If
there is any one cause more responsible than others for this
inferiority, it is the rapacity of the basket speculators.

750. Hudson, Travis. "Chumash Baskets in Russia." *The Mas-
 terkey* 57 (1983): 94-100.

 Hudson describes three Chumash baskets in the Museum of
Anthropology and Ethnology in Leningrad. They were probably
collected in the Santa Barbara area by Kyrill T. Khlebnikov,
the Siberian-born administrator of the Russian-American Com-
pany during his fifteen years in Russia America.

751. Hudson, Travis and Thomas C. Blackburn. *The Material
 Culture of the Chumash Interaction Sphere, Vol. II:
 Food Preparation and Shelter.* Ballena Press Anthropolo-
 gical Paper Series, no. 27. Santa Barbara: Ballena
 Press/Santa Barbara Museum of Natural History, 1983.

 This monograph is the second in a five part series on
Chumash Indian culture. Hudson and Blackburn discuss the
varied forms of Chumash basketry. The volume contains over
400 photographs and drawings of baskets and other objects
which pertain to storage, processing, cooking, serving, and

housing.

752. James, George Wharton. "Among the Mono Basket Makers." *Sunset Magazine* 6 (1901): 107-112.

James offers a brief sketch of the life of the Mono Indians, with good illustrations of their baskets.

753. _____. "Basketmakers of California at Work." *The Basket* 1 (1903): 2-18.

James discusses Washoe, Northern Paiute, and Southern Paiute baskets.

754. _____. "Poetry and Symbolism of Indian Basketry." *The Basket* 2.1 (1904): 19-31.

This article was collected from essays which appeared in the *Kindergarten Magazine* and the *Drawing and Manual Training Journal*. James consistently used the examples of Indian basketry to demonstrate that the Indian woman was not only an artist but in fact a superior artist to the majority of civilized American women. He describes and illustrates several baskets made by the Palatingwa Indians in the collection of Mrs. J. H. Babbitt and E. Mehesy, Jr. This article also appeared as *Poetry and Symbolism of Indian Basketry. Reprint from The Theosophical Path.* Point Loma: Printed at the Aryan Theosophical Press, 1913.

755. _____. *Practical Basketmaking.* Seattle: Shorey Book Store, 1967.

Drawing upon illustrations and descriptions from his *How to Make Indian and Other Baskets* and *Indian Basketry*, James provides models and instructions for the practical weaver to make various types of Indian baskets.

756. James, Harry C. *The Cahuilla Indians; the Men Called Master.* Los Angeles: Western Lore Press, 1960.

There is a brief discussion of baskets and granaries.

757. Johnson, Barbara. "Seri Indian Basketry." *Kiva* 25.1 (1959): 10-13.

The Seri Indians, who live on the island of Tiburon in the Gulf of California and on the adjacent Mexican mainland in northwestern Sonora, had dwindled to a population of 250. The hunting and gathering subsistence pattern of Seri culture is reflected in their basketry. Baskets are used in connection with the preparation of Seri foods.

758. Jones, Joan Megan. *Native Basketry of Western North America. The Condell Collection of the Illinois State Museum.* Springfield: Illinois State Museum, 1978.

NATIVE AMERICAN BASKETRY

The Condell Collection of basketry in the Illinois
State Museum contains many examples of the major styles of
basketry made by tribes of western North America, from the
Arctic southward along the coasts of Alaska, British Colum-
bia, the western United States, and into the Southwest.
Most of the baskets in the Condell Collection were made
during the latter part of the nineteenth century and early
part of the twentieth century. Thomas Condell had purchased
them from collectors, dealers, and the Indians themselves.
In some cases, entire private collections were obtained.

759. Joseph, Frank. "The Art of Basket Weaving." *Indian
 Historian* 1.3 (1967/1968): 35.

Joseph discusses briefly the manufacture of Maidu wil-
low and maple baskets. He offers suggestions to preserve
baskets in private collections and in museums.

760. Katzenberg, Dena S. *"And Eagles Sweep Across the Sky":
 Indian Textiles of the North American West*. Baltimore:
 The Baltimore Museum of Art, 1977.

This catalog contains "Baskets of the West." This pub-
lication and the accompanying exhibit deal with the Balti-
more Museum of Art's collectons of North American Indian wo-
ven artifacts. The collection focuses on the basketry of
the Northwest, California, and the Southwest. Baskets from
other museums and private collections have been included to
fill some of the gaps. The basketry section offers sketches
of only the salient tribal features. No attempt was made to
present a comprehensive survey.

761. Kelly, Isabel I. "Ethnography of the Surprise Valley
 Paiute." *University of California Publications in Amer-
 ican Archaeology and Ethnography* 31.3 (1932): 67-210.

Basketry of the Surprise Valley Paiute is discussed on
pages 120-137.

762. _____. "Yuki Basketry." *University of California Pub-
 lications in American Archaeology and Ethnology* 24.9
 (1930): 421-444.

Kelly deals with the basketry of the Yuki proper and,
to a lesser extent, that of the Huchnom. The analysis was
based on ninety-eight baskets from the University of Cali-
fornia Museum of Anthropology. The Yuki manufactured both
coiled and twined baskets. Coiled baskets were usually de-
corated, while twined baskets were undecorated. Kelly dis-
cusses these two types of basketry among the Yuki. She con-
cludes that Yuki basketry is unimpressive and mediocre by
Pomo or Maidu standards.

763. King, Thomas J., Jr. "A Cache of Vessels from Cotton-
 wood Spring (Riv-937)." *The Journal of California An-
 thropology* 3.1 (1976): 136-142.

King mentions a well-preserved burden basket, and in-
cludes a photograph and detailed description. There were
floral remains in the basket weave.

764. Kirk, Ruth E. "Panamint Basketry--A Dying Art." *The
Masterkey* 26.3 (1952): 76-86.

Death Valley, California is the home of a tribe of Sho-
shonean Indians known as the Panamint. Panamint culture had
undergone tremendous change. Basketry was about the last
remnant of material culture to survive. Only four women
were still making baskets. Kirk provides notes on manufac-
turing techniques, materials used, decorations, and time re-
quired in production.

765. Kojean, P. M. "Woven Vessels of the California Indi-
 ans." In *Culture and Life of the Natives of America*. By
 P. M. Kojean. Translated by Wilma Follette. Reprinted
 in Mapom Papers, no. 4. Leningrad: Naooka Publishing
 House, 1967.

The basketry in the collection of the Museum of Anthro-
pology and Ethnography of the Academy of Sciences U.S.S.R.,
N. N. Miklooho--Maklai Institute of Ethnography were ob-
tained by E. G. Voznesensky who had visited California in
1840 and 1841. Kojean describes the various types of
basketry made by the Indians of California. Particular at-
tention is given to the Pomo, southern Wintun, the Coast and
Plains Miwok, and the southern Maidu.

766. Kowta, Makoto and James C. Hurst. "Site Ven-15: The
 Triunfo Rockshelter." *UCLA-Archaeological Society An-
 nual Report* 2 (1960): 201-230.

The artifact description includes a detailed discussion
of basketry.

767. Krieger, Herbert W. "Aspects of Aboriginal Decorative
 Art in America." *Annual Report of the Smithsonian In-
 stitution for 1930*, pp. 519-556. Washington, D. C.:
 Government Printing Office, 1931.

Krieger illustrates woven bags (sally bags) of the Nez
Perce, Okinagon, and Salish Indians. Coiled baskets of the
Panamint, Pomo and Tulare Indians of California and the
Apache of the Southwest are also mentioned.

768. Kroeber, Alfred L. "Basket Designs of the Indians of
 Northwestern California." *University of California Pub-
 lications in American Archaeology and Ethnology* 2.4
 (1905): 105-164.

The Indian tribes of the extreme northwestern section
of California are in many respects unique in their culture.
Their specialized culture is most developed among the Yurok,

Karok, and Hupa. Kroeber obtained the names of the basket
designs from these three tribes in 1901, 1902, and 1903.
The Yurok were studied extensively.

769. _____. *Basket Designs of the Mission Indians*. Ameri-
can Museum of Natural History, Guide Leaflets, no. 55.
New York: American Museum of Natural History, 1922.

Kroeber describes and discusses the basket designs of
the Mission Indians of California.

770. _____. "Basket Designs of the Mission Indians of Cali-
fornia." *Anthropological Papers of the American Museum
of Natural History* 20 (1918): 149-183.

Kroeber discusses the basket designs of the Mission In-
dians of California. This article is reprinted in Robert
Heizer and M. A. Whipple, *The California Indians: A Source
Book* (Berkeley: University of California Press, 1970, pp.
269-275).

771. _____. "California Basketry and the Pomo." *American
Anthropologist* 11 (1909): 233-249.

Kroeber discusses the material, technique, name of de-
signs, and decorations of Pomo Indian basketry. This arti-
cle is reprinted in Robert F. Heizer and M. A. Whipple, *The
California Indians: A Source Book* (Berkeley: University of
California Press, 1970, pp. 251-263).

772. _____. "Ethnography of the Cahuilla Indians." *Univer-
sity of California Publications in American Archaeology
and Ethnology* 8 (1908): 29-68.

Basketry of the Cahuilla Indians is discussed on pages
41-51.

773. _____. *Handbook of the Indians of California*. Bulletin
of the Bureau of American Ethnology, no. 78. Washing-
ton, D. C.: Government Printing Office, 1925.

Kroeber offers a detailed overview of the basketry of
the California Indian tribes.

774. Lamb, Frank W. *Indian Baskets of North America*. La
Pine: Rubidoux Publication, 1972, 1976, 1981, and
1985.

Baskets of the California tribes is discussed on pages
47-76.

775. Lewis, Billy C. "Masterpieces of Basketry." *Americana*
10.3 (1982): 50-55.

Lewis discusses the work of Laura Somersol, a contempo-
rary Pomo basket maker.

776. Lopez, Raul A. and Christopher L. Moser. *Rods, Bundles, and Stitches: A Century of Southern California Indian Basketry*. Riverside: Riverside Museum Press, 1981.

This thoroughly researched catalog contains 436 large duo-tone photographs of baskets, six full-page color photographs of baskets, nineteen historical photographs of early basket makers and basket collectors.

777. Mason, J. Alden. "The Ethnology of the Salinan Indians." *University of California Publications in American Archaeology and Ethnology* 10 (1912): 97-240.

Basketry of the Salinan Indians is discussed on pages 143-152.

778. Mason, Otis T. *Aboriginal American Basketry: Studies in a Textile Art Without Machinery*. Annual Report of the U. S. National Museum for 1902. Washington, D. C.: Government Printing Office, 1904.

Mason discusses the basketry of the California Indian tribes on pages 440-487. For further details about Mason's classic study see entry **49**.

779. McClendon, Sally and Brenda Shears Holland. "The Basketmaker: The Pomoans of California," pp. 104-129. In *The Ancestors: Native Artisans of the Americas*. Edited by Anna Curtis Roosevelt and James G. E. Smith. New York: Museum of the American Indian, 1979.

The various groups in northern California that became known as the Pomo Indians amazed people with their basket making skills. Pomo baskets, however, were not made by a single tribe. They were produced by members of approximately seventy-two autonomous groups who lived 100 miles north of San Francisco. This is a detailed and authoritative study of the history and development of Pomo basket making.

780. McCown, B. E. "A Strange Cache in the Lava." *The Masterkey* 31 (1957): 24-31.

Near Little Lake, California a lava-formed cave was excavated. Some basketry was found among other remains.

781. McMillan, James H. "The Northeastern Maidu." *Plumas Memories* 34 (October 1969): 1-29.

The basketry of the Maidu is discussed on pages 14-15.

782. Meighan, Clement W. "The Colville Rock Shelter, Inyo County, California." *Anthropological Records, University of California Publications* 12.5 (1953).

Although no complete specimens were recovered, 115 fragments of baskets were found in the deposit. The Colville basketry fits into the pattern of Great Basin specimens. The most common form is an open-twined conical burden basket, but there are also examples of twined winnowers or seed-beaters, pitch-covered baskets, cooking bowls, and circular coiled trays.

783. Mendelsohn, Pam. "Northwest California Basketry." *Southwest Art Magazine* (June 1983).

Mendelsohn provides details of the basket making techniques of the Yurok, Wiyot, Karok, Tolowa, and Hupa Indians. Several basket makers and baskets are illustrated.

784. Merriam, C. Hart. "Some Little Known Basket Materials." *Science* 17.438 (1903): 826.

The Indians living on the lower slopes of the Sierras from Fresno River south to Kern used *Cladium Mariscus* to wrap around the coil of *Epicames regens*. The black in the design is made from the root of *Pteridiam aquilinum*. The red comes from the split branches of the rosebud, *Cercis occidentalis*. The tribes making baskets from *Cladium Mariscus* were the Nims, Chukchancys, Cochebus, Wusaches, Wiktchumnes, and Tulares. Merriam also discusses the red in the basket design of the Kern Valley, Neewooah, and Panamint Shoshone Indians. This material is derived from the unpeeled root of the tree yucca (*Yucca arborescens*).

785. _____. "Some Little Known Basket Materials." *Papoose* 1.7 (June 1903): 14-16.

This article originally appeared in *Science* 17 (1903): 826. Merriam discusses and identifies various plant materials used to make Indian baskets in California. See above entry.

786. _____. *Studies of California Indians.* Berkeley: University of California Press, 1962.

This collection of essays contains "Indians as Basket Collectors" on pages 106-109; "Tulare Basketry" on pages 110-116; and "The Basketry of the Mono" on pages 117-122.

787. Merrill, Ruth Earl. "Plants Used in Basketry by the California Indians." *University of California Publications in American Archaeology and Ethnology* 20 (1923): 215-242; reprint ed., Ramona: Ballena Press, 1973.

Merrill does not present new data about the plants used in basketry among the California Indians. Instead, she gathered and summarized what had already been written on this subject. In addition, an effort was made to determine what relation existed between the distribution of these plants

and their use in basketry.

788. Metzler, Sandra. "A Family Album of Pomo Baskets."
 Fiberarts 11.1 (January-February 1984): 63-65.

 Metzler describes the baskets of Virginia Buck and her
mother, grandmother, aunt, and a cousin. The Buck family
basket collection demonstrates the recent preference for
coiling and the Pomo tradition of gift giving.

789. Michael, Bill. "Eastern California Museum." *American
 Indian Basketry* 5.3 (1985): 21.

 The Eastern California Museum purchased the Rose Black
collection of American Indian baskets. Black operated a
store in Big Pine from approximately 1880 to 1940. In addi-
tion to collecting baskets, she gathered information about
the basket maker, the materials used in manufacture, and the
meaning of the designs. Much of these original notes have
been lost.

790. Miles, Charles. "Indian Basketry." *Hobbies: the Maga-
 zine for Collectors* 54.3 (May 1949): 140-141, 161.

 Miles offers some simple suggestions to those interest-
ed in collecting Indian baskets. He discusses the uses of
basketry, methods of construction, ethnic divisions in the
western part of North America, and materials.

791. _____. "Indian Relics." *Hobbies: the Magazine for
 Collectors* 76.7 (September 1971): 146-150.

 Miles discusses the dance basket and the babiche bag.
The dance basket of the lower Klamath River tribes of
northwestern California is cylindrical in shape and twined
woven. The ends of the basket are closed with soft leather.
There is a slit opening or mouth which extends the entire
length of the basket. A rod is enclosed in either lip. A
leather cord is used as a sling. The babiche is a long
buckskin string, fashioned by cutting around the edge. Hand
bags are made from a ball of babiche. Knotless netting is
the method of weaving these bags. The Babiche people live
in the Subarctic area between the Arctic tundra and forested
land in northern Canada. A Yurok Dance Basket and a babiche
bag are illustrated.

792. _____. "Notes on Indian Basketry." *Hobbies: the Maga-
 zine for Collectors* 76.10 (December 1971): 146-147,
 160.

 Miles poses several questions about the "interesting"
features of Indian basketry. Using the feather baskets and
miniatures made by the Pomo, he asks why they spent so much
time and imagination on "useless" artifacts? He suggests
that they were made for fun. To differentiate Indian bas-
ketry, Miles directs the attention of potential collectors

to the techniques for beginning the bottoms of baskets and the different ways of decorating the baskets.

793. Moriarity, J. R. "Evidence of Mat Weaving from an Early La Jolla Site." *The Masterkey* 40.2 (April-June 1966): 44-53.

Tule mats were woven by almost all of the tribes of California. During the summer of 1961, the first evidence of weaving or twining was found at the La Jolla Complex. A small fragment of twined mat weaving, radiocarbon-dated at about 5,000 B. P. was discovered. Moriarity describes attempts to identify botanically the fragments.

794. Moser, Christopher L. "The Art of Basket Collecting." *The Indian Trader* 13.4 (April 1982): 3, 5-12.

This brief article about basket collecting is reprinted from Raul A. Lopez and Christopher L. Moser, *Rods, Bundles, and Stitches: A Century of Southern California Indian Basketry* (Riverside: Riverside Museum Press, 1981).

795. _____. *Native American Basketry of Central California*. Riverside: Riverside Museum Press, 1986.

This is a superb catalog for the exhibition of "Native American Basketry from Central California" from the permanent collection of the Riverside Museum. The text is by Christopher L. Moser with articles by Craig Bates on "Hechenu Pulaka: The Changing Role of Baskets in a Northern Miwok Family" and Eva Slater on "Panamint Shoshone Basketry: A Change of Style."

796. Murphey, Edith Van Allen. *Indian Uses of Native Plants*. Palm Desert, California: Desert Printers, Inc., 1959.

Basketry is discussed on pages 1-11.

797. Newman, Sandra C. *Indian Basket Weaving: How to Weave Pomo, Yurok, Pima, and Navajo Baskets*. Flagstaff: Northland Press, 1974.

This is an extensive and comprehensive discussion of baskets produced by the Pomo, Yurok, Pima, and Navajo Indians. Newman lived among tribal members, learning basketry techniques firsthand.

798. Nuttall, Zelia. "Two Remarkable California Baskets." *Quarterly of the California Historical Society* 2.4 (January 1924): 341-343.

Nuttall discusses two baskets which display the royal arms of Spain woven into the design. The similarity of design and workmanship of both baskets indicates that they were made by converted Indian women at the Mission of the

Seraphic. The baskets were probably woven in 1822.

799. O'Neale, Lila M. "Tradition in Yurok Karok Basketry." In *The California Indians: A Source Book*, pp. 264-268. Edited by Robert R. Heizer and M. A. Whipple. Berkeley: University of California Press, 1970.

See next entry.

800. _____. "Yurok-Karok Basket Weavers." *University of California Publications in American Archaeology and Ethnology* 32 (1932): 1-184.

Influenced by James A. Teit, et al's *Coiled Basketry in British Columbia and Surrounding Region*, O'Neal attempts-- from the design stand point--to relate the weaver to the conventions, or to any variations which had taken place in form or pattern; and to let the weaver define in terms of the tenets of her craft the relative importance of its aspects. She demonstrates that Yurok-Karok basketry is molded by a definite body of established tradition.

801. Palmer, Edward. "Plants Used by the Indians of the United States." *American Naturalist* 12.9 (1878): 593-606 and 12.10 (1878): 646-655.

Palmer notes the use of *Rhus aromatica* var. *tribola* (squaw berry) to make baskets, and the use of *S. Diffusa* by the Cahuilla to make a fine black dye for baskets.

802. Pavlik, Josephine. "Chiloquin Woman Keeps Alive the Declining Art of Tule Weaving." *Herald and News* April 8, 1973, p. 26.

803. Peck, Stuart L. "A Fragment of Northern California Basketry from Southern California." *American Antiquity* 16 (1950): 70.

A basketry fragment from the Barston area may suggest contact south through Owens Valley and the Mohave Desert.

804. Peet, Stephen D. "The Ethnography of Art in America." *American Antiquarian and Oriental Journal* 26.4 (1904): 201-224.

Peet briefly mentions the basketry of the Tulare and Pomo Indians.

805. Peri, David W. and Scott M. Patterson. "The Basket is in the Roots, That's Where It Begins." *The Journal of California and Great Basin Anthropology* 3.2 (1976): 16-32.

Peri and Patterson discuss the basketry of the Pomo Indians, including materials, collecting, construction, and exchange value. They focus on the nineteenth and twentieth

basket makers.

806. Purdy, Carl. "The 'Dau' in Pomo Baskets." *Out West* 18.3 (1903): 317-325.

Purdy recounts the Pomo legend of the "Dau." The myth clearly shows that they believed in a particular race of spirits who inhabited the baskets, and that they needed a dau--or door--to escape through when the basket was destroyed.

807. _____. "The Pomo Indian Baskets and Their Makers." *Out West* 15.6 (December 1901): 438-449 and 16 (1902): 9-19, 151-158, and 262-273.

This article was reprinted in Don M. Chase, et al. *The Basket Maker Artists*. Sebastopol, California: D M Chase, 1977. Purdy provides detailed descriptions and discussion of Pomo Indian basket making.

808. _____. *The Pomo Indian Baskets and Their Makers*. Ukiah, California: Mendocino County Historical Society, 1971.

This is a reprint of the articles with the same titles which appeared in *Out West*. See above entries.

809. Putnam, Frederick W. "Textile Fabrics, Basket-work, etc. (from Santa Barbara sites)." In *U. S. Geographical Surveys West of the One Hundredth Meridian. Reports Upon Archaeological and Ethnological Collections from Vicinity of Santa Barbara, California, and from Ruined Pueblos of Arizona and New Mexico, and Certain Interior Tribes*, vol. 7. Washington, D. C.: Government Printing Office, 1879, pp. 239-250.

On pages 246-248, Putnam briefly discusses and illustrates fragments of baskets found in graves in southern California.

810. Reyman, Jonathan E., with Sandra Faikus, Sari Kessler, Laurie Ruedi, Anne Weirich, Susan Wexler. *A Catalogue of Native American Basketry at the LaSalle County Historical Society Museum Utica, Illinois*. Utica: Illinois State University, Anthropology Program, 1979.

Reyman discovered a collection of American Indian baskets in the LaSalle County Historical Society Museum in Utica, Illinois. The baskets were in need of cleaning and preservation. After restoration, an effort was made to identify the baskets. At least fifteen groups are represented by the various basketry specimens in the collection. California Indian baskets include those made by the Hupa, Pomo, and Tulare. The specimens in this catalog are listed in the order of the accession numbers assigned by the LaSalle Historical Society Museum.

811. Ross, E. H. "Basketry of the American Indian." *The Museum, Newark* n.s. 10 (1958): 14-27.

The Newark Museum began quite early to collect American Indian basketry. The baskets came primarily from the Cyrus O. Baker estate and the Gibson Collection. Using the museum's collections, Ross presents an overview of the Indian basketry of western North America.

812. Ross, George. "Lucy Telles, Basket Maker." *Yosemite Nature Notes* 26.4 (1948): 67-68.

Ross briefly discusses the basket making of Lucy Telles, a Miwok Indian.

813. Rozaire, Charles E. and Steve Craig. "Analysis of Basketry from Site LAn-227. P 131 (Appendix III)." In *The Archaeological Investigations of Three Sites on the Century Ranch*. Annual Report of the University of California Archaeological Survey, no. 10. Berkeley: University of California Archaeological Survey, 1968.

Rozaire and Craig discuss the basketry remains from Site LAn-227.

814. _____. "Analysis of Woven Materials from San Clemente Island," pp. 157-163. *Annual Report of the University of California Archaeological Survey*, no. 1. Berkeley: University of California Archaeological Survey, 1958-1959.

Rozaire describes forty-four pieces of twined basketry, representing fourteen baskets found on San Clemente Island.

815. _____. *Indian Basketry of Western North America*. Los Angeles: The Bowers Museum, 1977.

This catalog accompanied a 1977 exhibition of American Indian baskets at the Bowers Museum.

816. Sapir, Edward and Leslie Spier. "Notes on the Culture of the Yana." *Anthropological Records, University of California Publications* 3.3 (1943).

Sapir and Spier assume that basketry products played the same large part for the Yana as they did other California tribes. Their inference is based in part on the circumstances that baskets form the bulk of the two Yana collections known to them. Their discussion relies primarily on Sapir's notes on uses, materials, and designs from a collection he made for the Museum of Anthropology at the University of California and on an analysis of a collection in the Peabody Museum at Harvard University.

817. Schumacher, Paul. "The Methods of Manufacturing Pot-

tery and Baskets Among the Indians of Southern California." *12th Annual Report of the Peabody Museum of American Archaeology and Ethnology* 2 (1879): 521-525.

The basketry techniques of the southern California Indian tribes is very briefly described.

818. Sennett-Walker, Beth. "The Panamint Basketry of Scotty's Castle." *American Indian Basketry* 5.3 (1985): 13-17.

Sennett-Walker describes the Panamint basketry housed in Scotty's Castle in Death Valley, California.

819. Silva, A. and W. Cain. *California Indian Basketry, An Artistic Overview*. Cypress: Cypress College Fine Arts College, 1976.

This is a catalog of an exhibit of California aboriginal basketry at the Cyprus College Fine Arts Gallery. Each of the 168 baskets is illustrated, identified, and described.

820. Simpson, Richard. "Ooti A Maidu Legacy." *Sierra Heritage* 5.3 (December 1985): 18-33.

This article is excerpted from the book of the same title. Lizzie Enos, a Maidu Indian, tells the story of Ooti. The various uses of baskets during the making of acorn flour are described and illustrated.

821. Slater, Eva. "Panamint Shoshone Basketry 1920-1940: An Exhibit at the Bowers Museum in Santa Ana, California." *American Indian Basketry* 5.3 (1985): 18-20.

This exhibit offered an overview of the basket work of a small group of Indians scattered over the Death Valley region of California.

822. Smallwood, Clara Hunt. "The Rancho and the Basket--A Bit of Southern California History and a Woven Prophecy." *Out West* 8.1 (1914): 30-32.

Smallwood tells a romanticized story about a California Indian family near the Santa Rosa Mountains, in which the wife weaves a design into a basket foretelling the doom of the rancho upon which they live.

823. Smith, Gerald A. and Ruth D. Simpson. *Basket Makers of San Bernadino County*. San Bernadino: San Bernadino County Museum, 1964.

Smith and Simpson discuss and illustrate the basketry of the Serrano and Cahuilla, Chemehuevi, Panamint, and Mohave Indians.

824. Smith, Lillian. "Three Inscribed Chumash Baskets with Designs from Spanish Colonial Coins." *American Indian Art Magazine* 7 (1982): 62-68.

Smith describes the designs based on Spanish colonial coins found on three baskets made by Chumash Indians of California. The baskets came from the Museum of the American Indian, the Lowie Museum of Anthropology, and the Santa Barbara Museum of Natural History.

825. Southern Plains Indian Museum and Crafts Center. *Hupa-Yurok-Karok Basketry.* Anadarko: Southern Plains Indian Museum and Crafts Center, 1987.

This is a catalog of an exhibit of the Hupa, Yurok, and Karok basket makers of northwestern California. It includes basketry by notable weavers of the 1950s, 1960s, and 1970s, such as Lottie Beck, Amy Peters Smoker, Florence Harrie, Nettie McKinnon, Sarah Smoker, Lila Colegrove, Grace Davis, and Lucille McLaughlin.

826. Sparkman, Philip Stedman. "The Culture of the Luiseno Indians." *University of California Publications in American Archaeology and Ethnology* 8 (1908): 187-235.

Baskets of the Luiseno Indians are discussed on pages 204-205.

827. Steffa, Emil Paulicek. "Basketmakers of Coachella Valley: Previously Unpublished Manuscript of 1927," pp. 92-98. In *Native American Art from the Permanent Collection: Exhibition Catalog.* Edited by Kay Koeninger and Joanne M. Mark. Claremont: Galleries of the Claremont Colleges, Pomona College, 1979.

Steffa's previously unpublished manuscript documents each basket, basket maker's name and tribal affiliation, date and place of purchase, and cost. She provides unusual insight into the Indian basket makers of Coachella Valley at the turn of the nineteenth century.

828. Steward, Julian H. "Ethnography of the Owens Valley Paiute." *University of California Publications in American Archaeology and Ethnology* 33 (1933).

Basketry of the Owens Valley Paiute is discussed on pages 270-274.

829. _____. *Indian Tribes of Sequoia National Park Region.* Washington, D. C.: U. S. Department of the Interior, National Park Service, 1935.

Basketry is briefly discussed on pages 12-15.

830. Swartz, B. K., Jr. "A Study of the Material Aspects of

Northeastern Maidu Basketry." *Papers of the Kroeber An-thropological Society* 19 (1958): 67-85.

Northeastern Maidu basketry is equal to that of the Po-mo in craftsmanship and perhaps in diversity of types, but it is not as ornate. Swartz makes a brief survey of north-eastern Maidu basketry, discussing basket use, techniques of manufacture, motor habits, and use of the environment.

831. Timbrook, Jan. "Elementary, My Dear Hudson...in which an associate editor eliminates the unlikely, and turns up two rare baskets." *Santa Barbara Museum of Natural History Bulletin* 80 (1985).

Timbrook briefly discusses the acquisition and identi-fication of two baskets made by the Fernandeno and Gabrieli-no Indians of southern California.

832. Vaillant, George C. *Indian Arts in North America.* New York: Harper & Brothers, 1939; reprint ed., New York: Cooper Square, 1973.

Vaillant mentions baskets from the Tulare Indians and a Mission tribe of California.

833. Voegelin, Erminie W. "Tubatulabal Ethnography." *Anthropological Records,* no. 2. Berkeley: University of California Press, 1938.

This is a scholarly account about various cultural aspects of upper Kern River neighbors of southern Yokuts. Voegelin discusses basketry, woven ware, and cordage on pages 30-33.

834. Watkins, Frances E. "Another Basket Collection." *The Masterkey* 9.4 (1935): 120-122.

Watkins describes the basket collection of Martha A. Jenks, which she donated to the Southwest Museum. The col-lection consisted exclusively of baskets from Arizona and the Pacific coast.

835. _____. "The Caroline Boeing Poole Collection of Ameri-can Indian Baskets." *The Masterkey* 13.3 (1939): 93-95.

Watkins describes the collection of Colonel John Hudson Poole, which was presented to the Southwest Museum. The Caroline Boeing Poole Collection, as it became known, con-sists of approximately 2,500 baskets, woven for the use of the Indians who made them, not for sale or trade. Many show actual signs of the uses for which they were intended. Others are virtually new. There are no two baskets alike.

836. _____. "Crafts and Industries of the American Indian Women of California and the Southwest." Ph.D. disserta-tion, University of Southern California, 1942.

Watkins studied the field of material culture as it related to the Indian women of California and the Southwest. Detailed information regarding basketry and other crafts was limited because they had reached such a high degree of excellence that specialization had developed within the tribal groups. Watkins attempted to ascertain the place of Indian women of California and the Southwest in the economic and industrial life of the various cultural groups.

837. _____. "The Homer E. Sargent Collection." *The Master-key* 11.5 (1937): 174-176.

Watkins describes the basket collection of Homer E. Sargent of Pasadena, California. The majority of the baskets came from the San Joaquin Valley, an area according to Alfred Kroeber, "so mixed ethnologically that it is impossible to straighten out the tribes." The collection is accompanied by a descriptive catalog, including in some instances a photograph of the basket maker.

838. Weber, Francis J. "Chumash Indian Basketry at San Buenaventura." *The Ventura County Historical Society Quarterly* 24.1 (Fall 1978): 1-25.

Weber provides a brief overview of Chumash basketry. He focuses on the Chumash basket collection of Juan E. Camarillo (1867-1936), who had established a small family museum in a wing of the San Buenaventura Mission.

839. Weber, Michael. "Artifacts from the Northwest Coast California Baskets." *El Palacio* 82.4 (1976): 11-18.

Weber illustrates and identifies twelve baskets collected from the Chumash Indians by the members of the Malaspina Expedition.

840. _____. "Artifacts from the Northwest/California Baskets: A Photo Gallery." In *Malaspina Expedition; In Pursuit of Knowledge*, pp. 11-18. Santa Fe: Museum of New Mexico Press, 1977.

Weber illustrates and identifies ten baskets collected from the Chumash Indians by the Alejandra Malaspina Expedition.

841. Weltfish, Gene. "Problems in the Study of Ancient and Modern Basket-Making." *American Anthropologist* 34.1 (1932): 108-117.

Weltfish develops a typological consideration of North American prehistoric basketry and the historical problems suggested by it. Five general types of prehistoric basketry material are identified: Southwestern, Ozark Bluff Dwellers, Lovelock, Snake River, and California Cave. Significantly, parallels for the prehistoric technical types in

all five cases were found in modern areas closely contiguous to the prehistoric sites.

842. Whelpley, H. M. "Miniature Indian Baskets." *American Anthropologist* 14.2 (April-June 1912): 410.

Speaking before the Academy of Science of St. Louis, Dr. H. M. Whelpley described and exhibited two miniature baskets made by the Pomo Indians. The foundation of the baskets is white leaf willow (*Salix argyrophylla*) and is sewed with California sedge (*Carex barbarae*). One of the baskets was made by one of the few men weavers among the Pomo.

843. Willoughby, Nona Christensen. "Division of Labor Among the Indians of California," pp. 7-79. *Reports of the University of California Archaeological Survey*, no. 60. Berkeley: University of California Archaeological Survey, 1963.

The Indian women of California probably made most of the every day utensils, implements and containers that they used. Baskets and mats were a feminine specialty. The art of basketry was one of the few means by which women could gain prestige. Baskets were made and used extensively throughout California except in the Colorado River region where the Indians generally obtained them by trade. In a few instances, men did some coarse twined work. Tolowa, Nongatl, Mattole, and Sinkyone men made fish baskets. Pomo men made basketry baby carriers, carrying and storage baskets. Yuki men made coarse carrying baskets.

844. Wingert, Paul S. *Primitive Art.* London: Oxford University Press, 1963.

There are brief references to the baskets of the Apache and California tribes.

845. Woodward, Arthur. "An Immense Pomo Basket." *Indian Notes, Museum of the American Indian, Heye Foundation* 5.2. New York: Museum of the American Indian, Heye Foundation, 1928, pp. 178-183.

Woodward describes and illustrates a four feet in diameter and seventeen and one-half inch deep Pomo Indian basket collected by Thea Heye for the Museum of the American Indian.

846. _____. "The Pomo Baskets." *The American Indian* 5.4 (1931): 14.

See previous entry.

847. Zigmond, Maurice L. "Kawaiisu Basketry." *Journal of California Anthropology* 5 (1978): 199-215.

Zigmond describes the baskets made by the Kern County Kawaiisu Indians, the last of whom wove baskets until approximately 1930.

Northwest

848. Adams, D. I. "North American Basketry Hats." Master's thesis, University of California at Los Angeles, 1928.

Adams discusses the various techniques and styles of basketry hats of the Northwest Coast tribes.

849. Allen, Eleanor. "Squaw Grass and the Art of Basket Weaving--Mid-Summer Magic in the Northwest." *Travel* 65.3 (July 1935): 41-42.

Allen offers a general overview of the use of squaw grass (*xeroplyllum tenax*) in the manufacture of baskets in the northwest.

850. Anderson, Ada Woodruff. "Lost Industry of a Vanishing Race." *Harper's Bazaar* 32 (1899).

Anderson laments the decline of the quality of basket making among the Northwest Coast tribes. Noting the increased interest in basket collecting at the turn of the century, Anderson suggests that the best location to obtain prized baskets from the Indians was in the hop fields.

851. Anonymous. "Art of Weaving Basketry." *The American Indian* 2.11 (1928): 8.

This is a reprint of an article in *The Verstorian* in Sitka, Alaska by an eighth grade pupil, Margaret Shakes. She briefly discusses Tlingit basketry.

852. _____. "Early Olympian." *Pacific Discovery* 7.3 (May-June 1954): 16-17.

On page 16 there is a photograph of an aged blind Quinault woman weaving a basket.

853. _____. *Illustrated History of Indian Baskets and*

Plates Made by California Indians and Many Other Tribes. Susanville, California: 1915; reprint ed., Orange Cove: Leo K. Brown, 1967; Reedley, California: Leo K. Brown, 1972.

All of the baskets illustrated in this volume were exhibited in 1915 at the Panama-Pacific International Exposition. The emphasis was on the basketry of the northern California tribes. Included, however, are some excellent examples of baskets from the Northwest Coast.

854. _____. "Indian Baskets, Rare Works of Art by Aborigines of Washington and Alaska." *American Indian Basketry* 2.3 (1982): 8-11.

This article, embellished with photographs by Edward S. Curtis, originally appeared in the Sunday, July 22, 1900 *Seattle Post-Intelligencer*. The anonymous author provides insights about the collectors of Indian baskets and the aesthetic and monetary values attached to them.

855. _____. "Klickitat Indian Legend, Origin of Basket Weaving." *American Indian Basketry* 1.1 (1979): 31-33.

This article is reprinted from the *Toppenish Review-Wapoto Independent*. The author narrates the Klickitat legend about the origin of basket weaving.

856. _____. "The Klikitat and Their Basketry." *The Indian Trader* 4.1 (1973): 4-5, 21.

Briefly discusses the basketry of the Klickitat Indians.

857. _____. *Lost Perspectives: The Art and Culture of Western Washington Indians*. Tacoma: Washington State Historical Society, 1986.

This is a catalog of an exhibit held from June 17 to August 20, 1986. The text is by Nile Thompson. Illustrated are an Ozette hat, Makah hat, Nisqually basket, two Cowlitz baskets, Twana basket, Puget Sound basket, and Skagit and Chehalis baskets.

858. _____. "Makah Basketry...Then and Now." *The Indian Trader* 4.5 (1973): 1, 26-27.

Briefly describes the traditional and contemporary basketry of the Makah Indians.

859. _____. [Northwest Coast Masks and Attu Basketry.] *Report of the Provincial Museum of Natural History* (1924): A8-A9.

In this brief report to the Provincial Museum of Natural History, two Attu baskets are described and illu-

strated. They were presented to the museum by Nels S. Lougheed.

860. _____. *Plimpton Collection of Pacific Coast Indian Basketry. A Collection Numbering 260 Baskets, and Representing 84 Tribes & Localities*. West Newton: n.d.

This is one of the finest collections of Pomo and Tulare Indian baskets in the United States. There are fifty-five Pomo baskets, including the excellent examples of feather work. There are also twenty Tulare baskets, and several examples of Kern, Yokut, and Mono baskets. The Salish and Alaska tribes are also extensively represented.

861. Backlin-Handman, Hedy. Editor. *Art of the Northwest Coast*. Princeton: Art Museum, Princeton University, 1969.

This catalog illustrates and describes select ethnographic specimens from the Museum of Natural History at Princeton University.

862. Baird, Donald. "Tlingit Treasures: How an Important Collection Came to Princeton." *Princeton Alumni Weekly* 65.17 (February 1965): 6-11, 17.

Baird describes ethnographic items, including basketry, from the Libby Collection in the Museum of Natural History at Princeton University.

863. Baird, Genevieve. *Northwest Indian Basketry*. Tacoma: Washington State Historical Society, 1976.

The American Indian basketry collection in the Washington State Historical Society Museum contains two thousand examples of this particular art form. Over three-fourths of the baskets are from tribes of the Northwest. This book is limited to a discussion of Pacific Northwest coast basketry.

864. Barlee, N. L. "Salish Indian Basketry." *Canada West Magazine* 5.3 (Summer 1975): 16-20.

Barlee briefly discusses the basketry of the Salish Indians.

865. Barrett, Samuel A. "The Material Culture of the Klamath Lake and Modoc Indians of Northeastern California and Southern Oregon." *University of California Publications in American Archaeology and Ethnology* 5 (1907-1910): 239-293.

Basketry of the Klamath Lake and Modoc Indians is discussed on pages 253-257.

866. Barrow, Susan H. and Garland F. Brabert. *Arts of a Vanished Era: An Exhibition of the Whatcom Museum of*

History and Art, Bellingham, Washington. Bellingham: Whatcom Museum, 1968.

A collection of Northwest Coast ceremonial and utilitarian objects in contemporary and traditional style is displayed and catalogued. Artistic and crafted works are presented from the Haida, Kwakiutl, Nootka, Tsimshian, Tlingit, and Coast Salish tribes. Each article is named and the material, size, owner, and frequently tribal source are noted.

867. Bates, Craig D. "Tlingit Baskets." *Moccasin Tracks* 8.9 (May 1983): 6-10.

The Tlingit Indians are noted for their Chilkat blankets and basketry. By the turn of the century, Tlingit women were making baskets for sale to tourists as a major source of cash income. Bates describes the techniques, materials, and designs of Tlingit baskets.

868. Boas, Franz. "The Decorative Art of the North American Indians." *Popular Science Monthly* 63 (1903): 481-498.

Boas argues that the decorative designs used by primitive people are not only decorations but symbols of definite ideas. Various basketry designs of Indians from the Northwest Coast, Plateau, and Southwest are used to support this argument.

869. _____. *Primitive Art.* Cambridge: Harvard University Press, 1927.

Boas briefly discusses baskets and basket designs from the Northwest Coast.

870. Brandford, J. S. *From the Tree Where the Bark Grows: North American Basket Treasures from the Peabody Museum, Harvard University.* Cambridge: Harvard University Press, 1983.

The Peabody Museum, founded in 1866, houses nearly 3,000 baskets. Among the more significant are the baskets in the Fast Collection, an internationally renowned collection of Northwest Coast material. In 1982, the Peabody Museum and the New England Foundation for the Arts agreed to sponsor a traveling exhibit of North American Indian baskets. Only sixty-one baskets from the museum's collections were selected. This is a catalog of the exhibit.

871. Buchanan, Charles M. "Indian Basket Work About Puget Sound." *Overland Monthly* 31.185 (May 1898): 406-411.

Buchanan, who worked for the Bureau of Indian Affairs, became quite interested in the history and culture of the Indians of the state of Washington. He presents a general discussion of the baskets from the Puget Sound area. Several baskets from different tribes are illustrated.

872. C. F. R. "Two Collections of American Indian Baskets." *The Bulletin of the Cleveland Museum of Art* 17 (1930): 199-201.

 Describes the donation of the American Indian basket collections of Mrs. Horace Kelley and Mrs. Lionel A. Sheldon to the Cleveland Museum of Art. The baskets are primarily from the Southwest, California, and the Northwest Coast.

873. Chamberlain, Alexander F. "Kutenai Basketry." *American Anthropologist* 11.2 (April-June 1909): 318-319.

 Chamberlain observes that neither George Wharton James nor Otis T. Mason discussed in their publications the basketry of the Kutenai. The Kutenai made water-tight baskets from split roots. The other types of basketry of the Kutenai are briefly noted.

874. Chandra, Helen, Maija Sedzielarz, and Ron Weber. "Warp of Cedar, Weft of Spruce: Baskets of the Pacific Northwest." *Field Museum of Natural History Bulletin* 48.10 (November 1977): 18-21.

 The Field Museum of Natural History had a temporary exhibit of American Indian baskets from the Pacific Northwest. Most of the baskets were collected at the turn of the century. The authors provide an overview of basketry from this region.

875. Cline, Walter, Rachel S. Commons, May Mandelbaum, Richard H. Post, and L. V. W. Walters. "The Sinkaietk or Southern Okanagon of Washington," pp. 35-70. *Contributions from the Laboratory of Anthropology, General Series in Anthropology*, no. 2. Menasha: George Banta Publishing Company, 1938.

 In the chapter, "Material Culture," Post and Commons discuss and illustrate baskets, bags, and buckets.

876. Coast Area Planning Committee. *Skokomish Baskets and Canoes*. Washington, D. C.: Government Printing Office, 1981.

 This pamphlet is one of twenty-one from *The Indian Reading Series: Stories and Legends of the Northwest*. Written for juveniles, it introduces the most basic aspects of Skokomish baskets and canoes.

877. Coates, Mary H. "Indian Basketry." *Oregon Native Son* 2.3 (July-August 1900): 107-109.

 Coates provides a picturesque description of collectors of Indian baskets awaiting the arrival of a whaler and its crew of Indians. She urges the gathering and preservation of Indian baskets.

878. Cole, Douglas. *Captured Heritage: The Scramble for Northwest Coast Artifacts.* Seattle: University of Washington Press, 1985.

During the half century or so after 1875, a large number of items, both secular and sacred, left the hands of their native creators and users on the Northwest Coast for the private and public collections of the European world. Cole reassesses the development of museums and anthropology, and their relationship to the American Indian.

879. Copeland, Margaret Ayr. "An Analysis of Modoc Basketry." Master's thesis, University of Washington, 1956.

The major consideration of this thesis is the analysis of the basketry technique of the Modoc. Basketry persisted longer than other material traits of Modoc culture. Most of the data was derived from collections. One was the basket collection (sixty-one baskets) on loan to the University of Washington from S. C. Johnson of Berkeley, California; and 106 baskets from the Indian Museum of Sacremento, California.

880. Corey, Peter L. "Tlingit Spruce Root Basketry Since 1903." In *The Box of Daylight: Northwest Coast Indian Art*, pp. 137-138. Edited by Bill Holm. Seattle: University of Washington Press, 1983.

Corey briefly examines the spruce root basketry of the Tlingit since 1903.

881. Crawford, Virginia. "Artistic Basketry of the North American Indian." *The Bulletin of the Cleveland Museum of Art* 73.7 (September 1986): 278-297.

The basketry collection of the Cleveland Museum of Art emphasizes the western part of North America. Approximately one-half of the collection was donated in 1917 by William Albert Price and his wife. Crawford discusses the variety of form and design found in American Indian basketry. Baskets from the museum's collections are used to illustrate the text.

882. Cressman, L. S. "New Information on South Central Oregon Atlatls." *The Masterkey* 18 (1944): 169-179.

Archaeological finds from Warner Valley, Plush Cave are discussed. Cressman includes notes about the basketry remains.

883. Croes, Dale R. "Basketry from the Ozette Village Archaeological Site: A Technical, Functional, and Comparative Study." Ph.D. dissertation, Washington State University, 1977.

In this study prehistoric basketry items--including baskets, cradles, hats, mats, and tumplines--from the Ozette Village archaeological site in Washington are investigated on three analytical levels. The basketry attributes are considered and compared between the Ozette site and other Northwest Coast water-saturated archaeological sites. The basketry stylistic and technological classes are created using a paradigmatic classification framework. These basket, hat, and mat classes are compared between sites through the use of cluster analysis techniques. The results clearly demonstrate a continuity of basketry styles in three distinct regions of the Northwest Coast for the previous 2,000 to 3,000 years. This suggests techno-cultural continuity in these regions.

884. Cutter, C. E. "The Basketry of the Northwest." *Papoose* 1.8 (July 1903): 3-8.

Cutter describes growing interest in the Northwest among collectors of Indian baskets.

885. Davis, Robert Tyler. *Native Arts of the Pacific Northwest from the Rasmussen Collection of the Portland Art Museum.* Stanford: Stanford University Press, 1949.

Basketry is briefly mentioned in one paragraph on page 11. Two Tlingit twined spruce root baskets are illustrated.

886. Day, Rachel C. "The Basketry of the Salish Indians." *School Arts* 30 (1931): 631-633.

This is a brief description of Salish basketry. Design motifs on Salish baskets are illustrated.

887. Devine, Sue Evelyn. "Basketry Hats of the Northwest Coast." Master's thesis, University of Washington, 1980.

Devine discusses in detail the basketry hats of the Tlingit, Haida, Tsimshian, Nootka, and Kwakiutl.

888. _____. "Kwakiutl Spruce Root Hats." *American Indian Basketry* 1.4 (1981): 24-26.

Devine proposes that although reliable documentation does not exist for Kwakiutl hats, they can be identified on the basis of specific characteristics in construction and decoration. The use of two and three strand twining on the top of the hat, a zigzag skipstitch pattern on the brim, and the presence of a dark green paint are attributes of Kwakiutl spruce root hats. Relying on the ethnographic data of Franz Boas and Edward S. Curtis, Devine concludes that spruce root hats were developed among the Kwakiutl about 1860.

889. _____. "Nootka Basketry Hats - Two Special Types."

American Indian Basketry 1.3 (1981): 26-31.

The knob top whaling hat and black rim hat were two types of basketry hats produced with the greatest frequency by tribes of the Northwest Coast. The Kwakiutl and northern tribes made a conical, brimmed spruce root hat which was truncated at the top. The Nootka and southern tribes made a bowl-shaped cedar bark hat. Both of these hat types were woven in variations of the twined technique.

890. _____. "Spruce Root Hats of the Tlingit, Haida and Tsimshian." *American Indian Basketry* 2.2 (1982): 20-25.

Spruce root hats among the Tlingit, Haida, and Tsimshian represent the merging of two distinct art traditions, the weaving skills of women, and the painting abilities of the men.

891. Dockstader, Frederick J. "Indian Art of the Northwest Coast." *Craft Horizons* 21 (1961): 22-29.

Dockstader discusses the major styles and techniques of Northwest Coast art.

892. Dorsey, George A. "A Cruise Among Haida and Tlingit Villages About Dixon's Entrance." *Popular Science Monthly* 53.2 (June 1898): 160-174.

On page 163 is a photograph of a "Haida Woman of Massett Weaving a Basket." There is very little discussion about basketry. Dorsey states that an important industry in Massett village was the weaving of cedar bark into mats and baskets. The basic utensil for carrying was the white basket made of closely woven splints of maple.

893. Douglas, Frederic H. *Main Types of Basketry in Washington and Northwestern Oregon.* Denver Art Museum, Indian Leaflet Series, no. 98. Denver: Denver Art Museum, 1940.

Douglas attempts to indicate the main divisions of basketry in Washington and northwestern Oregon. Little or no attention was given to tribal differences. Nine types of baskets were identified, each having sub-divisions.

894. Douglas, Mary E. "Oregon Indian Basketry Types and Distribution." Master's thesis, University of Oregon, 1947.

895. Duff, Wilson. *The Upper Stalo Indians of the Fraser Valley, British Columbia.* Victoria: British Columbia Provincial Museum, 1952.

There is a section about basketry on pages 57-58. Relying on informants, Duff describes the coiled and imbricated baskets of cedar roots made by the Stalo Indians.

896. Dyler, Harry. "Mabel Taylor--West Coast Basket Weaver." *American Indian Basketry* 1.4 (1981): 12-23.

Mabel Taylor belongs to the Sheshaht Band of Vancouver Island's West Coast Indian people. Dyler describes the materials used to make a grass basket, method and color used in basketry, and basketry designs. The remainder of the article is devoted to detailed photographs of Mabel Taylor weaving a grass basket.

897. Emmons, George T. "The Art of the Northwest Coast Indians." *Natural History* 30 (1930): 282-292.

Emmons focuses exclusively on the carvings and paintings of the Northwest Coast Indians. There is no discussion about basketry or textiles.

898. _____. "The Basketry of the Tlingit." *Memoirs of the American Museum of Natural History* 3.2 (1903): 229-277.

The Tlingit, consisting of sixteen tribes, occupied southeastern Alaska. South of Frederick Sound simple plaiting in cedar bark prevailed. Throughout the northern area the elaborately decorated spruce root basket was made. Emmons focused on spruce root baskets.

899. Evans, Glen L. and T. N. Campbell. *Indian Baskets. (Part of Paul T. Seashore Collection).* Austin: Texas Memorial Museum, 1952; second edition, 1970.

This booklet describes and illustrates part of the Paul T. Seashore Collection in the Texas Memorial Museum in Austin. Most of the baskets were obtained by Seashore between 1930 and 1950, and are primarily from western North America. The subtitle was added to the second edition to distinguish the Seashore Collection from new basket acquisitions.

900. Fallon, Carol. *The Art of the Indian Basket in North America.* Lawrence: The University of Kansas Museum of Art, 1975.

This is a catalog of an exhibition of a selection of American Indian basketry from the nineteenth and twentieth centuries. There are examples of basketry from widely scattered areas of the United States and Canada. The emphasis, however, is on the western regions of both countries where there was the greatest basketry production with regard to numbers, technical proficiency, and aesthetic impact.

901. Farrand, Livingston. "Basketry Designs of the Salish Indians." *Memoirs of the American Museum of Natural History* 2.5 (1900): 391-399.

Farrand examines basketry designs among the Lillooet and Thompson Indians of British Columbia. James Teit was

responsible for collecting these baskets and explaining
their designs.

902. Fillon, Ray M. "Huckleberry Pilgrimmage." *Pacific Dis-
covery* 5.3 (May-June 1952): 4-13.

Fillon discusses and illustrates Klickitat baskets used
in the harvesting of huckleberries.

903. Frohman Trading Company. *Alaska, California and Nor-
thern Indian Baskets and Curios, Wholesale and Retail.*
Portland: Binford & Mort, 1977; reprint of the 1902
edition.

This is a catalog, embellished with excellent photo-
graphs, of the baskets offered for sale by the Frohman Tra-
ding Company of Portland, Oregon.

904. Gifford, Edward W. "Indian Basketry." In *Introduction
to American Indian Art, Part II*. By Oliver LaFarge and
others. New York: The Exposition of Indian Tribal
Arts, Inc., 1931; reprint ed., Glorieta, New Mexico:
Rio Grande Press, 1970; and 1979.

This is a collection of essays first issued in 1931 as
an ephemera publication of the Exposition of Indian Tribal
Arts, Inc. in New York City. It was later bound into a two-
volume set, entitled *Introduction to American Indian Art*.
There are illustrated examples of all forms of American In-
dian crafts. Gifford presents an overview of the Indian
basketry of the Northwest Coast.

905. Goddard, Pliny Earle. *Indians of the Northwest Coast*.
American Museum of Natural History, Handbook Series,
no. 10. New York: American Museum of Natural History,
1924.

Goddard discusses the nets, mats, baskets, and blankets
of the Northwest Coast tribes.

906. Gogol, John M. "The Butler Museum of American Indian
Art to Close." *American Indian Basketry* 2.1 (1982): 6-
7.

The Butler Museum of American Indian Art was located in
Eugene, Oregon. Elizabeth Butler wanted to make the muse-
um's collections a gift to the state of Oregon, but bureau-
cratic red-tape prevented this. The Philbrook Art Center in
Tulsa, Oklahoma was the recipient.

907. _____. "Columbia River Indian Basketry." *American In-
dian Basketry* 1.1 (1979): 4-9.

The basketry of the Klickitat, Cowlitz, Wasco and Wish-
ram, Nez Perce, Chinook, and Clatsop are individually dis-

cussed and illustrated.

908. _____. "Contemporary Lummi Indian Basket and Blanket Weaving." *American Indian Basketry* 2.1 (1982): 7.

Gogol briefly discusses the active weaving of Lummi baskets as well as Salish wool blankets by Bill James and his mother, Fran. Florence Kinley, James' aunt, also weaves cedar bark baskets.

909. _____. "Cornhusk Bags and Hats of the Columbia." *American Indian Basketry* 1.2 (1980): 4-11.

Gogol points out that the term *cornhusk* in reference to bags and hats woven by Columbia River Plateau Indians has become a generic term that refers to all types of overlay twined weaving in this area. The twined basketry of these tribes, which was made from a variety of barks, roots, grasses, and especially native hemp, are discussed.

910. _____. "Cowlitz Indian Basketry." *American Indian Basketry* 5.4 (1985): 4-20.

The Cowlitz Indians of western Washington have been highly regarded for their coiled cedar root baskets. Although there are numerous coiled cedar root baskets attributed to the Cowlitz, there are very few with documentation about the tribal origins of the basket maker. Mary Kiona, the last of a long line of Cowlitz basket makers, is a notable exception. The life and basket work of Mary Kiona are discussed. Much of the information comes from the notes of Martha Hardy, a high school teacher, who interviewed Kiona on several occasions in the 1960s.

911. _____. "Elsie Thomas Shows How To Make a Traditional Klickitat Indian Basket." *American Indian Basketry* 1.1 (1979): 18-29.

Elsie Thomas, mother-in-law of Nettie Kuneki, demonstrates how to make a traditional Klickitat Indian basket.

912. _____. "Klamath, Modoc, and Shasta Basketry." *American Indian Basketry* 3.2 (1983): 4-17.

Klamath/Modoc basketry is the last surviving form of a weaving tradition which developed from the lake and marsh culture that dominated eastern Oregon and Nevada in prehistoric times. The art of twining basketry from split tule and cattails, however, is on the verge of extinction. Shasta basketry is closely related to that of the Klamath/Modoc because of the use of a warp of two-strand twisted tule. It is readily distinguishable from Klamath/Modoc basketry because of the general use of full overlay background in beargrass with design in maidenhair fern.

913. _____. "Nootka/Makah Twined Fancy Baskets." *American*

Indian Basketry 1.4 (1981): 4-11.

Gogol focuses on how the Nootka/Makah adopted wrapped twined weaving, which has become synonomous with their basketry. The Nootka/Makah likely followed other Puget Sound tribes who produced baskets to sell to White collectors.

914. _____. "Traditional Arts of the Indians of Western Oregon." *American Indian Basketry* 4.2 (1984): 4-28.

Gogol, relying on diverse sources, presents an overview of the traditional arts of the Indians of western Oregon. Particular attention is given to the Kalapuya Indians. The basketry styles of this tribe are discussed, based on information obtained by Melville Jacobs from John Hudson (the last speaker of the Santiam Kalapuya).

915. _____. "The Twined Basketry of Western Washington and Vancouver Island." *American Indian Basketry* 1.3 (1981): 4-11.

Twined basketry is one of the oldest forms of basketry among the Coast Salish and Nootkan tribes of the Olympic Peninsula and the west coast of Vancouver Island. These tribes obtained much of their food resources from the ocean, and developed a wide variety of twined, twilled, and plaited utility baskets to gather and store this bounty. Gogol discusses the overlay and wrapped twining techniques of the Nootka/Makah, Quinault, Chehalis, and Skokomish.

916. Gunther, Erna. *Art in the Life of the Northwest Coast Indians.* Portland: Portland Art Museum, 1966.

Basketry of the Northwest Coast tribes is discussed on pages 40-51.

917. _____. "Design Units on Tlingit Baskets." Master's thesis, Columbia University, 1920.

See next entry.

918. _____. *Design Units on Tlingit* Baskets. Sitka: Sheldon Jackson Museum, 1984.

This is the published version of Gunther's Master's thesis written in 1920 at Columbia University. Gunther identifies seven characteristics in the designs of the Tlingit baskets. They are: (1.) cylindrical baskets having horizontal bands of designs; (2.) all designs are woven in these bands of which there are one, two, or three on each basket; (3.) designs are built up on lines, quadrilaterals, and triangles; no circles or curves are used; (4.) designs have tremendous variation; (5.) there is no tradition about combinations of designs on baskets; (6.) certain repetitions occur frequently; and (7.) color cannot be associated with specific designs. Gunther astutely concluded that the "me-

thod of trying to discover symbolism in every design and the method used in this paper of analyzing the design as it stands are mere makeshifts as far as the real psychology of the artist is concerned."

919. _____. *Ethnobotany of Western Washington*. Seattle: University of Washington Press, 1945.

Gunther discusses plants, their uses and preparation by the Indians, with notes on the quickly disappearing nature lore of the tribes of western Washington.

920. _____. "Indian Craft Enterprise in the Northwest." *Human Organization* 20 (1961/1962): 216-218.

The present absence of aboriginal arts and crafts among Northwest Coast Indians in Canada and the United States is analyzed. The decline in traditional purpose, modern marketing techniques, and the import of foreign replicas are viewed as reasons for the disappearance of traditional crafts from the regional native economy. Gunther suggests methods of reintroducing these activities for modern ends.

921. _____. "The Modern Basketry of the Makah." *Indians at Work* 2.20 (June 1, 1935): 36-40.

Gunther states that because of the emphasis on boxes of cedar to store their goods and to cook their food, basketry among the Makah did not play a very important part in the household economy. Exceptions were the burden baskets for picking berries and openwork baskets for clam digging and carrying fish.

922. _____. *The Permanent Collection Vol. 1. The First in a Series of Catalogs on the Permanent Collection of the Whatcom Museum of History and Art*. Bellingham: Whatcom Museum, 1975.

This is the first in a series of catalogs on the permanent collection of the Whatcom Museum of History and Art in Bellingham, Washington. Erna Gunther was primarily responsible for the organization, description, and photographing of the American Indian artifacts in the collection. Nootka, Salish, and Tlingit baskets are briefly discussed and illustrated.

923. Haeberlin, Herman K. "Principles of Esthetic Form in the Art of the North Pacific Coast." *American Anthropologist* 20 (1918): 258-264.

Haeberlin argues that in the carvings and paintings (totem poles, house fronts, basketry, canoes, dishes or spoons) of the Northwest Coast tribes, there are always certain characteristic features of style.

924. Halliday, C. C. "Basketry Hats of the East Asiatic Re-

gion as Part of a Circum-Pacific Distribution." Master's thesis, University of California at Berkeley, 1947.

Basketry hats of the Northwest Coast tribes are discussed.

925. Harner, Michael J. and Albert B. Elsasser. *Art of the Northwest Coast*. Berkeley: University of California Press, 1965.

Basketry of the Northwest Coast tribes is briefly mentioned on page 12.

926. Hawkins, Elizabeth. *Indian Weaving, Knitting, Basketry of the Northwest*. Saanichton: Hancock House, 1978.

This booklet offers only a fleeting glimpse of mat making and basketry of the Northwest.

927. Hawthorn, Audrey. *Art of the Kwakiutl Indians and Other Northwest Coast Tribes*. Seattle: University of Washington Press, 1967.

Basketry hats are discussed and illustrated on pages 184-190. Baskets and mats are described and illustrated on pages 234-235.

928. Hodge, Frederick W. "A Nootka Basketry Hat." *Indian Notes, Museum of the American Indian, Heye Foundation* 6.3. New York: Museum of the American Indian, Heye Foundation, 1929, pp. 254-258.

Hodge describes and illustrates a Nootka basketry hat which was obtained from the Peabody Museum of American Archaeology and Ethnology of Harvard University.

929. Hutchcroft, David, Marilyn Chechik, and Richard Renshaw-Beauchamp. "EgSt 2. A Basketry Cache on Seymour Inlet." *Datum: A Newsleter of the Heritage Conservation Branch* 5.1 (Winter 1980): 1, 11-14.

This site is located on the south side of Seymour Inlet. It consists of a small rock ledge, bounded by steep cliffs. In 1977, a large cache of cedar bark basketry was discovered in the rock shelter. The authors describe the efforts to salvage the basketry material.

930. Inverarity, R. B. *Art of the Old Northwest Coast Indians*. Berkeley: University of California Press, 1950.

Inverarity states that "this book is not concerned with the textile arts." He briefly mentions basketry on page 16.

931. _____. *Northwest Coast Indian Art, A Brief Survey*. Washington State University Museum Series, no. 1.

Seattle: Washington State University, 1946.

Inverarity offers a brief overview of Northwest Coast
Indian art.

932. Jackson, Nancy Susan. "Northwest Coast Basketry Col-
 lections and Collectors: Collections in the Thomas
 Burke Memorial Washington State Museum." Master's the-
 sis, University of Washington, 1984.

Jackson, in this study of Northwest Coast Indian bas-
ketry, attempts to document and provide a context for the
phenomena of Northwest Coast Indian basket collecting in the
United States. Emphasis is given to Seattle and the sur-
rounding region in the late nineteenth and early twentieth
centuries. The early establishments and prominent indivi-
duals who were involved in the sale, distribution, and col-
lecting of baskets in the Seattle area are identified and
discussed.

933. Johannesson, Kathy. "Making Cattail Mats." *American
 Indian Basketry* 4.3 (1984): 18-19.

Susan Johnson demonstrates how to make cattail mats.

934. _____. "Making Cedar Bark Mats." *American Indian Bas-
 ketry* 4.3 (1984): 12-17.

Susan Johnson demonstrates how to make a large cedar
bark mat.

935. _____. "Making Openwork Burden Baskets." *American In-
 dian Basketry* 4.3 (1984): 4-11.

Johannesson, with the advice and assistance of Susan
Johnson (daughter of Chief Andrew Lazzar of the Sooke Band),
describes her efforts to learn how to make openwork burden
baskets.

936. Jones, Joan Megan. *The Art and Style of Western Indian
 Basketry*. Blaine, Washington: Hancock House Publish-
 ers, 1982.

The American Indian basket collections of the Maryhill
Museum of Art include both the older traditions and styles
influenced by culture contact with Whites. This book serves
as an introduction to the styles and techniques of American
Indian basketry of western North America, with examples from
the Maryhill Museum of Art.

937. _____. *Basketry of the Quinault*. Tahola: Quinault In-
 dian Nation, 1977.

Jones describes the kinds of baskets made by Quinault
women many years ago and by women presently living on the
Quinault Reservation. Old styles of baskets no longer made

are illustrated by photographs of baskets from museums. The women basket makers at Taholah provided information about old and new basketry techniques, how they gathered the material and prepared it for basket making. Several different styles of weaving and different types of sewed baskets are described.

938. _____. *Introducing Western Indian Basketry*. North Vancouver: Hancock House, 1981.

Jones introduces the basic techniques, styles, and designs of the Indian basketry of western North America.

939. _____. *Native Basketry of Western North America. The Condell Collection of the Illinois State Museum*. Springfield: Illinois State Museum, 1978.

The Condell Collection of basketry in the Illinois State Museum contains many examples of the major styles of basketry made by tribes of western North America. Most of the baskets in the Condell Collection were made during the latter part of the nineteenth century and early part of the twentieth century. Thomas Condell had purchased them from collectors, dealers, and the Indians themselves. In some cases, entire private collections were purchased.

940. _____. *Northwest Coast Basketry and Culture Change*. Thomas Burke Memorial Museum, Research Report, no. 1. Seattle: Thomas Burke Memorial Museum, 1968.

In essentially the same format as the author's master's thesis, this study identifies basket attributes useful for analyzing change in the manufacture of baskets through time. Attributes selected for this study are: construction techniques of basket bottom, body, and rim; decoration style and technique; and shape. Baskets with a known chronology used in this research are from the collections of the Thomas Burke Memorial Washington State Museum and the Field Museum of Natural History. Jones groups the tribes of the Northwest into three sub-areas: Wakashan group, Coast Salish, and the Northern group. They are treated as single geographic units. The methods used in this study resemble frequency seriation. Basket attributes are coded and sorted. These data are used to construct graphs (ten year time intervals) which show the change through time of the frequency of occurence of the basketry modes.

941. _____. "Northwest Coast Basketry and Culture Change." Master's thesis, University of Washington, 1968.

See above entry.

942. _____. "Northwest Coast Indian Basketry: A Stylistic Analysis." Ph.D. dissertation, University of Washington, 1976.

Jones attempts to create typologies of Northwest Coast Indian basketry as a way to examine artifact styles and the distribution and changes in these styles. Stylistic attributes of basket bottom, body and rim construction, basket shape, and aspects of decoration were selected for examination. Nearly 3,000 examples of the basketry of the Tlingit, Haida, Tsimshian, Kwakiutl, Bella Coola, Thompson, British Columbia Salish, Nootka, Makah, Puget Sound Salish, Quinault and Skokomish were studied. The time period covered is 1820 through 1940.

943. Jones, Suzi. Editor. *Webfoots and Bunchgrassers; Folk Art of the Oregon Country*. Eugene: Oregon Arts Commission, 1980.

This book is a catalog for a traveling exhibit of Oregon folk art, which includes a selection of illustrations of American Indian baskets from the Oregon area. Included are examples of the Klamath, Wasco, Siletz, Nez Perce, Tillamook, Klickitat, Hupa, and Paiute. There is an essay by Barre Toelken about the role of basketry in American Indian life. It serves as an introduction to the catalog.

944. _____. *Pacific Basketmakers: A Living Tradition*. Fairbanks: University of Alaska Museum, 1983.

This catalog of the 1981 Pacific Basketmakers Symposium and Exhibition featured traditional basket makers from the Commonwealth of the Northern Marianas, Hawaii, Guam, American Samoa, and all of Alaska. Presented are their experiences, techniques, and works.

945. Kasner, Leone Letson. *Siletz: Survival for an Artist*. Dallas, Oregon: Printed by Itemizer-Observer, 1976.

In a chapter about "The Basketry," Kasner describes the basketry of the Siletz since the creation of their reservation in the latter part of the nineteenth century. Various types of Siletz basketry are illustrated by Kasner.

946. Katzenberg, Dena S. *"And Eagles Sweep Across the Sky": Indian Textiles of the North American West*. Baltimore: The Baltimore Museum of Art, 1977.

This catalog contains "Baskets of the West." *"And Eagles Sweep Across the Sky"* and the accompanying exhibit deal with the Baltimore Museum of Art's collections of North American Indian woven artifacts. The collection focuses on the basketry of the Northwest, California, and the Southwest.

947. Kew, Dell and Pliny Earle Goddard. *Indian Art and Culture of the Northwest Coast*. Saanichton, British Columbia: Hancock House, 1974.

Kew and Goddard discuss in turn the nets, mats, and

baskets of the Northwest tribes. There are several black and white photographs of baskets and basket makers, along with drawings of specific types of baskets and hats.

948. Kirk, Ruth. "The Last Days." *Pacific Discovery* 18.1 (January-February 1965): 2-9.

Kirk laments the decline in basket making, especially among the Makah Indians.

949. Knudtson, Peter M. "Weavers of Wood: A Small Number of Haida Indian Women Help Keep the Fine Art of Northwest Coast Basketry Alive." *Natural History* 91.5 (1982): 40-47.

Knudtson provides a detailed overview of Haida basketry and focuses especially on baskets made from the slender roots of the Sitka spruce.

950. Krimmel, Kristen. "Sechelt's Last Basket Weaver." *Westworld* 2.1 (January-February 1976): 42-43, 45.

Mary Jackson is one of the last practicing basket makers among the Sechelt Indians. Krimmel describes and illustrates the traditional cedar root baskets made by Jackson.

951. Kuneki, Nettie, Elsie Thomas, and Marie Slockish. *The Heritage of Klickitat Basketry, A History and Art Preserved.* Portland: Oregon Historical Society, 1982.

The authors, who are Klickitat basket makers, prepared this study in order to preserve the craft of making Klickitat baskets. They provide detailed instructions and illustrations about the making of their baskets.

952. Laforet, Andrea. "Tsimshian Basketry." In *The Tsimshian: Images of the Past; Views for the Present*, pp. 215-280. Edited by Margaret Seguin. Vancouver: University of British Columbia, 1984.

Laforet presents the principal forms and technical characteristics of Tsimshian basketry. The study is based on 203 baskets in the collections in the National Museum of Man, the British Columbia Provincial Museum, the University of British Columbia Museum of Anthropology, the Field Museum of Natural History, and the American Museum of Natural History.

953. Lamb, Frank W. *Indian Baskets of North America.* La Pine: Rubidoux Publications, 1972, 1976, 1981, and 1985.

Baskets of the Northwest Coast tribes are discussed on pages 23-45.

954. Lindsay, Thomas. B. "Basketry and Weaving of the North Pacific Coast." *Scottish Art Review* 8 (1961): 16-21.

Lindsay describes and illustrates a small collection of basketry and weaving specimens from the Pacific Northwest which were purchased by the Glasgow Art Gallery and Museum in 1902. Significant items include a Haida ceremonial hat, blanket cape and apron. There are also several basketry hats from this area and a woman's basketry hat from the Hupa Indians of northern California.

955. Lobb, Allan. "Indian Baskets of Alaska and the Northwest." *Alaska* 44.11 (November 1978): 46-49.

This is a book review of Lobb's *Indian Baskets of the Northwest Coast*. It is illustrated with color photographs of the baskets of the Tlingit, Haida, Aleut, and Eskimo.

956. _____. *Indian Baskets of the Northwest Coast.* Portland: C. H. Belding, 1978.

Some of the best examples of Northwest Indian basketry are photographed against the natural scenery of their places of origin. Lobb discusses the native materials and weaving techniques of the Northwest tribes. Much of the text relies on the report of Teit, Haeberlin, and Roberts on the coiled basketry of British Columbia.

957. Lobb, Allan and Art Wolfe. "Glimpses into a Lost World: A Photographic Portfolio of Northwest Indian Baskets." *American West* 15.5 (1978): 34-45.

This is a picture essay of representative examples of late nineteenth and early twentieth century baskets of historic Indian tribes of the Pacific northwest. The baskets are photographed in their natural setting.

958. Long, Dorothy. "A Comparison of the Art and Design of the Basketry and Costumes of the Nez Perce Indians with that of the Northwest Coast Indians." Master's thesis, University of Idaho, 1953.

959. MacCallum, Spencer H. and Kathy Way. *Tribal Arts of the Pacific Northwest.* Alta Loma: Rex W. Wignall * Museum Gallery, Chaffey Community College, 1976.

Way presents a general overview of Northwest coast basketry designs, decoration, and ornamentation. A spruce root hat and basket are illustrated.

960. Malin, Edward and Norman Feder. *Indian Art of the Northwest Coast.* Denver: Denver Art Museum, 1968.

This essay originally appeared in the *Denver Art Museum Winter Quarterly* (1962). It contains photographs and text of a Nootka basketry hat, Wishram and Wasco basketry bags, a

Haida basketry hat, and a Haida painted basket.

961. Marr, Carolyn J. "Salish Baskets from the Wilkes Expedition." *American Indian Art Magazine* 9 (1984): 44-51, 71.

Marr analyzes regional variations among baskets of the Coast Salish Indians, focusing on the baskets collected by Charles Wilkes' 1841 expedition to northwestern Washington.

962. Marr, Carolyn J. and Nile Thompson. "Suquamish Indian Basketry." *American Indian Basketry* 1.4 (1981): 28-31.

Although Suquamish basketry is not well-documented, an examination of thirty-five selected examples and information from first-hand accounts from tribal members established certain identifiable characteristics.

963. Mason, Otis T. *Aboriginal American Basketry: Studies in a Textile Art Without Machinery*. Annual Report of the U. S. National Museum for 1902. Washington, D. C.: Government Printing Office, 1904.

Mason discusses the basketry of the Northwest Coast Indian tribes on pages 391-439. For further details about Mason's classic study entry **49**.

964. _____. "Klikitat Baskets." *American Anthropologist* 5.1 (January-March 1903): 171-172.

Mason identifies six attributes of Klickitat baskets. These baskets are flat and glossy on the outside. There are differences in sewing which produce a bifurcated effect due to the systematic splitting of stitches underneath by the passing stitch. The bottom is a rectangular flat coil. In older baskets the bottom rests on the ground, but in others an additional hoop is sewed on to make a stand. The imbrication on some baskets covers only the top part of the body. In some baskets, the ornamentation is not imbricated at all, but runs along over and under the stitches.

965. McArthur, H. H. "Basketry of the Northwest." in *Basketry of the Coast and Islands of the Pacific*, pp. 16-24. Portland: J. K. Gill, 1896.

In this brief essay, McArthur notes the principal basketry styles and techniques of the Aleut, Tlingit, Clallam, Makah, and Klickitat tribes. He also discusses briefly the baskets of the tribes of northern California.

966. McIver, Lucy. "Attu Basketry." *Handweaver & Craftsman* 24.1 (1973): 35-37.

McIver describes the gathering and preparation of beach rye grass for weaving baskets. Diagrams, illustrations, and photographs depict the steps in making a twined Attu basket.

She notes that thimble baskets, cigar holders, and miniature replicas of traditional baskets were made for tourists.

967. Meany, Edmond S. "Attu and Yakutat Basketry." *American Indian Basketry* 2.2 (1982): 11-19.

This article appeared originally in *Pacific Monthly* 10 (1903): 211-219. Meany distinguished Attu and Yakutat basketry from the more general term, Aleutian.

968. Miles, Charles. "Burden Baskets." *Hobbies: the Magazine for Collectors* 78.9 (November 1973): 144-145.

Burden baskets were carried on the back, usually held in place by a long strap or band which passed across the forehead. Miles briefly describes the burden baskets of the Northwest Coast tribes and the Plains Indians.

969. _____. "Central Sub-Area of the Northwest Coast Culture Part III." *Hobbies: the Magazine for Collectors* 71.3 (May 1966): 114-116.

Miles briefly mentions the use of basketry for cooking.

970. _____. "Indian Basketry." *Hobbies: the Magazine for Collectors* 54.3 (May 1949): 140-141, 161.

Miles offers some simple suggestions to those interested in collecting Indian baskets. He discusses the uses for basketry, methods of construction, ethnic divisions in the western part of North America, and materials.

971. _____. "Indian Relics." *Hobbies: the Magazine for Collectors* 76.7 (September 1971): 146-150.

Miles discusses the dance basket and the babiche bag. The dance basket of the lower Klamath River tribes of northwestern California is cylindrical in shape and twined woven. The ends of the basket are closed with soft leather. There is a slit opening or mouth which extends the entire length of the basket. A rod is enclosed in either lip. A leather cord is used as a sling. The babiche is a long buckskin string, fashioned by cutting around a hide edge. Hand bags are made from a ball of babiche. Knotless netting is the method of weaving these bags. The Babiche people live in the subarctic area between the Arctic tundra and forested land in northern Canada. A Yurok Dance Basket and a babiche bag are illustrated.

972. _____. "Mat Making." *Hobbies: the Magazine for Collectors* 78.7 (September 1973): 142-143, 147.

Miles defines mats as "woven, textiles, made with basketry technique and using material of a kind associated with basketry as distinguished from cloth." The material was pliable, but certainly not limp. He argues that the prove-

nance of most mat making was the Northwest Coast. There were two types of tools for the manufacture of two different types of mats. Choppers and pounders were used to prepare ribbons of inner-bark. A long, eyed needle was used for weaving the mats.

973. Molson, Velina P. "The Basket of the Klickitat." In *Basketry of the Coast and Islands of the Pacific*. Portland: J. K. Gill, 1896.

Molson provides a very good description of Klickitat basketry.

974. Naylor, Blanche. "Exposition of Indian Tribal Arts." *Design* 34.1 (May 1932): 17-21.

Naylor notes the success of the exhibition of Indian art at the Grand Central Art Galleries in New York City. Various baskets from California, the Southwest, and Northwest were included. Several baskets from the Northwest are illustrated.

975. Nelson, Jenny. *The Weavers*. Vancouver: WEDGE, Faculty of Education, The University of British Columbia, 1983.

Written for juveniles, this book discusses and illustrates the basket making of the Haida Indians of Queen Charlotte Island.

976. Nordquist, Delmar L. "Basketry from Site 45Sn100, General Comments." *The Washington Archaeologist* 4.9 (September 1960): 2-6.

Nordquist describes basketry remains from the Snoqualmie River Site. Plain weave was the predominate basketry type. They were made of split cedar or cedar bark. Most of the specimens were "clam baskets."

977. _____. "Open Plaited Basketry from 45Sn100." *The Washington Archaeologist* 4.11 (1960): 2-5.

Nordquist briefly describes open plaited basketry remains from the Snoqualmie River Site.

978. _____. "Twana Twined Basketry." *The Washington Archaeologist* 3 (1959): 2-3.

Nordquist briefly describes the twined basketry of the Twana.

979. Nordquist, Delmar L. and G. E. Nordquist. *Twana Twined Basketry*. Ramona: Acoma Books, 1983.

In this discussion, Twana is used in a generic sense when referring to the culture as a whole. Skokomish refers to the geographic locality of the village of *Sqoqobish*.

Basketry, typical of the region, is considered to be Twana. Basketry of the reservation period and from the village is referred to as Skokomish. Emily Miller and Louisa Pulsifer, two well-known Skokomish (Twana) basket makers are shown in the process of gathering and preparing basketry materials and weaving baskets. There is a detailed analysis of Twana twined basketry designs.

980. Paul, Frances. *The Spruce Root Basketry of the Tlingit*. Lawrence: Publications of the Education Division of the United States Indian Service, Haskell Institute, 1944; fascimile reprint edition Sitka: Sheldon Jackson Museum, n.d.

This is a detailed study of Tlingit basketry with descriptions of designs, methods of manufacture, and materials.

981. Petitt, George A. *The Quileute of La Push*. Anthropological Records, University of California Publications 14 (1950).

Petitt's Quileute informants recalled that in the days before baskets were made for the tourist trade there were about five general types of baskets. All were twilled or twined and undecorated. They all served a utilitarian purpose.

982. Portland Library Association. *Basketry of the Coast and Islands of the Pacific; etc., Exhibited April, 1896, at the Portland Library*. Portland: J. K. Gill, 1896.

This pamphlet contains Colonel James Jackson, "Ancient Art and Custom," Velina P. Molson, "The Basket of the Klickitat" and H. K. McArthur, "Basketry of the Northwest."

983. Pribnow, Signe. "Beatrice Black--Quileute Basket Weaver." *American Indian Basketry* 1.3 (1981): 20-25.

Pribnow and her husband, who was employed by the Indian Health Service, lived for two years on the Quinault Reservation. During this period, Signe became a friend of Beatrice Black, a Quileute basket maker. Black taught her to weave a Quileute basket. Included are photographs of the various stages of making a basket.

984. Purvis, Ron. "B. C. Indian Baskets--A Beautiful But Fast Disappearing Art Form." *Lillooet District Society, Bulletin* 1.2 (August 1973): 3-6.

Purvis describes the basket making of the Pavilion Band from Lillooet, British Columbia.

985. _____. "A Cradle for Tradition: Interior Salish Revive Famous Basketry." *BC Outdoors* 35.5 (May 1979): 45-

49.

Recounting his prediction that coiled, cedar root baskets would disappear, Purvis notes that "Interior Salish Indian basketmaking is alive and thriving just outside of Lillooet." In 1977, a small group of Indian women of the Pavilion Indian Band twenty miles north of Lillooet formed the Pavilion Indian Crafts Center. They sought to develop a lifestyle where, ideally, their people both young and old would have the opportunity to earn their living with the community. The lifestyle would enable young people to develop skills so that they would not have to leave home to seek work in the cities, and enable the elders to make use of their traditional skills and also teach the younger generation the crafts.

986. _____. "Treasure Trails." *BC Outdoors* 29.3 (May-June 1973): 20.

Purvis predicts that the weaving of coiled, cedar root baskets is in danger of disappearing. He notes that this type of basket is still being made in the Lytton, Lillooet, and Mount Carrie areas by a "few industrious and artistic Salish basket makers who spend long hours with their arthritic hands in cold water working at a truly British Columbian art." He describes and illustrates a "nut basket," so called because of its resemblance to a hazel nut in shape.

987. Ray, Verne F. *The Sanpoil and Nespelem: Salishan Peoples of Northeastern Washington.* University of Washington Publications in Anthropology, no. 3. Seattle: University of Washington Press, 1933.

The basketry and matting of the Sanpoil and Nespelem is discussed on pages 35-39.

988. Reagan, Albert B. "Plants Used by the Hohs and the Quileutes." *Transactions of the Kansas Academy of Science* 37 (1934): 55-70.

Reagan provides a detailed list of the plants used by the Hoh and Quileute Indians to make baskets and mats.

989. _____. "Various Uses of Plants by West Coast Indians." *Washington Historical Quarterly* 25.2 (April 1934): 133-137.

Reagan discusses the various uses of cedar other than for making canoes. He mentions basketry made of reeds (basket straw) and split roots of cedar trees.

990. Reyman, Jonathan E., with Sandra Faikus, Sari Kessler, Laurie Ruedi, Anne Weirich, Susan Wexler. *A Catalogue of Native American Basketry at the LaSalle County Historical Society Museum Utica, Illinois.* Utica: Illinois State University, Anthropology Program, 1979.

Reyman discovered a collection of American Indian bas-
kets in the LaSalle County Historical Society Museum in Uti-
ca, Illinois. The baskets were in need of cleaning and pre-
servation. After restoration, an effort was made to identi-
fy the baskets. At least fifteen groups are represented by
the various baskets in the collection. Northwest tribes in-
clude the Klickitat and Salish.

991. Ross, E. H. "Basketry of the American Indian." *The
Museum, Newark* n.s. 10 (1958): 14-27.

The Newark Museum began quite early to collect American
Indian basketry. The baskets came primarily from the Cyrus
O. Baker estate and the Gibson Collection. Using the muse-
um's collections, Ross presents an overview of the Indian
basketry of western North America.

992. Sauter, John and Bruce Johnson. *Tillamook Indians of
the Oregon Coast.* Portland: Binford & Mort, 1974.

Indians of the Tillamook Coast spent many hours gather-
ing and digging food to supplement their predominantly fish
diet. Gathering consisted of collecting wild bird eggs,
young shags or other sea birds not old enough to fly,
shellfish and mollusks at low tide, and several varieties of
berries. Whether food was gathered or dug, the common car-
rying utensil was a fiber basket that was usually woven by
the women. Baskets were made in all shapes and styles. Some
were watertight and used for cooking, while others were
open-webbed so that wet objects such as clams would drain.
Some baskets were fitted with a long strap which hung around
the neck, leaving the hands free for working. As practiced
by the Indians, basketry was a complex art with numerous
weaving patterns incorporated into many basket styles and
decorating designs. The skill and imagination involved is
impressive. With few tools they formed practical baskets
that were also works of art. Several photographs of baskets
are included; also there is a photograph of a Tillamook In-
dian woman weaving baskets. The photographs are from the
Tillamook County Pioneer Museum.

993. Schackleford, R. S. "Legend of the Klickitat Basket."
American Anthropologist 2 (1900): 779-780.

Shackleford paraphrases a narrative about the origin of
basket weaving among the Klickitat.

994. Schlick, Mary D. "Cedar Bark Baskets." *American Indian
Basketry* 4.3 (1984): 26-29.

Warner Jim, a Yakima Indian, describes how to make ber-
ry baskets from a single piece of cedar bark.

995. _____. *Design Elements in Yakima Weaving.* Toppenish:
Kamiakin Research Institute, 1977.

996. _____. "Wasco Wishxam Basketry: Who Were the Wea-
vers?" *American Indian Basketry* 5.4 (1985): 21-27.

Schlick discusses the Sally bags of the Wasco-Wishxam
bands of the Mid-Columbia region. The use of Indian hemp
(*Apocynum Cannabinum*) and native grasses to make soft twined
bags was characteristic of all peoples living on or near the
Columbia River in this region. The Wasco-Wishxam made a
distinctive type of bag using full-turn twining to work com-
plex geometric or human and animal designs into the fabric.

997. Shotridge, Louis. "Tlingit Woman's Root Basket." *Mu-
seum Journal, University of Pennsylvania* 12.3 (1921):
162-178; reprinted Sitka: Sheldon Jackson Museum,
1984.

This article was reprinted by the Sheldon Jackson Muse-
um in 1984. The reprint contains an appendix of the Tlingit
terms used by the author. Louis Shotridge was a member of a
traditional Tlingit family. Consequently, he was able to
present an insider's view of Tlingit basketry. He discusses
the history, techniques, and significance of Tlingit basket
making. He includes illustrations from baskets in the Uni-
versity Museum of the University of Pennsylvania.

998. Smith, Marian W. and H. J. Gowers. "Basketry Design
and the Columbia Valley Art Style." *Southwestern Jour-
nal of Anthropology* 8 (1952): 336-341.

Smith and Gowers describe and analyze a twined basket
in the British Museum. They include a photograph of the
basket design.

999. Smith, Marian W. and D. Leadbetter. "Salish Coiled
Baskets." In *Indians of the Urban Northwest*, pp. 111-
132. Edited by Marian W. Smith. Columbia University
Contributions to Anthropology, no. 36. New York: Co-
lumbia University, 1949.

Smith and Leadbetter discuss and analyze design motifs
on Salish baskets. They include illustrations and charts
concerning the use of the various motifs.

1000. Spier, Leslie. "Klamath Ethnography." *University of
California Publications in American Archaeology and
Ethnology* 30 (1930).

Baskets of the Klamath are discussed on pages 177-193.

1001. Spier, Leslie and Edward Sapir. "Wishram Ethnogra-
phy." *University of Washington Publications in
Anthropology*, no. 3. Seattle: University of Washington
Press, 1930.

Baskets and bags of the Wishram are discussed on pages
192-197.

192-197.

1002. Steltzer, Ulli. *Indian Artists at Work*. Seattle: University of Washington Press, 1977.

This is a beautifully illustrated collection of photographs showing Northwest Coast Indian artists at work. Included are Nootka, Haida, Kwakiutl, Salish, and Athabascan basket makers.

1003. Stern, Bernard J. *The Lummi Indians of Northwest Washington*. New York: Columbia University Press, 1934.

In the chapter, "Weaving and Woodworking," Stern briefly discusses basket making of the Lummi.

1004. Stewart, Hilary. "Basketry and Bear Grass." *The Midden* 12.3 (June 1980): 10-13.

Many believe basketry in the Northwest is a dying art. This may have been true a few years ago, but there has been a resurgence of interest in basket making as young women care enough to find the time to learn and practice the art. Perhaps the prices paid for new baskets have now made it worthwhile for the young people to take up the art. The Nootka of Vancouver Island are noted for the fine close weaving of their baskets. They use swamp grass or tall basket sedge (*Carex Obnupta*), over a warp of inner cedar bark. Another ideal material is bear grass (*xerophyllum tenax*), but it does not grow in the Nootka's habitat. They buy it from the Makah.

1005. _____. *Cedar, Tree of Life to the Northwest Coast Indians*. Seattle: University of Washington Press, 1984.

Stewart discusses the various uses of the cedar tree in the making of baskets among the Northwest Coast Indians.

1006. Sturtevant, William C. "Traditional Crafts and Art of Northwest Coast Indians." In *Festival of American Folklife*, pp. 18-26. Edited by Peter Greenwood. Washington, D. C.: Smithsonian Institution and National Park Service, n.d.

Sturtevant briefly discusses the major traditional arts and crafts of the Northwest Coast tribes.

1007. Sunderland, Florence. "Klamath Basketry." *Screenings* 8.7 (1959): 1-2.

Sunderland briefly discusses Klamath basketry.

1008. _____. "Chinook Basketry." *Screenings* 8.4 (April 1959): 1-3.

Sunderland briefly discusses Chinook basketry.

1009. Suquamish Museum. *The Eyes of Chief Seattle*. Seattle: University of Washington Press, 1985.

With an emphasis on previously unpublished photographs and the techniques of oral history, this catalog provides an introduction to the American Indian cultures of the Puget Sound region. A combination of text and illustrations documents the traditional arts and subsistence activities. The continuing impact of treaty negotiations, boarding school education, and the shift to wage labor are discussed. The tribe's villages, dwellings, food gathering and preparation, basket making, matting, and weaving, canoes, and spiritual life are discussed.

1010. Teit, James A. *The Thompson Indians of British Columbia*, pp. 163-392. Memoirs of the American Museum of Natural History, no. 2. New York: American Museum of Natural History, 1900.

Basketry of the Thompson Indians is discussed on pages 187-191.

1011. _____. "Yakima and Klickitat Basketry." *American Indian Basketry* 1.1 (1979): 14-17.

This article is reprinted with minor changes from James A. Teit, H. K. Haeberlin, and Helen H. Roberts, *Coiled Basketry in British Columbia and Surrounding Region*. Annual Report of the Bureau of American Ethnology 41. Washington, D. C.: Government Printing Office, 1928. Although there is some question concerning the materials used in specific baskets and which tribes actually made the twined baskets and bags discussed in Teit's report, his study remains the only comprehensive analysis of Northwest Indian basketry.

1012. Teit, James A., H. K. Haeberlin, and Helen H. Roberts. *Coiled Basketry in British Columbia and Surrounding Region*. Annual Report of the Bureau of American Ethnology 41. Washington, D. C.: Government Printing Office, 1928.

This is the most comprehensive study of Northwest Indian basketry.

1013. Thompson, Nile. "Ed Carriere Continues a Suquamish Tradition." *American Indian Basketry* 4.3 (1984): 20-25.

Ed Carriere, a Suquamish Indian from the Port Madison Reservation, continues a basketry tradition passed down within his family. Carriere makes six types of baskets, although not all of them were traditionally made by the Suquamish. Clam and burden baskets are Carriere's specialties.

1014. Thompson, Nile and Carolyn Marr. *Crow's Shells: Artistic Basketry in Puget Sound*. Seattle: Dushayay,

1983.

Focusing on Twana and Puget Sound Salish baskets, this study deals with the cultural background as well as artistic merits. Stylistic features are analyzed and illustrated, including materials, dyes, techniques, design types, training of basket makers, and role of baskets in ceremonial and everyday life.

1015. Thompson, Nile, Carloyn Marr, and Janda Volkmer. "Twined Basketry of the Twana, Chehalis and Quinault." *American Indian Basketry* 1.3 (1981): 12-19.

The Twana, Chehalis, and Quinault made decorated twined baskets which had the shared characteristics of similar geometric and realistic figures, and ornamentation along the rim. The distinguishing features of the twined baskets of these three tribes are the use of different materials, shapes, design fields, design elements and techniques. The major difference in weaving techniques, however, is that the Chehalis used wrapped twining while the Quinault and Twana used overlay twining.

1016. Tozier, Dorr Francis. *Arts and Crafts of the Totem Indians. Collected by Captain D. E. Tozier.... Classified and Photographed by Prof. W. H. Silstrap, Curator, Ferry Museum, Tacoma.* Tacoma: Central News Company, n.d.

Professor W. H. Silstrap provides illustrations of the extensive basket collection of Captain D. F. Tozier. All of the baskets were in actual use when collected.

1017. Turner, Nancy J. *Plants in British Columbia Indian Technology.* British Columbia Provincial Museum, Handbook no. 38. Victoria: British Columbia Provincial Museum, 1979.

This volume is the third handbook of the British Columbia Provincial Museum to deal with the uses of plants by the native peoples of British Columbia. Turner focuses on the use of plants by Coastal and Interior tribes because of the overlap between these two geographical regions in the species of plants used for technological purposes. Baskets made from cedar, juniper, spruce, bear grass, and birch bark are described and illustrated.

1018. Underhill, Ruth. *Indians of the Pacific Northwest. Washington,* D. C.: Education Division of the U. S. Office of Indian Affairs, 1944.

See the section on "Women's Work" for a discussion of basket making.

1019. Wardle, H. Newell. "Certain Rare West-coast Baskets." *American Anthropologist* 14.2 (April-June 1912): 287-

313.

Wardle studied a number of Northwest Coast baskets from the perspective of design and weaving in the collection of the Academy of Natural Sciences in Philadelphia, Pennsylvania.

1020. Waterman, T. T. "Basketry and Textiles." In *Notes on the Ethnology of the Indians of Puget Sound*, pp. 1-36. Indian Notes and Monographs, Miscellaneous Series, no. 59. New York: Museum of the American Indian, 1973.

This manuscript was written by Waterman in 1921. He describes the basketry and textiles of the Indians of Puget Sound.

1021. Weber, Ronald L. "Emmons's Notes on Field Museum's Collection of Northwest Coast Basketry: Edited, With an Ethnoarchaeological Analysis." *Fieldiana Anthropology* 9 (1986).

Although George T. Emmons had little experience in ethnography before coming to Alaska, he quickly became the leading authority on Tlingit culture. Emmons provided significant collections of Tlingit material culture to several major museums. The Field Museum purchased some of Emmons' collections of Tlingit specimens, including a large number of baskets. Detailed notes accompanied the Emmons basket collection. They identify pieces as to location of manufacture and collection, and include tribal and village names. Also included are Tlingit names for basketry forms, weaving techniques, and designs. Each basket in the Emmons collection was plotted on a two-dimensional grid as an experiment in typology. Weber wanted to determine if a classification could be discerned similar to the one Emmons obtained from his informants. The scales proved that Emmons' description of functional categories was based on actual shapes and dimensions which can be discovered and isolated without the aid of Tlingit informants.

1022. _____. "Tsimshian Twined Basketry: Stylistic and Cultural Relationships." *American Indian Basketry* 2.2 (1982): 26-30.

Basketry traditions tend to develop in areas where there is significant social interaction. Consequently, it is possible to examine structural and aesthetic features in baskets from neighboring cultural areas and to predict the nature and degree of culture contact between the basket makers. Plaited baskets made of red cedar bark is a widespread basketry tradition of the Northwest Coast. Twined and coiled baskets, however, are more regional and correspond to linguistic families. Weber identifies two traditions of cylindrical, twined basketry on the Northwest Coast. There is a northern tradition of plain two-and three-strand twining centered around the Haida and Tlingit

area. The second tradition is located in the north western corner of Washington. An analysis of several baskets in the collections of the National Museum of Canada, which have the same starts and are woven in a combination of "Z" and "S" weave with overlay decoration, are identified as being of Gitksan origin. Weber concludes that the Gitksan basketry tradition was introduced by a single basket maker, who had learned her basketry techniques from a Twana or other Coast Salish weaver. She later came to the Gitksan area after her tradition had developed.

1023. Widrig, Charlotte D. "Basket Weaving by Indians Van-ishing Art." *Tacoma Sunday Ledger-News Tribune (Pacific Parade)*. June 10, 1956, p. 3.

1024. _____. "Indian Art is Fun." *Seattle Times (Magazine Section)*. July 1, 1951, p. 5.

1025. _____. "Land of Many Baskets: Seattle." *Seattle Times (Magazine Section)*. December 23, 1956, p. 10.

1026. _____. "Own an Indian Basket? Cherish It!" *Seattle Times (Magazine Section)*. July 15, 1956, p. 4.

1027. Willoughby, Charles C. "Hats from the Nutka Sound Re-gion." *American Naturalist* 37 (1903): 65-68.

Willoughby describes the woven hats of the Nootka Indians. He discusses how they were made and their designs. Included are detailed drawings of weaving techniques and photographs of four examples.

1028. Wilson, Renate. "Basket Makers of Mount Carrie." *The Beaver* 295 (Autumn 1964): 26-33.

The methods used to weave baskets are illustrated by text and photographs.

Plateau

1029. Anonymous. *American Indian Art: Form and Tradition.* Minneapolis: Walker's Art Gallery, 1972.

Discusses on pages 71-73 the baskets of the Intermontane people (between the Rocky Mountains and the Cascade Mountains).

1030. Boas, Franz. "The Decorative Art of the North American Indians." *Popular Science Monthly* 63 (1903): 481-498.

Boas argues that the decorative designs used by primitive people are not only decorations but symbols of definite ideas. Various basketry designs of Indians from the Northwest, Plateau, and Southwest are used to support this argument.

1031. Cheney Cowles Memorial Museum. *Cornhusk Bags of the Plateau Indians.* Spokane: Cheney Cowles Memorial Museum, Eastern Washington Historical Society, 1974.

Cornhusk bags are a distinctive type of flexible finger woven bag made by the Indian women of the Columbia and Snake River Plateau. The technique, design aspects, and history of cornhusk bags are briefly discussed.

1032. Clark, Ella E. *Indian Legends from the Northern Rockies.* Norman: University of Oklahoma Press, 1966.

Clark briefly discusses on page 8 the basketry of the Plateau Indians.

1033. Connette, Ann. "Nez Perce Indians." *Handweaver & Craftsman* 21.4 (Fall 1970): 5-7, 34.

With the support of a grant by the Manpower Development and Training Act, efforts were made to preserve among the

Nez Perce the traditional crafts of leather tanning and smoking, leatherwork, beadwork, and twining with cornhusks and wool. Classes, sponsored by the Lewis-Clark Normal School in Lewiston, Idaho, are taught on the Reservation by experienced Nez Perce women. Detailed instructions are provided to weave a Nez Perce bag.

1034. Culin, Stewart. *Games of the North American Indians*. Annual Report of the Bureau of American Ethnology 24. Washington, D. C.: Government Printing Office, 1907.

Various types of baskets used in the games of North American Indians are described.

1035. Gogol, John M. "Columbia River/Plateau Indian Beadwork." *American Indian Basketry* 5.2 (1985): 4-27.

Gogol presents an overview of Plateau Indian beaded bags. The Nez Perce are mentioned only cursorily because they will be treated separately in another study.

1036. _____. "Ida Blackeagle, Master Nez Perce Weaver." *American Indian Basketry* 1.2 (1980): 30.

Ida Blackeagle, a weaver of Nez Perce cornhusk bags, died several years ago. She was not well-known outside of Idaho. She was responsible for teaching a number of students, including Rose Frank.

1037. _____. "Rose Frank Shows How to Make a Nez Perce Cornhusk Bag." *American Indian Basketry* 1.2 (1980): 22-31.

Rose Frank studied weaving under the guidance of Ida Blackeagle, a master Nez Perce weaver. Frank demonstrates how to make a Nez Perce cornhusk bag.

1038. Loeb, Barbara. "Mirror Bags and Bandolier Bags: A Comparison." *American Indian Art Magazine* 6.1 (Winter 1980): 46-53, 88.

Loeb, comparing bandolier bags with classic mirror bags gnerally attributed to the Crow Indians, attempts to pinpoint a subgroup of beadwork that looks Crow but can be documented as being Plateau or Great Basin in origin. She suggests that the bandolier bag is a Plateau/Great Basin product.

1039. Miller, G. Lynette. "Flat Twined Bags of the Plateau." Master's thesis, University of Washington, 1986.

The flat twined bags of the Plateau tribes is one of the more common artifacts. Nevertheless, Plateau bags have not been studied as much as other forms of American Indian basketry. Miller attempts to distinguish the works of the various Plateau tribes which made twined bags and investi-

gates the changes through time in the materials and designs used in making twined bags.

1040. Quihuis, Lelia Lavine. "The Corn Husk Bags of the Nez Perce." *Hobbies: the Magazine for Collectors* 70.1 (March 1965): 114-116, 125.

Quihuis describes with much enthusiasm her acquisition of several rare Nez Perce cornhusk bags.

1041. Ray, Verne F. *The Sanpoil and Nespelem: Salishan Peoples of Northeastern Washington.* University of Washington Publications in Anthropology, no. 3. Seattle: University of Washington Press, 1932.

Basketry and matting of the Sanpoil and Nespelem are discussed on pages 35-39.

1042. Reyman, Jonathan E., with Sandra Faikus, Sari Kessler, Laurie Ruedi, Anne Weirich, Susan Wexler. *A Catalogue of Native American Basketry at the LaSalle County Historical Society Museum Utica, Illinois.* Utica: Illinois State University, Anthropology Program, 1979.

Reyman discovered a collection of American Indian baskets in the LaSalle County Historical Society Museum in Utica, Illinois. The baskets were in need of cleaning and preservation. After restoration, an effort was made to identify the baskets. At least fifteen groups are represented by the various basketry specimens in the collection. There were several Nez Perce baskets in the collection.

1043. Schlick, Mary D. "Art Treasures of the Columbia Plateau Indians." *American Indian Basketry* 1.2 (1980): 12-21.

Schlick discusses the twined weaving of the Indians of the Columbia River Plateau. Generally referred to as Nez Perce bags, this form of basketry was made by all the Sahaptin-speaking groups, the Wishram and Wasco, and some of the Interior Salish. Incomplete documentation has hindered identifying the source of many Plateau twined bags.

1044. _____. "A Columbia River Indian Basket Collected by Lewis and Clark in 1805." *American Indian Basketry* 1.1 (1979): 10-13.

Schlick investigates a Wasco bag collected by Lewis and Clark in 1805. The bag is now in the Peabody Museum of Harvard University. The identification of this Wasco bag establishes the antiquity of Wasco-Wishram figured basketry.

1045. Shawley, S. D. "Hemp and Cornhusk Bags of the Plateau Indians." *Indian America* 9.1 (1975): 25-29.

Shawley examines in detail the hemp and cornhusk bags

of the Plateau Indians. Attention is given to the technical and stylistic changes through time in these bags. Materials, techniques, designs, and collectors of cornhusk and hemp bags are examined.

1046. Walker, Deward E. *Indians of Idaho*. Moscow: The University Press of Idaho, 1978; second printing, 1980.

Basketry of the Nez Perce is discussed on page 73.

1047. Wyman, Anne. *Cornhusk Bags of the Nez Perce Indians*. Southwest Museum Leaflets, no. 1. Los Angeles: The Southwest Museum, n.d.

Several collectors donated cornhusk bags to the Southwest Museum. Wyman describes the technique, materials, and designs of the Nez Perce cornhusk bags.

Subarctic

1048. Anonymous. "Making a Micmac Basket." *Cape Breton's Magazine* 2 (1973): 3-5.

Demonstrates how to make a Micmac basket.

1049. Brasser, Ted J. *"BO'JOU, NEEJEE!" Profiles of Canadian Indian Art*. Ottawa: National Museum of Man, 1976.

An Iroquoian, Algonkin, and Ojibwa basket are illustrated, but there is very little discussion about basketry in the text.

1050. Davidson, D. S. *Decorative Art of the Tetes de Boule of Quebec*. Indian Notes and Monographs, Museum of the American Indian, Heye Foundation, no. 10. New York: Museum of the American Indian, Heye Foundation, 1928.

Davidson discusses the decorative motifs used on birch bark containers and moccasins by the Tetes de Boule of Quebec--a semi-nomadic tribe--and the negative effects of acculturation on their artistry.

1051. Department of Indian Affairs and Northern Department, Marketing Centre. *Indian Arts and Crafts*. Ottawa: Department of Indian Affairs and Northern Department, 1968.

Various Indian art forms, including basketry, are presented and described in this catalog from the Marketing Centre in Ottawa.

1052. Dickenson, Victoria and Patricia Gratten. *Grass Work of Labrador*. St. John's: Art Gallery, Memorial University of Newfoundland, 1979.

This exhibit of the sewn coil grass basketry of Labrador, organized by the Art Gallery of the Memorial University

of Newfoundland, examines the history of this particular
form of basketry and introduces the skilled and creative
basket makers of today.

1053. Florian, Mary-Lou. "Waterlogged Artifacts: The Na-
 ture of the Materials." *The Journal of the Canadian
 Conservation Institute* 2 (1977): 11-15.

Waterlogged and deteriorated tissue of such recovered
basketry has no inherent strength, compactness or unity; and
the only thing that actually keeps it together is the com-
pacted soil matrix in which it is buried. It is the puff of
fibers and cell remnants that have to be conserved.

1054. Gordon, Joleen. "The Basketry Traditions of Nova
 Scotia." *Shuttle, Spindle and Dyepot* 17.2 (Spring
 1986): 52-57.

There are three traditional styles of basketry in Nova
Scotia: Micmac, European, and Black. The Micmac Indians,
the largest group of weavers in the province, make baskets
as a source of income. Ash (Fraxinus) is preferred, but ma-
ple and poplar are also used. Micmac baskets are woven en-
tirely of splints.

1055. _____. *Edith Clayton's Market Basket*. Halifax: The
 Nova Scotia Museum, 1977.

On pages 33-35, Gordon discusses Micmac and Malecite
wood splint basketry.

1056. _____. *Withe Baskets, Traps and Brooms*. Halifax:
 The Nova Scotia Museum, 1984.

On pages 6-7, Gordon explores the possibility that the
Micmac may have been familiar with withe basketry prior to
contact with Europeans.

1057. Gray, Viviane. "The Many Forms of Micmac Baskets."
 Tawow 5.2 (1976): 50-55.

Gray discusses the sweetgrass, wood and birch bark
baskets made by the Micmac Indians. She notes that the
latest form of basket work is the wood splint basket.

1058. Harper, J. Russell. *Portland Point: Preliminary
 Report of the 1955 Excavation*. The New Brunswick Museum
 Historical Studies, no. 9. St. John's: The New Bruns-
 wick Museum, 1956.

This is the preliminary site report about the Portland
Point, New Brunswick excavation. It contains two appendi-
ces. The first appendix discusses a contact period "copper-
kettle" burial near Pictou, Nova Scotia. It mentions the
discovery of fiber-woven artifacts. The second appendix,
"Netting and Matting Weaves of the Micmacs and Maliseets,"

provides much more detail about the material from the Pic-
tou Site, and compares it with fragments from a burial at
Red Bank, New Brunswick and a charred fragment from Portland
Point.

1059. _____. "Two Seventeenth-Century Copper-Kettle Buri-
als." *Anthropologica* 4 (1957): 11-36.

This is a condensed article about the Pictou Site, at
which fiber-woven artifacts were discovered.

1060. Indian and Northern Affairs Canada. *Atlantic Region
Indian Art Juried Exhibition.* Amherst, Nova Scotia:
Department of Public Affairs, Atlantic Region, Indian
and Northern Affairs, 1986.

Included in this exhibit are a "Nest of Fancy Apple
Baskets" made by Rita and Noel Smith, both Micmac Indians.

1061. Macfie, J. "Crafts of the Cree." *Beaver* 288.2
(1957): 53-57.

Macfie notes the profound changes in the material
culture of the Cree Indians due to contact with Whites.
Snowshoes, babiche bags, cradle boards, and moccasins, how-
ever, continue to be made and used by the Cree. There is a
photograph of a reed mat used for drying blueberries.

1062. McFeat, Tom F. S. *Museum Ethnology and the Algonkian
Project.* National Museum of Canada Anthropology Papers,
no. 2. Ottawa: Queen's Printers, 1962.

McFeat provides an overall view of the culture of the
northeastern Algonkian tribes and notes, in particular, cer-
tain surviving elements. McFeat considered the contribution
that could be made to the understanding of the tribes by
well-planned museum projects which included field research
and a study of specimens. Using the Malecite basket indus-
try as illustrative of his theory, he offers a wealth of
valuable primary source Malecite material.

1063. _____. "The Object of Research in Museums," pp. 91-
99. *Contributions to Ethnology V.* National Museums of
Canada Bulletin, no. 204. Ottawa: Queen's Printers,
1967.

Six propositions which outline McFeat's philosophy of
museology and the relationship between ethnology and museum
research are presented. The basket industry of the Malecite
of New Brunswick is discussed. The form, principle, use,
and meaning of the baskets are examined.

1064. _____. "Two Malecite Family Industries: A Case Stu-
dy." *Anthropologica* 4 (1962): 233-271; reprinted in *The
Native Peoples of Atlantic Canada*, edited by H. F.
McGee. Ottawa: Carleton University Press, 1983.

The development of cottage industry among the five Mal-
ecite reserves in New Brunswick is discussed. Baskets and
barrel making, with reference to two families, are con-
trasted in order to inflate the function of each in a chang-
ing Indian identity.

1065. Miles, Charles. "Indian Relics." *Hobbies: The Maga-
zine for Collectors* 76.7 (September 1971): 146-150.

Miles discusses the dance basket and the babiche bag.
The dance basket of the lower Klamath River tribes of
northwestern California is cylindrical in shape and twined
woven. The ends of the basket are closed with soft leather.
There is a slit opening or mouth which extends the entire
length of the basket. A rod is enclosed in either lip. A
leather cord is used as a sling. The babiche is a long
buckskin string, fashioned by cutting around a hide edge.
Hand bags are made from a ball of babiche. Knotless netting
is the method of weaving these bags. The Babiche people
live in the subarctic area between the Arctic tundra and
forested land in northern Canada. A Yurok dance basket and
a babiche bag are illustrated.

1066. Pelletier, Gaby. "The Analysis and Classification of
Maliseet Splint Ash Baskets." Honours Field Project in
Anthropology, University of New Brunswick, Fredericton,
New Brunswick, 1973.

1067. _____. "The Basket Case." *Journal of the New Bruns-
wick Museum* 1 (1977): 72-77.

Pelletier describes the work and fancy baskets of the
Maliseet Indians. By examining these baskets, she argues,
changes in the economic, political and social culture of the
Maliseets can be partially ascertained.

1068. _____. *Micmac and Maliseet Decorative Traditions*.
Saint John: The New Brunswick Museum, 1977.

This is a catalog of Maliseet and Micmac decorative
arts from the collections of The New Brunswick Museum.
Birch bark and splint ash baskets are illustrated.

1069. _____. "New Brunswick Indian Crafts." *Canadian An-
tiques Collector* 10 (January-February 1975): 14-18.

Pelletier briefly describes Maliseet Indian baskets.

1070. Rogers, Edward S. *The Material Culture of the
Mistassini*. Canada National Museum, 28. (1967).

Rogers briefly describes the baskets of the Mistassini
Indians.

1071. Salo, Christine. "Athapaskan Birch Bark Containers:

Styles and Construction," Master's thesis, University
of Washington, 1983.

Salo provides a detailed discussion of the various
types of birch bark containers made by the Athapaskan.

1072. Smith, Jean. "Indian Artifacts." *Canadian Antiques
Collector* 10 (January-February 1975): 14-18.

Smith is a lecturer and collector of antiques. In this
article she describes and illustrates some of the Indian ar-
tifacts found in antique shops in Canada. There is a brief
discussion of Indian basketry, along with photographs of
several Indian baskets.

1073. Speck, Frank G. *Art Processes in Birch Bark of the
River Algonquin, a Circumboreal Trait*, pp. 229-274.
Bulletin of the Bureau of American Ethnology, no. 128.
Anthropological Papers, no. 17. Washington, D. C.:
Government Printing Office, 1941.

The birch bark basketry of the River Desert Band, River
Du Lievre Band, Golden Lake Band, Mattawa Band, and Timiska-
ming Band are discussed.

1074. _____. *Beothuk and Micmac*. Indian Notes and Mono-
graphs, Museum of the American Indian, Heye Foundation.
Miscellaneous Series, no. 22 New York: Museum of the
American Indian, Heye Foundation, 1922.

Speck comments on the now extinct Beothuk and the
Micmac of Newfoundland, and the contacts that once may have
occurred between them. He includes information on Micmac
housing, crafts, dress, and hunting territories.

1075. _____. "Indian Art Handicrafts of Eastern Canada."
School Arts 43.8 (April 1944): 266-270.

Certain characteristics of art design of Indian groups
of eastern Canada have been assigned to two possible ori-
gins. Marius Barbeau argued that the whole art form of Al-
gonkian-speaking tribes in Canada within the sphere of early
French influence acquired and developed their decoration
patterns from the convents of Quebec since 1669. Others
have argued that the Indians of eastern Canada possessed an
art tradition which pre-dates the arrival of the French.
This art form was expressed in body-tatooing, in painting,
and etching on bark and skin in the form of patterns which
have persisted to the present. Speck argued strongly in
support of the latter explanation.

1076. _____. *Montagnais Art in Birchbark*. Indian Notes and
Monographs, Museum of the American Indian, Heye Founda-
tion, no. 11 New York: Museum of the American Indian,
Heye Foundation, 1937.

Speck discusses the making and ornamentation of birch bark containers in the lower St. Lawrence region, especially those of the Montagnais bands at Lake St. John.

1077. . "River Desert Indians of Quebec," pp. 240-252. *Indian Notes, Museum of the American Indian, Heye Foundation* 4.3. New York: Museum of the American Indian, Heye Foundation, 1927.

Speck suggests that there is no supportive evidence that the weaving of basswood fiber bags or mats existed among the River Desert Band of Algonquin Indians. The simple checker-weave, however, in cedar bark occurred in the making of various bags and floor mats. Ash splints had become extensively used in basket weaving. Splint baskets, called *awedjoenagen*, appeared to have a strong hold on this band. A splint basket and unusual basketry knife-sheath are illustrated.

1078. Steinbright, Jan, editor. *From Skins, Trees, Quills and Beads: The Work of Nine Athabascans*. Fairbanks: Institute of Alaska Native Crafts, n.d.

This collection of essays contains "Birch Bark Baskets--Sarah Malcolm" and "Willow Root Baskets--Lina Demoski." Sarah Malcom and Lina Demoski are Athabascan basket makers. Their techniques and styles are described and illustrated. Although no attempt is made to show "step-by-step" the making of their baskets, Steinbright demonstrates "the value in these crafts as material expressions of cultural values many Athabascans today are struggling to keep alive."

1079. Wallis, Wilson D. and Ruth Saltwell Wallis. *The Micmac Indians of Eastern Canada*. Minneapolis: University of Minnesota Press, 1957.

The Wallises note that cedar, spruce, juniper, and other woods were used to make baskets. They relate the story told by Peter Ginnish which explains the origin of basket making and the methods of making baskets. On page 76 are four illustrations showing the method of making a splint basket.

1080. Webber, Alika Podolinsky. "Birchbark Baskets." *Imperial Oil Review* 57.4 (1973): 2-7.

Webber, who did fieldwork among the people of Manouane, one of the three surviving sub-bands of the Tetes de Boule tribe of the upper Saint-Maurice region of Quebec, describes the making of birch bark containers. Included are various photographs of the actual steps in making these baskets.

1081. Whitehead, Ruth Holmes. *Elitekey: Micmac Material Culture from 1600 to the Present*. Halifax: The Nova Scotia Museum, 1980.

The Micmac used wood splints in checker, twill, and hexagonal weaves, and also wicker-wove the shoots of witherod, yellow birch, elder and willow to make baskets. Whitehead offers considerable documentation to demonstrate that the Micmac were twill- and checker-plaiting cedar bark prior to the seventeenth century.

1082. _____. *Plant Fibre Textiles from the Hopps Site: BkCp-1*. Halifax: The Nova Scotia Museum, 1987.

This is a detailed and thorough examination of the fiber-woven textiles from the Hopps Site.

Arctic

1083. Anonymous. "Making Whalebone Baskets." *Arctic Cubs* (May 19, 1943-44): 1.

This is a brief description of baleen baskets.

1084. _____. "Plant Lore of the Dena'inas (birch bark baskets)." *Alaska Magazine* 44.8 (August 1978): 55-57.

Dena'inas, also known as Tanainas, live in the Cook Inlet area. Lime Village, on Stony River, is a stronghold of Dena'ina culture. The Bobby family practices traditional subsistence activities. They peel birch bark in the summer to make baskets.

1085. Brockliss, Ramona Park. "Vanishing Aleutian Art." *Alaska Life* 4.2 (1941): 13-14.

Brockliss briefly describes Atka and Attu basketry, including cursory comments about construction, weave, and beauty.

1086. Burkher, Howard H. and Pauline C. Burkher. "Behind Baleen Baskets." *Smoke Signals* 10 (1954): 13-15.

The Burkhers briefly describe the making of baleen baskets.

1087. Burkher, Pauline Chastain. "From the Whale's Mouth." *Alaska Sportsman* 10.2 (February 1944): 14-15, 24.

Burkher describes and illustrates the manufacture of baleen baskets made by Eskimos at Point Hope and Point Barrow.

1088. Cavana, Violet V. *Alaska Basketry*. Portland: Privately Printed by the Beaver Club of Oregon, 1917.

Cavana surveys woven wild-rye grass basketry of the Bristol Bay and Kuskokwim River area and coiled grass and willow basketry from the Norton Sound and Arctic Ocean, noting construction materials and decorative designs. This survey of basketry includes several pages describing construction, decoration, and designs of Aleut baskets in which she points out local variations in Aleut basketry art form among the Unalaska, Unmak, Atka, and Attu Islands. She considers Attu basketry the finest of any Aleut basketry and suggests that this was partly because the Attu Aleuts had been least distracted by acculturative processes.

1089. Chandonnet, Ann. "MINGQAALIYARAQ: Books on Eskimo and Aleut Basketry." *American Indian Basketry* 2.2 (1982): 31-32.

This is a review of *Kiliikaq Yugnek*, a cultural heritage magazine written and published by Bethel Regional High School students, and Kathleen Lynch's *Aleut Basket Weaving*.

1090. _____. "Sophia Pletnikoff's Cloth Made of Grass." *Alaska Journal* 5.1 (Winter 1975): 55-58.

Chandonnet discusses preparation of materials used to make baskets.

1091. Ernst and Ernst. Management Services Division. *Alaska Native Arts and Crafts Cooperative Association, Inc.: A Recommended Program for Alaskan Native Handcraft Development.* Seattle: Ernst & Ernst, Management Services Division, 1967.

The future of the Alaskan Native Arts and Crafts Cooperative Association, Inc. depended on the changing nature of the handcraft industry of the Alaskan Eskimos and Indians and the competing efforts being made to sell their products. This report presents a general review of the handcraft industry and its scope and market. On pages III-66 to III-69 basketry is briefly discussed. Ernst states that the "production level of the best products has decreased over the years since the monetary return from this craft is generally unrewarding and could never hope to approach even a reasonable economic return to the craftsman."

1092. Frembling, Elizabeth. "The Native Artcrafts of the Islands of the World." *School Arts* 45.1 (September 1945): 3-10, 31-36.

On page 11, there are illustrations of Aleut Indian baskets and woodcarvings.

1093. Frohman Trading Company. *Alaska, California and Northern Indian Baskets and Curios, Wholesale and Retail.* Portland: Binford & Mort, 1977; reprint of the 1902 edition.

This is a catalog, embellished with excellent photo-
graphs, of the baskets offered for sale by the Frohman Tra-
ding Company of Portland, Oregon.

1094. Gogol, John M. "Indian, Eskimo, and Aleut Basketry
 of Alaska." *American Indian Basketry* 2.2 (1982): 4-10.

Gogol offers a brief overview of the basketry of the
Indians, Eskimos, and Aleuts of Alaska.

1095. Gray, Minnie Aliitchak, Tupou L. Pulu, Angeline New-
 lin, Ruth Ramoth-Sampson. *Birch Bark Basket Making
 Aimmiliq QIA GUMIK*. Anchorage: National Bilingual Ma-
 terials Development Center, n.d.

The construction of birch bark baskets among the
Alaskan Native peoples is described.

1096. Hamar, Arlie. *Baskets of Alaska*. Cincinnati: The
 Mosaic Press, 1982.

The Mosaic Press of Cincinnati, Ohio publishes minia-
ture books. This book, which measures three-quarters of an
inch by one inch, is a survey of the basketry of Alaska's
native peoples. Much of the information comes from Hamar's
personal contacts with the basket makers.

1097. Hudson, Raymond L. "Designs in Aleut Basketry." In
 Sheldon Jackson Museum Centennial Celebration. Juneau:
 Division of Alaska State Museums, 1987.

Hudson discusses the designs in Aleut basketry in the
collection of the Sheldon Jackson Museum. Aleut basketry
designs were created in two ways. One design was achieved
by altering the regular sequence of warp and weft. Another
way was to insert a colored fiber which wrapped the weft or
paralleled the warp. This latter method is known as false
embroidery.

1098. Institute of Alaska Native Arts, Inc. *From Skins,
 Trees, Quills and Beads: The Work of Nine Athabascans*.
 Fairbanks: Institute of Alaska Native Arts, Inc.,
 1984.

The arts and crafts of Sarah Malcolm, Eliza Jones, Ho-
ward Luke, Lavine and Susie Williams, Lina Demoski, Sally
Hudson, Shirley Holmberg and Julia Peter are documented.
Contains information on birch bark baskets, fish nets,
snowshoes, fish traps, willow root baskets, skinsewing,
quillwork, and beadwork.

1099. Jochelson, Walderman. *History, Ethnology and Anthro-
 pology of the Aleut*. Washington, D. C.: Carnegie
 Institution of Washington, 1933.

NATIVE AMERICAN BASKETRY

Among the various cultural activities of the Aleut, Jochelson discusses the "Grass Work of Aleut Women." Photographs of woven grass cigarette-holders from the University Museum in Boston are included. There is very little discussion about the actual manufacture of baskets. The process of weaving grass is shown in Jochelson's *Archaeological Investigations in Aleutian Islands*, Washington, D. C.: Carnegie Institution of Washington, 1925 in Figure 5b.

1100. Jones, Livingston F. "Basketry." In *A Study of the Thlingets of Alaska*, pp. 85-91. By Livingston F. Jones. New York: Fleming H. Revell, 1914.

Relying heavily on George T. Emmons' study, Jones briefly describes Tlingit basketry. He discusses the growing market for baskets among tourists.

1101. Jones, Suzi, editor. *The Artists Behind the Work*. Fairbanks: University of Alaska Museum, 1986.

This catalog features the life histories of Lena Sours, an Inupiaq skin sewer; Nick Charles, a Yup'ik carver; Frances Demientieff, a bead worker; and Jennie Thlunaut, a Chilkat blanket weaver. Although basketry is not a specific focus of these artists, there are photographs of spruce root baskets made by Jennie Thlunaut.

1102. _____. *Pacific Basketmakers: A Living Tradition*. Fairbanks: University of Alaska Museum, 1983.

This catalog of the 1981 Pacific Basketmakers Symposium and Exhibition features traditional basket makers from the Commonwealth of the Northern Marianas, Hawaii, Guam, American Samoa, and all of Alaska. Presented are their experiences, techniques, and works.

1103. Kennedy, Michael. "Reviving Native Arts." *Alaska Review* 4.2 (Fall 1970): 11-39.

Kennedy briefly discusses the revival of basket making in Alaska.

1104. Kissell, Mary L. "An Aleutian Basket." *The American Museum Journal* 7 (1933): 133-136.

Kissell describes Attu basketry in detail, from the selection of materials and their preparation to weaving patterns and ornamentation.

1105. Lamb, Frank W. *Indian Baskets of North America*. La Pine: Rubidoux Publication, 1972, 1976, 1981, and 1985.

Baskets of the Eskimo are discussed on pages 146-149.

1106. Lee, Molly. "Alaska Eskimo Baleen Baskets." *Historic Nantucket* 29.1 (1981): 19-24.

Lee briefly describes the making of baleen baskets.

1107. _____. "Baleen Basketry of the North Alaskan Eskimo." Master's thesis, University of California, 1981.

See next entry.

1108. _____. *Baleen Basketry of the North Alaskan Eskimo.* Barrow: North Slope Borough Planning Department, 1983.

The Eskimos of North Alaska began to make baleen baskets in response to tourist demands about fifty years ago. Lee seeks to make a permanent record of baleen basket making before this art form becomes extinct, and to contribute to the growing body of information about tourist art and to its legitimization.

1109. _____. "Native Baskets: From Housewares to Souvenirs." *Alaska Journal* 9.4 (Autumn 1979): 87-90.

When trade was established between Natives of Alaska and Europeans, many hand-woven items were replaced in everyday use by man-produced articles of foreign manufacture. This contact also brought new outlets for the weavers. The years 1890 to 1920 marked the zenith of Aleut basketry. Only a handful of basket weavers are left today. The future of Aleut basketry depends on maintaining traditional high standards of quality, public appreciation of the art, and remuneration to the weaver.

1110. _____. "Objects of Knowledge: The Communicative Aspects of Baleen Baskets." *Etudes/Inuit/Studies* 9.1 (1985): 163-182.

Lee suggests that the communicative dimension of tourist art may be more sensitive than is usually supposed. Aesthetically and communicatively, the baleen basket characteristics create a visual syntax for objectifying Inuit thought. Destined for life in an alien culture, the basket, like a letter, encodes and stores for later transmission a message about being Inupiat.

1111. _____. "Pacific Eskimo Spruce Root Baskets." *American Indian Art Magazine* 6.2 (1981): 66-73.

Lee discusses twined spruce root baskets of the Pacific Eskimo. She argues that these baskets stand as a distinctive type, no longer made and previously unrecognized.

1112. Lynch, Kathleen. *Aleut Basket Weaving.* Anchorage: ALL Project at the University of Alaska, 1977.

This booklet, based on information obtained from Sophia Pletnikoff of Unalaska, discusses Aleut basket weaving.

1113. Madison, Allan. "Alaskan Basketry." *The Indian's Friend* 23.8 (April 1911): 12.

Reprinted from the Chemawa *American*, this brief passage briefly describes Alaskan Native baskets.

1114. McDowell, Lloyd W. *Alaska Indian Basketry.* Seattle Alaska Steamship Company, 1905; facsimile edition reprinted Seattle: Shorey Book Store, 1966.

McDowell discusses types of baskets, how they are made, and how to start a collection.

1115. Osgood, Cornelius. *Ingalik Material Culture.* Yale University Publications in Anthropology, no. 22. New Haven: Yale University Press, 1940.

Osgood provides detailed descriptions and illustrations of birch bark baskets, a fish net basket made from strips of spruce root, and twined grass baskets.

1116. Partnow, Patricia H. *Floral Resources in Makushin Bay: The Aleuts of the Eighteenth Century. Social Studies Unit, Book III.* Anchorage: Alaska Native Education Board, Inc., 1976.

This booklet illustrates major plant resources in Makushin Bay. Partnow explains how plants were used by eighteenth century Aleuts. Beach grass was used in weaving baskets.

1117. Porcher, C. Gadsen. "Basketry of the Aleutian Islands." *The Basket* 2.2 (April 1904): 67-79.

Among basket collectors at the beginning of the twentieth century, the term "Attu Basket" referred to a beautifully woven, frail, and very expensive basket which came from an indefinitely situated island near Alaska. The isolation and inaccessibility of the island of Attu was the primary reason for the high value of its baskets. Many of the baskets which did reach the market were incorrectly identified as Attu. In the eight Aleutian villages--Attu, Atka, Nikolski, Unalaska, Makushin, Kashiga, Chernofski, and Beorka--the basketry materials are the same, except for those used in decoration. The baskets from each of these villages is discussed.

1118. Ransom, Jay Ellis. "Aleut Basket Weaving: A Vanishing Art." *Alaska Journal* 8.3 (Summer 1978): 229-231.

Ransom briefly describes Aleut basketry and notes the decline in basket making. He points out that in the late 1920s and early 1930s an unidentified collector purchased

nearly every available Aleut basket in the western
Aleutians.

1119. Ray, Dorothy Jean. "Birch Bark Baskets of the Kobik
Eskimos." *Alaska Sportsman* 31.3 (March 1965): 15-17.

Ray describes the construction and use of birch bark
baskets. Several photographs are included with the text.

1120. Samuelson, Virginia and Eunice Neseth. *How to Attu:
A Guide to Making Your Own Attu Basket*. Kodiak: Arctic
How To Books, 1981; second edition, 1983.

This booklet provides information about how to make
Attu baskets. The information is based on notes taken in
the workshop class in Attu basketry weaving taught by Eunice
Neseth at the Alaska Pacific University in 1980.

1121. Shapsnikoff, Anfesia T. and Raymond L. Hudson.
"Aleut Basketry." *Anthropological Papers of the Univer-
sity of Alaska*, 16.2 (1974): 41-69.

This study is based on the collaboration of an Unalaska
school teacher and the later Mrs. A. T. Shapsnikoff, who was
one of the few remaining practitioners of the art of Attu
basketry. Hudson learned this art during the course of
their work. His detailed description of gathering and
preparing the grass and constructing the baskets and weaving
forms and basket designs used helps to preserve the art of
Aleut basketry.

1122. St. John, G. B. "Alaskan Basket Sellers." *Travel* 14
(June 1909): 420-421.

St. John briefly discusses the sale of Eskimo baskets
to tourists.

1123. Steinbright, Jan. *Interwoven Expressions: Works By
Contemporary Alaska Native Basketmakers*. Fairbanks:
Institute of Alaska Native Basketmakers, Inc., n.d.

This is the catalog of an exhibition of Alaska Native
basketry organized by the Institute of Alaska Native Arts.
A photograph of each of the basket makers, an example of
their work, and autobiographical comments are the basic com-
ponents of the catalog.

1124. _____. "Weaving a Design for the Future." *Alaska
Journal* 12.1 (Winter 1982): 40-41.

Fourteen Aleut basket makers got together in 1981 and
discovered, to their surprise, that the traditional art was
still very much alive, but for how much longer no one would
predict.

1125. Stevens, Bob. "The Basket Weavers of Nanivak."

Alaska 36.7 (July 1970): 32-33.

Stevens briefly describes coiled grass baskets of Nunivak Island. He notes that elderly women who found short lengths of nylon rope on the beach, would unravel the rope and weave baskets from the strands.

1126. Titus, Dorothy and Matthew Titus. *Dats'en lo k'eytth'ok tr'eghonh: This is the Way We Make Our Baskets.* Fairbanks: University of Alaska Museum, 1985.

The Tituses discuss the process of constructing Athabaskan birch bark baskets. The text is in English and Athabaskan.

1127. Wardle, H. Newell. "Attu Treasure." *Museum Bulletin, University of Pennsylvania* 11 (1946): 23-26.

Wardle describes Attu coiled grass baskets.

1128. Widgrig, Charlotte D. "Natives of Alaska Adept Basket Weavers; Fashion Variety of Styles." *The Tacoma News Tribune, Pacific Parades Magazine*, January 20, 1957.

Author Index

Note to the reader: This index is keyed to each
bibliographical entry. All numbers refer to a
bibliographical entry.

Author Index

Author Index

Author Index

Author Index

Author Index

Tantaquidgeon, Gladys 77, 78, 79, 80
Taylor, Douglas 197
Teit, James A. 1010, 1011, 1012
Thomas, Elsie 951
Thompson, Nile 962, 1013, 1014, 1015
Thompson, Rahmona A. 118
Timbrook, Jan 748, 831
Titus, Dorothy 1126
Titus, Matthew 1126
Tozier, Dorr Francis 1016
Tschopik, Harry 610, 611, 612
Tuohy, Donald R. 368, 369, 370
Turnbaugh, Sarah Peabody 81, 82, 613, 614
Turnbaugh, William A. 82
Turner, Nancy J. 1017
Underhill, Ruth M. 436, 1018
Vaillant, George C. 832
Van Oot, B. H. 198
Van Roekel, Gertrude B. 615
Vidler, Virginia 83
Vivian, G. 616
Voegelin, Erminie W. 833
Volkman, Arthur G. 84
Wadsworth, Beula Mary 268, 617
Walker, Deward E. 1046
Walker, Edwin F. 372
Wallace, William J. 618
Wallis, Ruth Saltwell 1079
Wallis, Wilson D. 1079
Walpole, Mary 470
Walters, L. V. W. 875
Waltrip, Lela 373
Waltrip, Rufus 373
Wardle, H. Newell 374, 375, 1019, 1127
Waterman, T. T. 1020
Watkins, Frances E. 619, 620, 834, 835, 836, 837
Waugh, Frederick W. 85
Way, Kathy 959
Webb, Clarence H. 137
Webber, Alika 86, 1080
Webber, Laurence 87
Weber, Francis J. 838
Weber, Michael 839, 840
Weber, Ronald 874, 1021, 1022
Weltfish, Gene 199, 294, 376, 621, 622, 623, 841
Weslager, C. A. 88
West, Marguerite 624
West, Patsy 200
Wheat, Margaret M. 377
Whelpley, H. M. 842
White, John Kennardh 89, 269
Whiteford, Andrew Hunter 270, 271, 272, 541, 542
Whitehead, Ruth Holmes 1081, 1082
Whiting, Alfred F. 625
Widrig, Charlotte D. 1023, 1024, 1025, 1026, 1128
Williamson, A. 626

Subject Index

Note to the reader: This index is keyed to each
bibliographical entry. All numbers refer to a
bibliographical entry.

Subject Index

Snoqualmie 976
Southern Okanagon. See Sinkaietk.
Southwest Indian arts and crafts, changing economy 378,
 388, 605, 606
 decorative arts 591
The Southwest Society 533
Spiro Mound 104, 129, 275, 276
Split-stitch 593
Straw baskets 77, 79
Sun Basket Dance 438
Sun House Collection 630
Suquamish 962, 1009
Surprise Valley Paiute 761
Swallow Shelter 297
Sweet grass baskets 8, 9, 74, 152, 156, 180, 207, 214, 238,
 248, 268, 273
Tanainas 1084
Tarahumara 484, 506, 621
Tetes de Boule 86, 1050, 1080
Thomas Site 669
Thompson Indians 942, 1010
Tillamook 943, 992
Tlingit 851, 862, 867, 880, 885, 887, 890, 892, 898, 917,
 918, 922, 965, 997, 1021
Todd's Valley Indians 744
Tolowa 783
tos 390
Trans-Pecos Texas 379
Tsimshian 887, 890, 942, 952, 1022
Tubatulabal 833
Tulare 633, 641, 744, 767, 786, 804, 810, 832
Tule bag 377
Tule weaving 802
Tunica 103, 177
Twana. See Skokomish.
Twined bags 252, 269, 270, 272
Twined beaded bags 243
Umpqua 692
Upper Stalo Indians 895
Ute 277, 506, 596, 601, 602, 612
Walapai 580
Walpi 472
Wampanoag 77
Wasco/Wishram 907, 943, 960, 995, 1001
Washoe 318, 322, 324, 327, 328, 329, 330, 331, 332, 334,
 338, 350, 356, 357, 367, 370, 373, 374, 383, 652, 684,
 753
Water jugs 406, 549, 727
Western Archaic textile complexes 300
Western Nevada Complex 300, 301, 302, 303
Whatcom Museum, collections of 866, 922
Wheelright, Mary Cabot, collection of 23
Wigwamatew 86
Wikchamni 716
Wilson Museum, collections of 4
Winnebago 210, 211, 242, 247